UNIONE

LIBERI

TRADIZIONE

RISPETTO

AUTONOMI

SOLIDALI

SPORTING LISBON ULTRAS

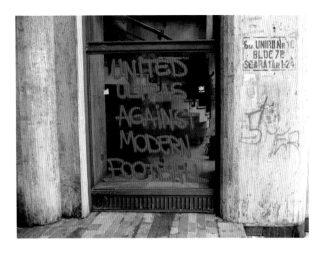

 Two Finger Salute

A catalogue record for this book is available from the British Library.

First Edition 2019
First published in Great Britain in 2019 by Carpet Bombing Culture.
An imprint of Pro-actif Communications
www.carpetbombingculture.co.uk
Email: books@carpetbombingculture.co.uk
©Carpet Bombing Culture. Pro-actif Communications

Written by: Patrick Potter

ISBN: 978-1908211-85-9

CARPET BOMBING CULTURE

www.carpetbombingculture.co.uk

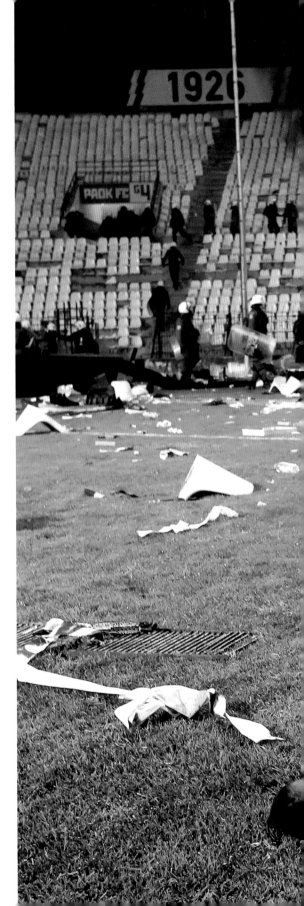

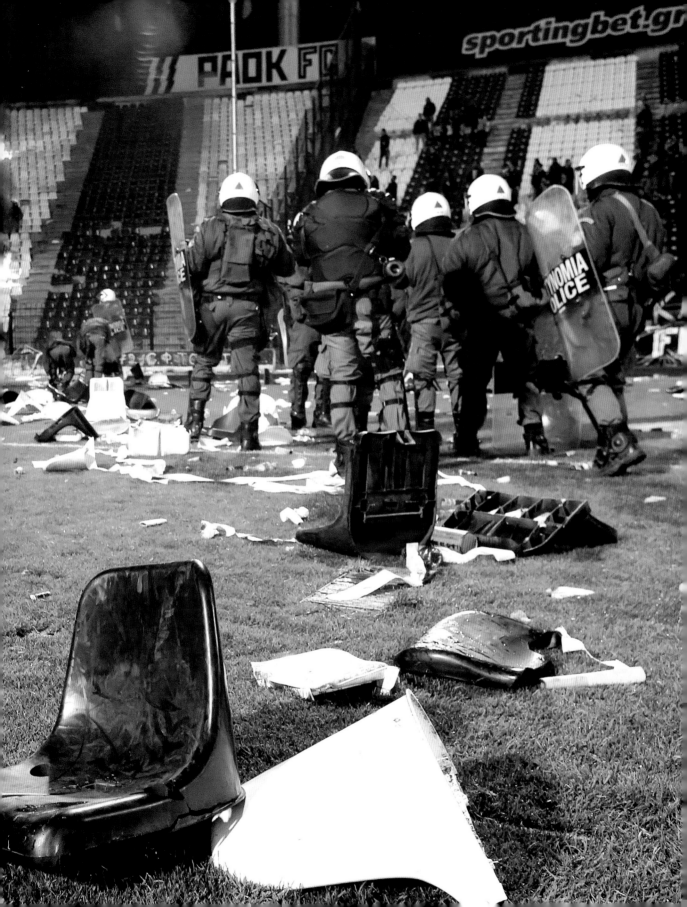

ULTRAS: A WAY OF LIFE

THERE ARE THOSE THAT SUPPORT A FOOTBALL TEAM, AND THERE ARE THOSE THAT SUPPORT A TEAM FANATICALLY; AND THEN THERE ARE THE ULTRAS.

This book is the story of the international culture of the football Ultra. For anyone who has ever been to a match and stared in open mouthed wonder at the displays of the organised gangs of Ultras, the gigantic banners and flags, the displays of synchronised placards, the flares, the chanting.

Are they hooligans? Political groups? Criminals or true fans? The truth is complicated. The permutations are as wide as they are tall, political/non-political, violent/non-violent, those that only go to home games and those that only travel away. No one definition can possibly encompass accurately what is at play.

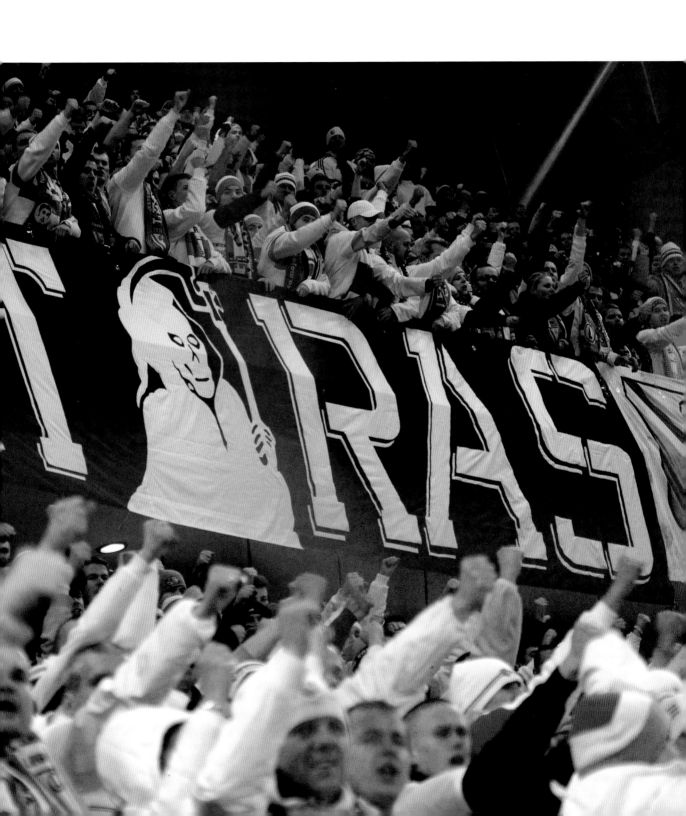

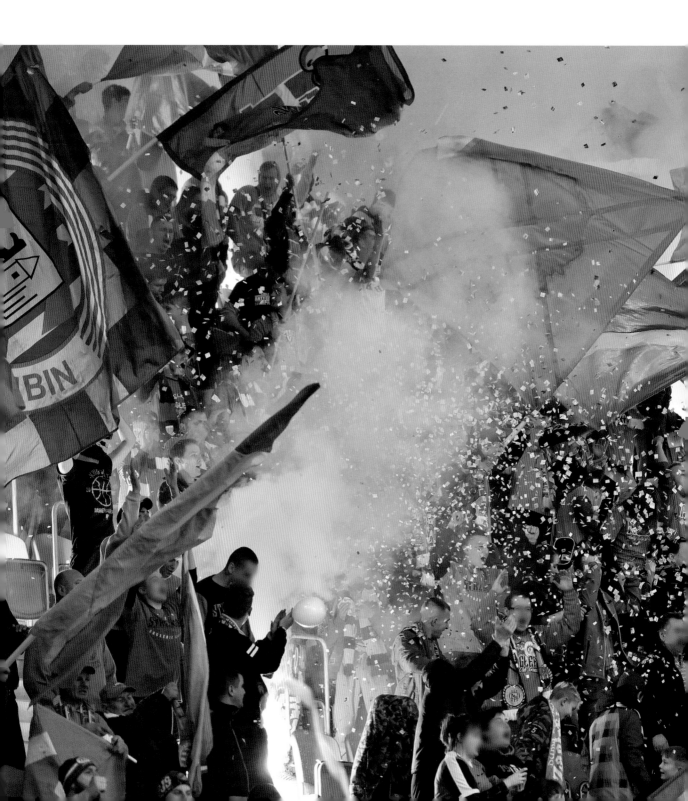

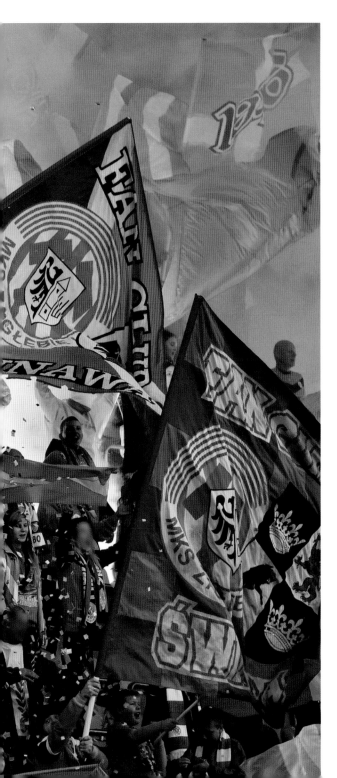

For over 70 years organised groups of Ultra fans have existed, emerging from the Torcida culture in Brazil, broadcast around the world in the 1950 World Cup and taking firm root in Italian culture from 1951 to the present day. When people think of Ultras they think first of Italy, but it's way bigger than that.

Latin America, North Africa, Western Europe, Southern Europe, Eastern Europe, Russia, there are even Ultras groups cropping up in Japan and the USA. Everywhere the culture has its own distinctive regional characteristics, joined by a common thread of fanatical, tribal and aggressive displays of loyalty to a team and the community that the team represents.

Beneath the surface of modern life, the ancient urge for tribal warfare lives on.

There are social forces and psychological drivers that are continually in play as Ultras struggle against the gentrification of modern football.

A book looking at Ultras is bound to be contentious, whether you are disgusted or fascinated - this is human behaviour. For some, this has always been and will always be, a way of life.

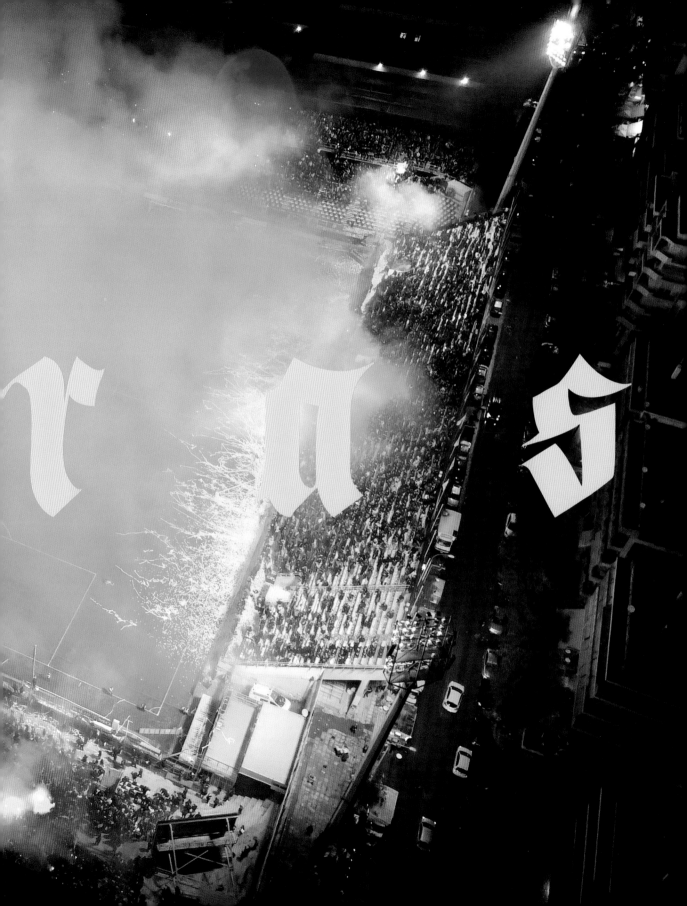

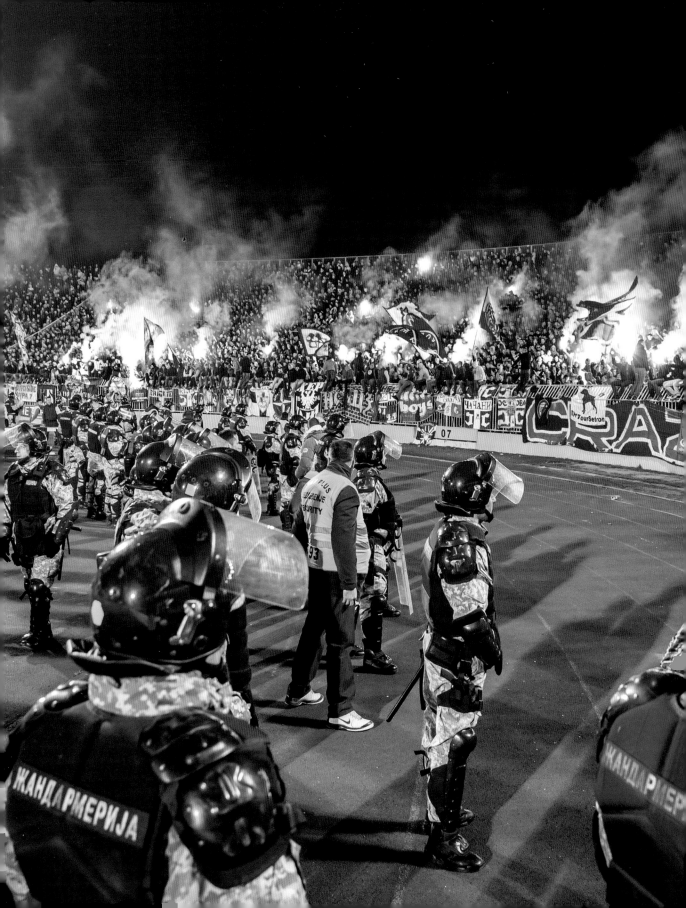

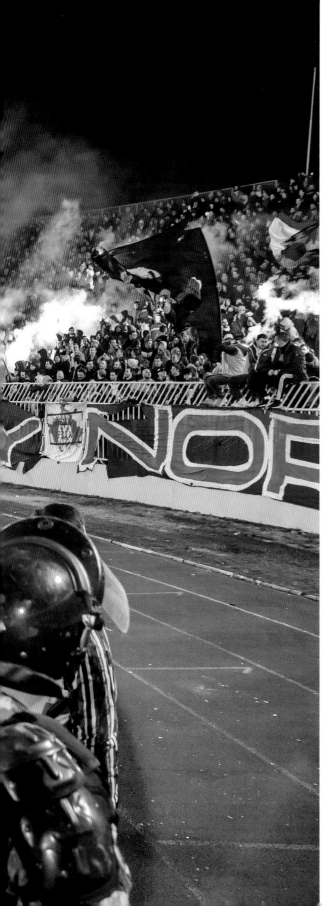

ULTRAS

A WAY OF LIFE

CONTENTS

ULTRAS: A WAY OF LIFE? 4

WHO ARE YA 10

TRIBAL WARFARE 16

A BRIEF HISTORY OF FOOTBALL 25

THE ENGLISH DISEASE 38

FOOTBALL WITHOUT FANS IS NOTHING 51

THE FIGHT FOR THE SOUL OF MODERN FOOTBALL 59

I SAY FUTBOL, YOU SAY FUTEBOL 64

LAS BARRAS BRAVAS 75

CAIRO'S ULTRAS 82

ULTRAS ITALIA 93

TROUBLE NEVER COMES ALONE 110

POLAND'S ULTRAS 118

TORCIDA SPLIT 126

SPARTAN ATTITUDE 132

OTTO MANIA 143

FUSBALL 149

IBERIAN BARBARIANS 156

ALLEZ PUTAIN 162

BALKANISED 168

AZOV BATTALION 177

ULTRAS ASIA 186

HUP HOLLAND HUP 195

MAJOR LEAGUE ULTRAS 196

SINGING WHEN YOU'RE WINNING 202

FIFA GO HOME 206

THEY THINK IT'S ALL OVER 214

WHO ARE YA?

DEFINITION OF ULTRA

THERE IS A LINE BETWEEN THE ORDINARY FOOTBALL FAN AND THE ULTRA FAN. IN THE HIERARCHY OF FANDOM, THE ULTRA SITS AT THE TOP. WHERE THEY EXIST, THEY OWN TERRITORY AT THEIR HOME STADIUMS. AND THE LINE BETWEEN THEM AND THE REST IS OFTEN A PHYSICAL BARRIER, USUALLY AN UNSPOKEN LAW.

Difference is a keyword. One club may have two groups of Ultras that have totally different perspectives on what they do. Their passion for the club may be equal, but their group culture may be different.

And across the world, different national and regional cultures of football make for differing types of Ultra allegiance. While in some countries the Ultras have been linked to organised crime, in many others they have not. And crucially, most Ultras are not necessarily Hooligans. Although some Ultras groups clearly do have a history of violence.

For most people involved in Ultra organisations, their allegiance is their bond. It gives them a sense of belonging and purpose, a sense of pride and an experience of shared passion. A shared community encompassing organisation, policy, direction, community and charity.

Violence is not the point. If it was the point they wouldn't make themselves so highly visible. They wouldn't travel in large groups, waving flags. They would, like many hooligans have, disguise themselves in nondescript clothing, wear the enemy strip, travel in small groups on regular transport, and avoid police escorts. This pattern of behaviour is not what Ultras are generally about.

It is impossible to make a working definition of Ultras that would satisfy everybody involved. But the one thing we can do is state clearly that the terms Ultra and Hooligan are not used interchangeably in this book.

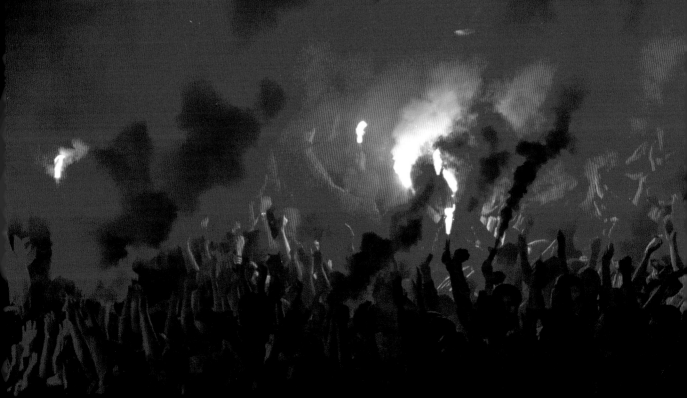

FOOTBALL WASN'T

INVENTED IN 1992

TRIBAL WARFARE

FOR ROUGHLY 192,000 YEARS, BETWEEN THE APPEARANCE OF MODERN HUMANS AND THE ARRIVAL OF FARMING - HUMANS WERE UNIVERSALLY - TRIBAL ANIMALS. IT TOOK ANOTHER 9700 YEARS FOR THE GAME OF FOOTBALL TO ARRIVE, DURING WHICH TIME - FOR THE VAST MAJORITY OF HUMANS, THE VILLAGE BOUNDARIES WERE THE EDGES OF THE EARTH.

Our sense of identity has evolved to be tribal, parochial, local, familial. The relatively new invention of national identity forms a thin crust atop a deep layer of partisan instinct. And football is one of the few spaces left in modern society when the expression of those tribal loyalties is still encouraged.

And there are some people who need it, really need it, more than the average joe. For some, the flags are more than flags, the colours are more than colours. For some, the expression of their willingness to live and die for the tribe - is their very reason to live. They see themselves as a band apart, a relic from a primal age - their disdain for the normal supporter is almost as deep as their hatred for their enemy tribes. These are Ultra fans. Ultra traditional - as in basically medieval.

There is no tongue in cheek, no irony, no distance. It is a fanatical subculture, one in which the value systems of liberal modernism are often inverted. It has its own codes of behaviour, its own sense of honour, its own version of morality. And although there are significant differences between regional versions of Ultra fan culture - the beating heart of it all is a nostalgia for tribal identity.

The whole story of modern football since the 1960's has been a series of attempts to civilise the game, yet the Ultras never really went away. What makes this culture so compelling? Is there a little part of all of us, buried deep beneath the layers of good education, that longs for victory?

In a world in which we are told place no longer means anything, where locality and community are casualties of the digital future - loyalty to a team, loyalty to an area, loyalty to a social class perhaps, are all out of time. And yet here they are, continuing to exist in this highly structured and obsessive world, where liberal values are turned upside down and men act like vikings.

Football has claims to being a working class sport. And working class culture, used to be, a culture of community spirit and mutual support. A flashback to the golden age of football as a community ritual, a space where identity is created as much as expressed.

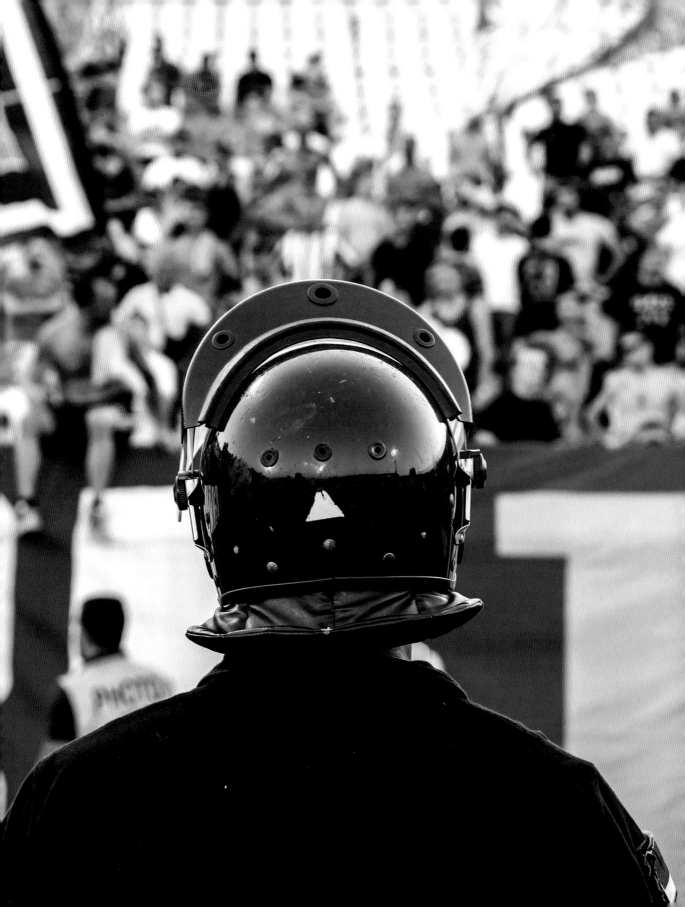

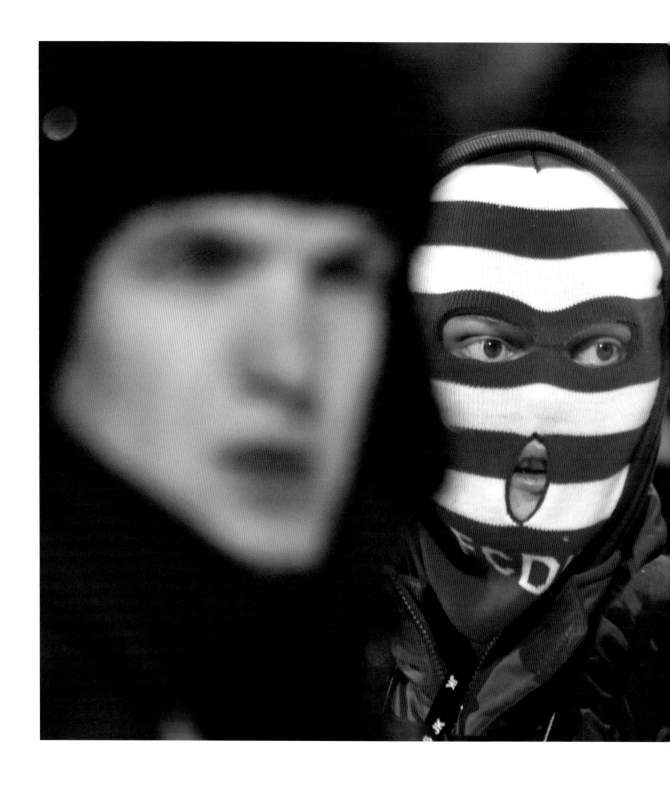

John Clarke, writing on Football Hooliganism in 1973, claimed that football was integral to working class culture because it matched core working class values. These were "Excitement, physical prowess, local identity and victory." As a quick thought experiment, if we invert these values do we get something that looks like middle class culture? "Mindfulness, intellectual prowess, international identity, avoidance of conflict." It kind of works doesn't?

These are old ideas about the labouring class - and they come from the idea that hard physical work creates the need for physical prowess. Boring repetitive labour creates the need for excitement and 'letting off steam'. Local networks of support, extended families and the lack of freedom of movement create strong territoriality.

And victory in sport, or in violence, is (supposedly) the only way for working class men to experience a fleeting moment of high status. So football then, offers a potent package. You can satisfy all these needs in one day at the local football ground and, even if you do get arrested, you can still be back at work on time come Monday.

The excitement, the passion and pride and the 'psychological sense of being at one with the crowd' were most intoxicating from the stands. Football was essentially a game of physical combat - in 1973 you could say this with a straight face, images of Neymar rolling across the pitch were yet to be witnessed. Footballers were as hard as their fans.

The point that Clarke makes is that casual violence was so embedded in the culture of labouring men that it hardly merited talking about. They didn't see it as a problem. And they always claimed that involvement was more or less optional. There was always a lot more smoke than fire. And although violence was temporarily legit, it was limited - it wasn't supposed to get out of hand.

Much later on, organised hooliganism would lead to some pretty extreme violence. But this is English football as described in 1973. Most of the players were working class and many of them were local to the area which the teams represented. And this leads us to one of football's enduring myths - it is a route to success that does not depend on being born into the right social class. The working class football superstar is still a powerful influence on young men growing up.

Already in 1973 the game was in the early stages of gentrification. And a key part of that process was redefining the 'true supporter'. Increasingly the rough and ready chaps who occasionally fought at the matches were rebranded as 'not real football fans' who were only there for the violence. They became 'hooligans'. The true fan was then the new middle class audience who appreciated the technicity of the play and sat in a seat while he watched. The increase of 'hooliganism' could then be seen as an attempt made by working class football fans to hold on to the elements of the game that were in the process of being purged.

Art imitates life and life imitates art. As the media blew up the folk devil version of the hooligan, hooligans played up to the myth. They fed each other in an explosive cycle throughout the 1970's and 1980's leading up to the slick, organised and weaponised violence of the casual firms. This pattern played out in many other footballing nations, as travelling fans inspired one another.

Back to the 21st century and this phenomenon is still in full swing. Although British football has been largely pacified, and even Italian football is much less wild than it was in the 1990's the central conflict between the old school fan and the corporate football entertainment complex is still there, still echoing the struggle between glossy postmodern urban capitalism and angry, parochial, left behind regionalism.

All over the world, cracks are appearing in the facade of modern culture - as micro-identities throughout Europe agitate for separation from larger nations, and a return of all manner of local patriotisms finds a voice in the resurgence of right wing populist heroes like Berlusconi, Farage, Le Pen and Italy's Five Star movement. In the terraces, the football fans are perhaps the canaries in the mineshaft. Three times in recent history, football's Ultra fans have slipped easily from the terraces onto the front lines of popular revolutions and civil wars, in Serbia, Cairo and Ukraine. The militias in the Crimea are manned by many an Ultra even now.

The struggle between Ultras and Modern Football is a foreshadowing of a wider struggle to be played out beyond the football stadiums of this world. Do we have to choose between Premier League style Liberal Capitalism versus the return of Right Wing Populism? Or is there another way, a move toward fan owned, non-league football by the people for the people?

Ultimately, it's fans like you who will decide.

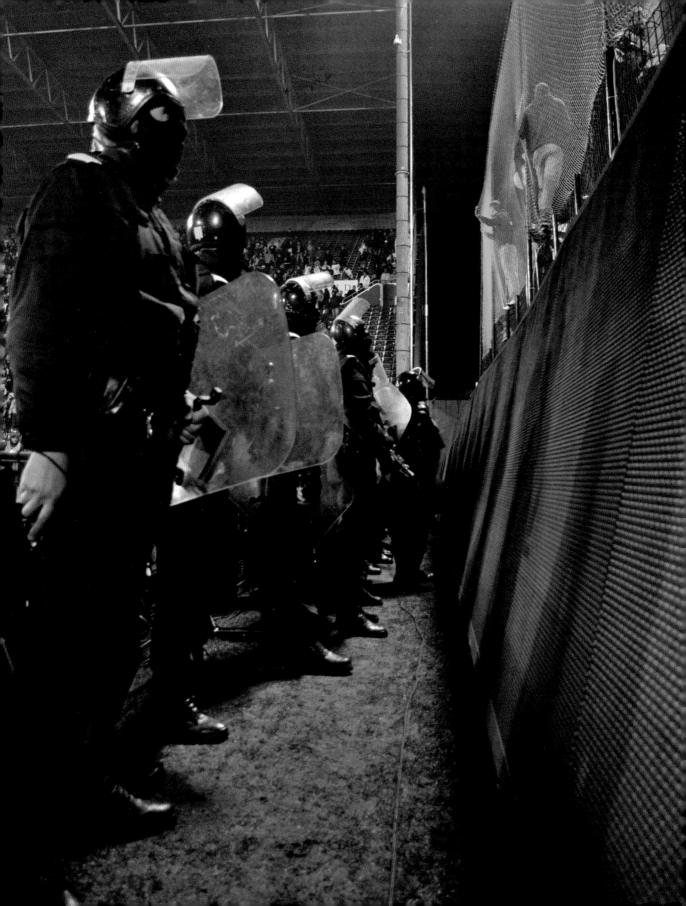

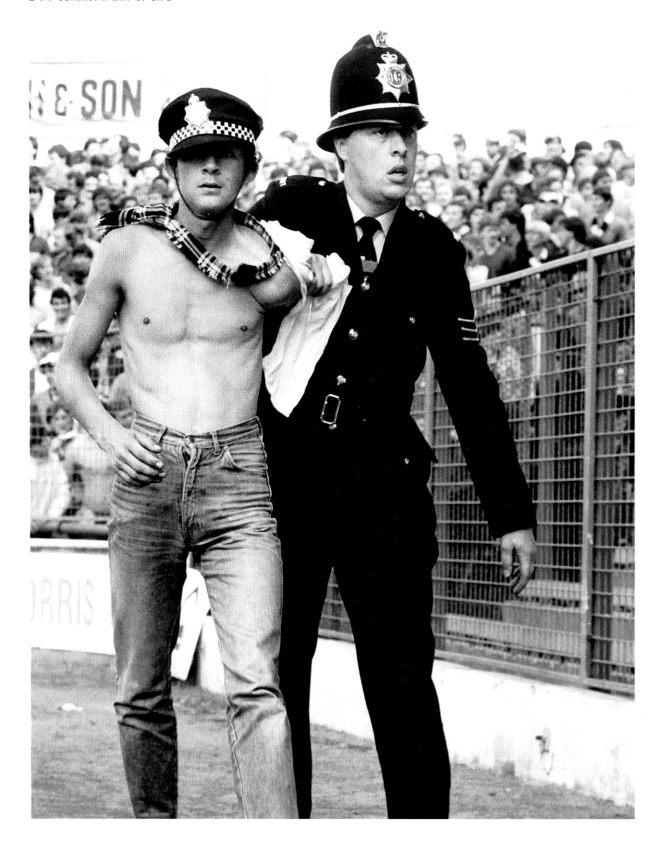

A BRIEF HISTORY OF FOOTBALL

When West Ham moved from Upton Park to the London Stadium in 2016, they lost one young fan to Italian third division football. Justin explained to the BBC:

> *"The first season at the new stadium, **I started to feel a change, I started to feel more like a customer, more like a consumer and less like a fan.** People were more concerned about having a chat and talk about the Wi-Fi, talk about what they are up to over the weekend. I was worried about my style of support, [that] the traditional way of following your team had died there."*

https://www.bbc.co.uk/bbcthree

In the centuries old story of football, something had gotten lost along the way. Something was missing. The wild howling, the fanatical support, the passion, the tribalism, the sense of being 'part of something, part of the movement'. In a word - *catharsis*.

Catharsis. The need to let it all out. To blow off steam. To explode. After the work is done, after all the restrictions, the boredom the tension and the stress of the working week, month or year. We have always needed moments of carnival, moments when the social order is loosened, the rules relaxed. The only way that strict rules ever really survive is through the organised use of catharsis. If you do not have Saturday, Monday would never survive.

Long before there were fixed weekends in your labour contract, there were religious festivals. Shrovetide in Britain, and much of the Christian world, back in the middle ages was one such festival of release. And it was long associated with the precursor of modern football - a game played between villages, where a stuffed pig's bladder was punched, kicked, wrestled and grabbed by hundreds of players across hours of play where the pitch was the villages and the land between them, every field ditch and bridge, and the object was to battle the ball into a goal in your opposing village.

This was *shrovetide football* and it existed in a world where there was no freedom, there was almost no travel at all, the confines of your village were the limits of your world, they were your whole identity. The lords that you served, to whom you effectively belonged, were not really the locus of your pride, you fought for the honour of your village, just like the workers of medieval Venice fought on the bridges for the honour of their tiny scrap of the city - this was the one time you could be more than just a peasant, you could be the hero of your scrap of mud and huddle of shacks - you could be *somebody*.

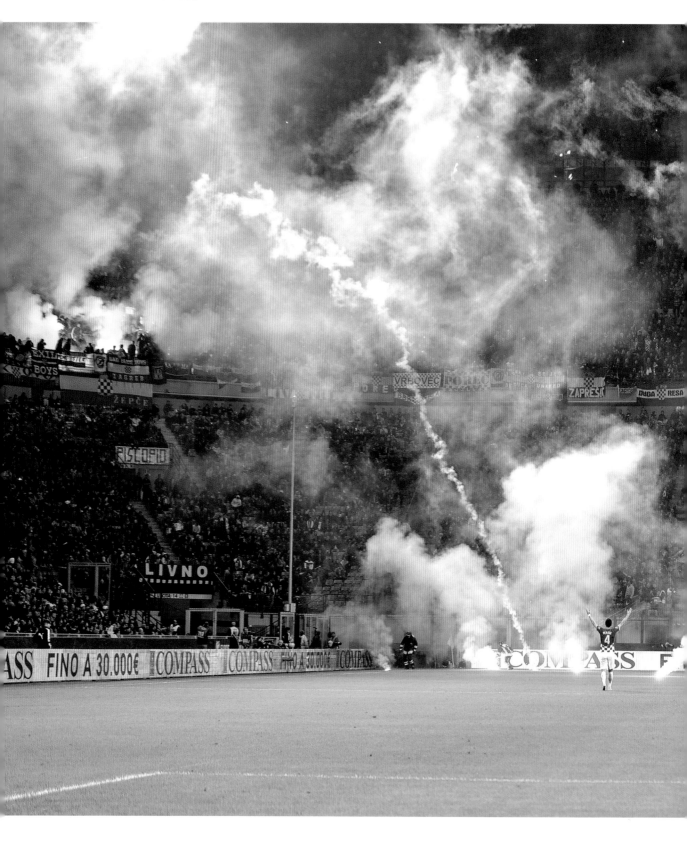

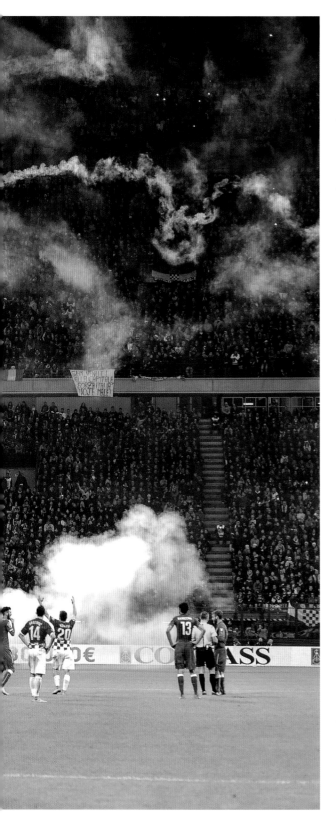

Although we often think of the middle ages as a time of unbridled misery, there were some freedoms that the peasants enjoyed that we do not. They had commons, land held in common that they could use to graze livestock or grow extra crops. This began to change from the 16th Century onwards as landowners fenced off huge tracts of land for larger farms, placing the commons under private ownership. There were riots, and there were 'football' matches that 'accidentally' smashed all the fences around the newly enclosed lands. This was an early example of football spilling out of it's cathartic function, to something more directly attacking the power of the ruling class.

> *"Disguising the fence burning as a football match had special significance because among the land to be enclosed at West Haddon was a common or wold covering 800 acres, or almost a third of all the open land in the Parish."*

> - JM Neeson, 'Commoners: Common Right, Enclosure and Social Change in England, 1700-1820' CUP (1996)

Not surprisingly, medieval football was repeatedly banned. One of the main problems being that it injured the nation's stock of available soldiers. The commoners were supposed to spend their free time practicing the use of the longbow, the secret weapon of Tudor England's armies. It was a bloody difficult weapon to use, and many were fined for playing football instead of practicing.

Football also came under attack from the church, as working people in Christian nations only had one day off work - and that was Sunday, the holy Sabbath upon which one should only exert efforts in praising God, not slide tackling Big Jim from the next village.

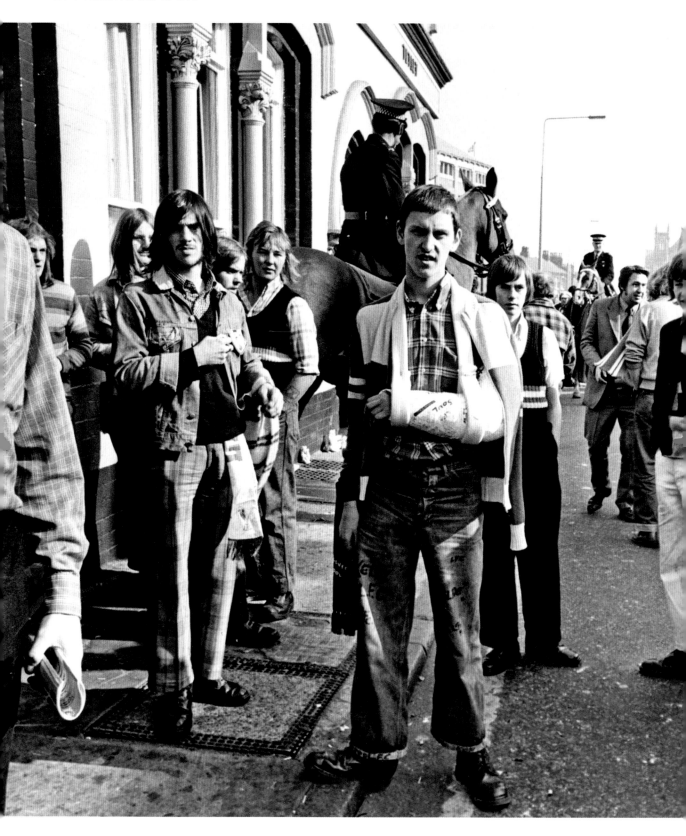

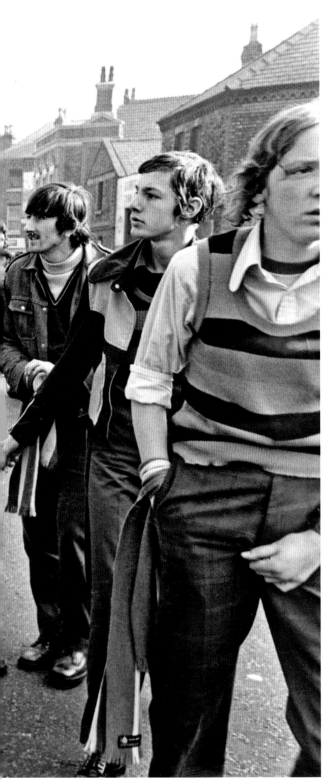

Any organised activity by the workers for the workers smacked of a threat to status quo, and as the industrial revolution saw football, like the workers, moving into the cities the Victorians (The British under Queen Victoria 1837-1901) began the long process of turning football into a game for gentlemen.

> *The 'Muscular Christians' of Victorian times not only saw that, properly altered, given a set of rules, the game could be used to impose discipline first of all on the upper classes themselves in their public schools; and from there to help impose discipline, team spirit, physical fitness on unruly workers.* - mudlark121

https://pasttenseblog.wordpress.com (2016)

The Victorians rebranded Britain as a moral force seeking to civilise the world (while pilfering everything that was not nailed to the floor). They wanted a disciplined and industrious working class to fill up their new factories, because it was high time for an industrial revolution. Riotous Folk Football matches that lasted three days, and ended with more broken arms than goals, didn't fit this picture - the ugly game was about to get a rule book. But they didn't want to make the game too technical just yet...

Looking at their history books, Victorians had concluded that Empires tended to collapse because their ruling classes went soft. How could one make sure one's heirs were tough enough to rule the world?

'Muscular Christianity' became the big idea of the day. It was time for Britain to 'man up', to drop all this namby pamby intellectual nonsense and engage in manly pursuits and godly works. Football was the ideal medicine for effeminate rich boys who read too much poetry. Just as it was the ideal method for

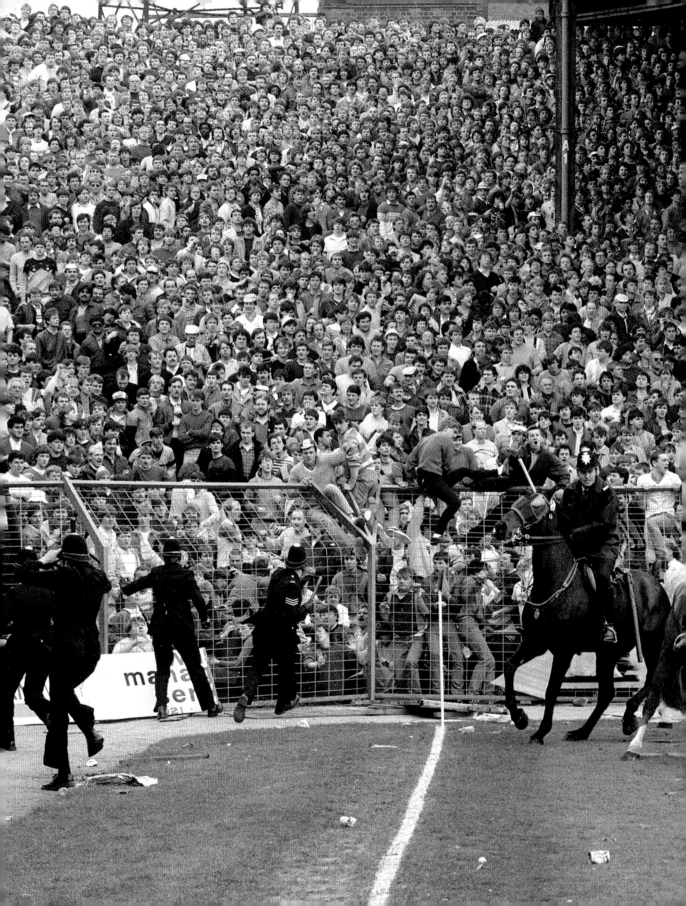

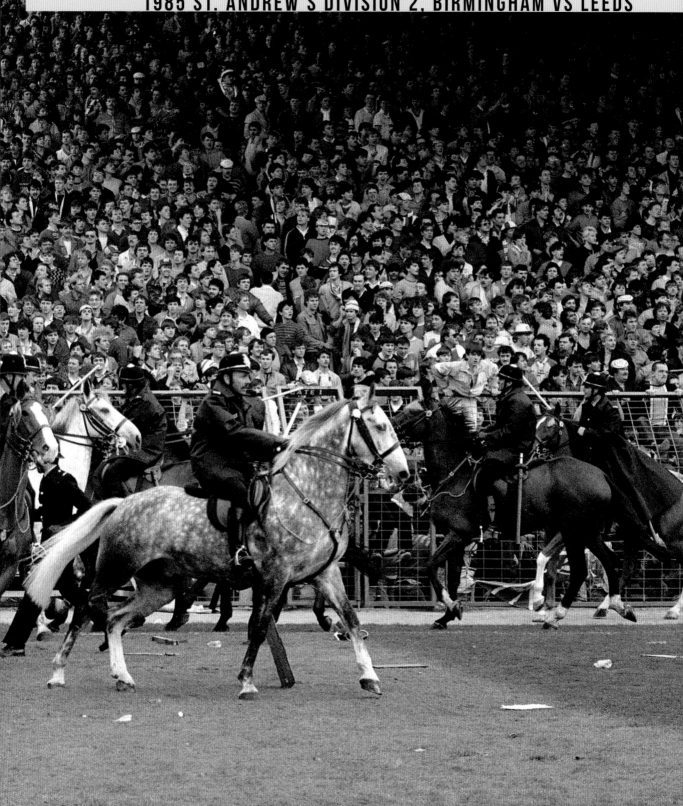

keeping your factory workers fit, healthy and well disciplined. So it became a public school staple, at the same time as factory owners began starting teams for their workers. However, It was soon to diverge into two completely different games: Rugby and football.

The Englishman goes through the world with a rifle in one hand, a bible in the other and football boots in his school bag, so they used to say. At Rugby school the players were encouraged to use 'hacking' shins as a tactic. The softies at Eton invented the referee and linesman. The game gradually split into two variations - rugby and football (aka 'The Dribbling Game', which for some reason, never caught on as a name).

Rugby became a game for ruffians played by gentleman and football a game for gentlemen played by ruffians, so the saying goes.

In 1857, Sheffield Football Club became the first football club in the world. Brilliantly illustrating the importance of Yorkshire during the industrial revolution. Notts County became the first professional club in 1864, drafting their own rules and banning 'hacking'. In 1864 Notts County became the first professional club and the FA was formed by twelve clubs in a meeting in London in 1863. Blackheath dropped out when hacking was banned, because they were savagely violent cockneys. The FA then was a microcosm of the industrial revolution - featuring teams from the nations most industrial areas.

The FA cup arrived in 1871 and the English football league arrived in 1888. The game rapidly professionalised, matching the speed and vigour with which so many other new industries cropped up at the time.

During the industrial revolution football was an expression of pride in your area or pride in your industry. Teams formed by workmates and funded by the employers were a big part of the Edwardian game. The lads from the Lancashire and Yorkshire Railway depot became Manchester United, Thames Ironworks staff formed West Ham, workers at Singer Bicycles formed Coventry City and of course it was the workers at the Royal Arsenal in Woolwich who became Arsenal.

This beautifully illustrates some of the contradictions in working class life - the job, the town and the industry were part of your identity and a source of pride even while the exploitation that you experienced could sometimes be brutal to the point of murderous. It's also a good example of how the bosses recognised that funding football teams was a good way to increase that sense of team spirit and keep their workers loyal to the firm.

FOOTBALL SPREADS ACROSS THE WORLD

The Victorians were internationally minded - and were keen to export sports to their dominions so that we could experience centuries of thrashings by superior foreign teams. The first modern Olympics were held in Athens in 1894 and football became an Olympic sport at the Paris Olympiad of 1900.

Football clubs appeared across the world in the 1800's as the English moved around the Empire and beyond to work, or settle. All classes were involved in this time of movement as workers looked for better opportunities in the 'new world' and educated chaps exported their engineering skills and indulged in various imperial adventures, looking to make their fortunes.

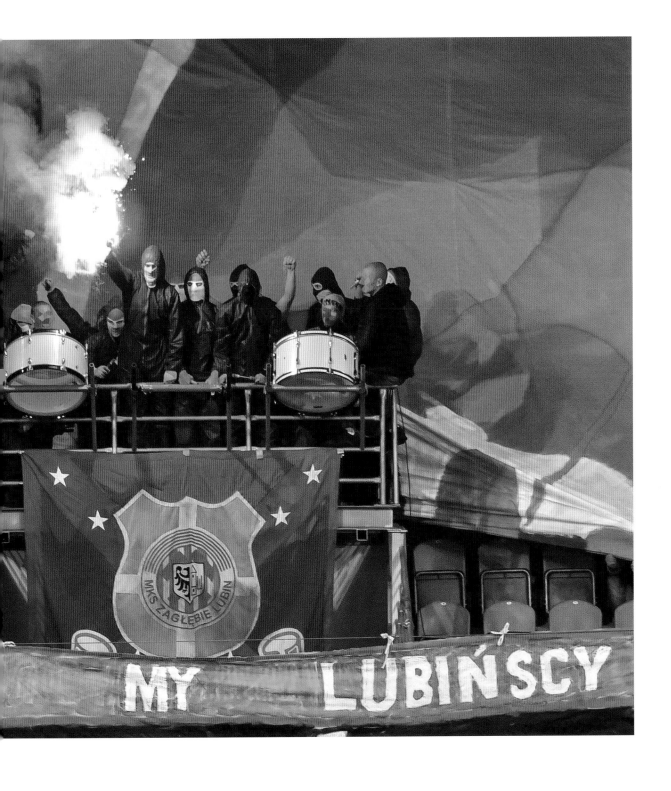

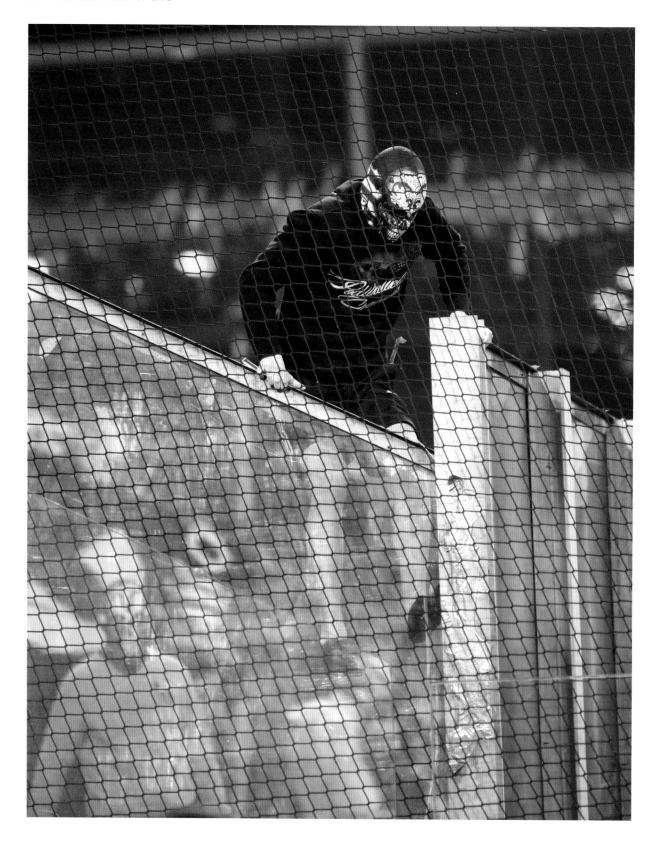

They all took their favourite game with them, sowing the seeds of both football and rugby clubs in Australia, the Americas and Continental Europe. And of course, sailors of all nations played a big role in exporting new ideas around the world. It was English and Dutch sailors who were credited with bringing the game to Brazil, and Croatian sailors who brought the Torcida back to Europe eighty years later.

Interestingly, the association of the game with Ivy League universities in North America led to football becoming a very middle class institution in the USA in contrast to it's proletarian image in the rest of the world.

At the dawn of the 20th century, the British Football Association eyed the creation of FIFA with suspicion and envy. International Football was already beyond their control, it belonged now to a wider world. Formed in Paris in 1904, FIFA was to govern international competition between the now well-established national associations in Switzerland, Sweden, Spain, the Netherlands, Germany, France, Denmark and Belgium. Fast forward to now and there are over two hundred nations represented in FIFA.

The inaugural FIFA World Cup in Montevideo, Uruguay in 1930 cemented the cultural importance of football in Latin America. It had gone from being a European import to becoming a fundamental element of life for ordinary people in countries like Uruguay, Argentina and Brazil.

Between the two World Wars the impulse to use sport to create international unity was a part of the drive towards a re-invigorated Olympics as well as FIFA's competition. However, the scars were too fresh for the UK who refused to participate until the 1950's.

The 1950 World Cup in Brazil saw England return to world football only to discover that the game really did not belong to them anymore. It was a festival of international football culture demonstrating not only the dominance of Latin America but also strong teams from Sweden, Yugoslavia, Italy, Switzerland and even the USA. And it was an opportunity for the seeds of the fervent style of Latin American support to spread to the rest of the world.

In the 1960's the advent of television had a massive impact on the reach of the game and in the UK the 1966 World Cup win drew in a new generation of young fans. The era of football superstars had arrived, alongside the golden age of the skinhead bootboys. The 1970's and 1980's were the zenith of the 'hooligan' in the UK, and although the 1990's saw the systemic gentrification of football in Britain, abroad it was the halcyon period for Italian, Argentine and Russian Ultras. Now the football world is divided among nations where stadiums are so tightly controlled you can't even light a fart, and stadiums such as those found in Athens where you can still wander across the pitch to casually set the away fans banners on fire.

The new stadiums are an improvement on the old, but the balance between a safe space and a steril space is difficult to strike. We've come a long way since we pushed one another gleefully down the village well to celebrate Shrovetide, but have we lost something? Should we chat idly about the wifi signal strength in the stadium while nibbling a gluten free prawn sandwich? Have we simply betrayed the soul of football?

THE ENGLISH DISEASE

ALL YOUNG MEN ARE CONCERNED WITH STYLE, BUT NOWHERE HAS THE LINK BETWEEN STYLE OF DRESS AND FOOTBALL FAN CULTURE BEEN SO PRONOUNCED AS IT HAS IN THE UNITED KINGDOM. WHILE ACROSS THE WORLD ULTRAS EXPRESS THEIR FANATICAL LOYALTIES THROUGH SCARVES, FLAGS AND FOOTBALL SHIRTS - BRITISH FANS HAVE LONG SINCE ESCHEWED THIS TYPE OF BEHAVIOUR, PREFERRING TO EXPRESS THEIR IDENTITIES THROUGH HEAVILY CODED COUNTERCULTURAL STYLES OF DRESS.

SKINHEADS

The Skins were not the first working class style tribe to emerge out of the 1960's, they followed in the footsteps of the Teds and the Mods - evoking a nostalgia for their working class roots with steel capped workers boots, cropped hair, sta-prest trousers, shirts and braces. It was a stripped down, no-nonsense look in stark contrast to the pyschedelic peacock revolution and the flowery nonsense their middle class contemporaries were engaged in.

After the 1966 World Cup win a new generation flooded local football grounds on a Saturday, going in large groups of friends rather than with their dads, as changes in ticket pricing encouraged them in. In London, many of these lads were Skinheads and the bootboy style marked out the more hardcore fans.

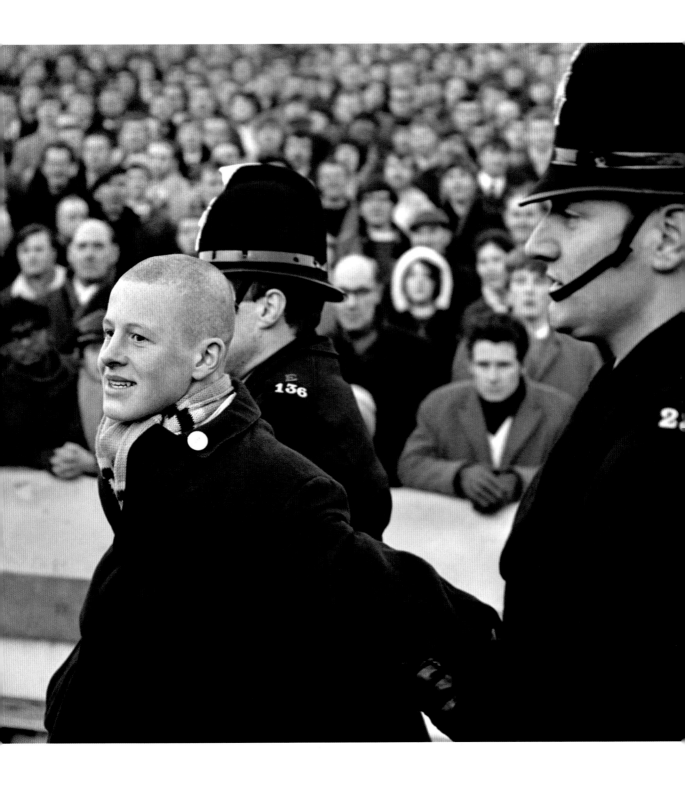

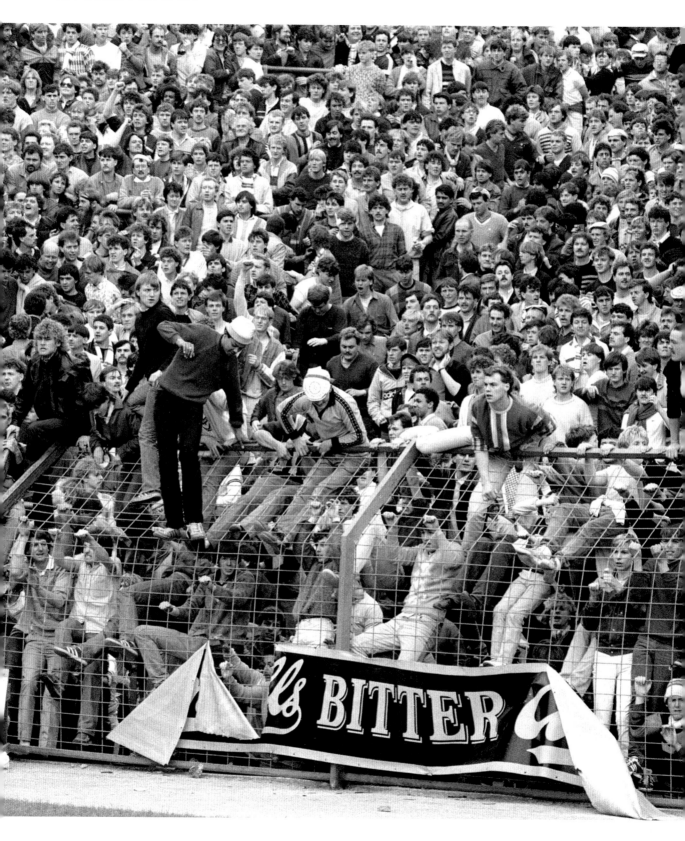

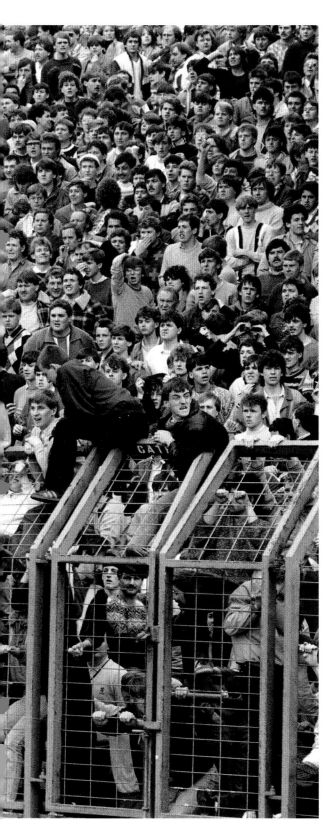

As these lads started travelling to away games the style swept the nation. The Skinhead look became the uniform of the British hooligan. And the hooligan became the big moral panic of the decade.

By the late 1970's, the wind of change was already blowing. In Britain at least, the bonehead boot boy was about to become a dinosaur surrounded by vicious little mammals in Italian sportswear...

THE ONLY COUNTRIES THAT HAVE A CLUE ABOUT WHAT TO WEAR ARE THE HOME NATIONS AND SOME OF THE ITALIANS. THE REST OF EUROPE ARE JUST SHIRTS, SCARVES AND BUMBAGS.

ENGLAND SUPPORTER

CASUALS

Scally is a term for a very particular type of petty criminal from the two great cities of the industrial North West of England, Liverpool and Manchester. It was in Liverpool that the conditions for the creation of a uniquely British form of fan culture could emerge in the late 1970's. First and foremost, Liverpool was a sort of city state, a place that always believed itself to be unique, separate from and simply better than the rest of the UK. While most regional kids desperately try to keep up with the style dictates of the capital city, Liverpool merrily goes it's own way, convinced of its cultural superiority to both London and Manchester. It was also a city that felt under siege through the 1980's as central government tried to strip the socialist city council of its powers.

In the 1970's Liverpool won four First Division titles. At the same time the economy of the city went under due to a downturn in manufacturing and shipping. Structural unemployment for the young was a feature of life there for the duration of the 1980's. There were a lot of angry young men supporting LFC, and many of them were pretty handy at shoplifting and they had an eye for fancy modern sportswear. Then from 1974 to 1984 LFC dominated in Europe, and the fans, thanks to a student travel ticket scam, followed them, to cities where the security guards in the big sportswear shops had never had to face an army of scallies before.

A LOT OF PEOPLE STILL CANT UNDERSTAND HOW YOU CAN SPEND £400 ON CLOTHING AND THEN GO OUT AND SCRAP IN IT.

80s CASUAL

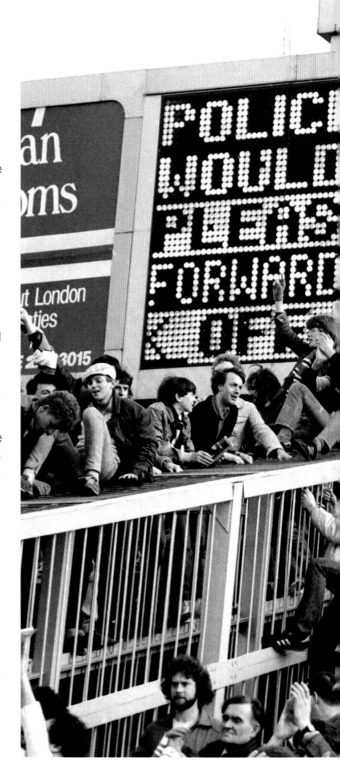

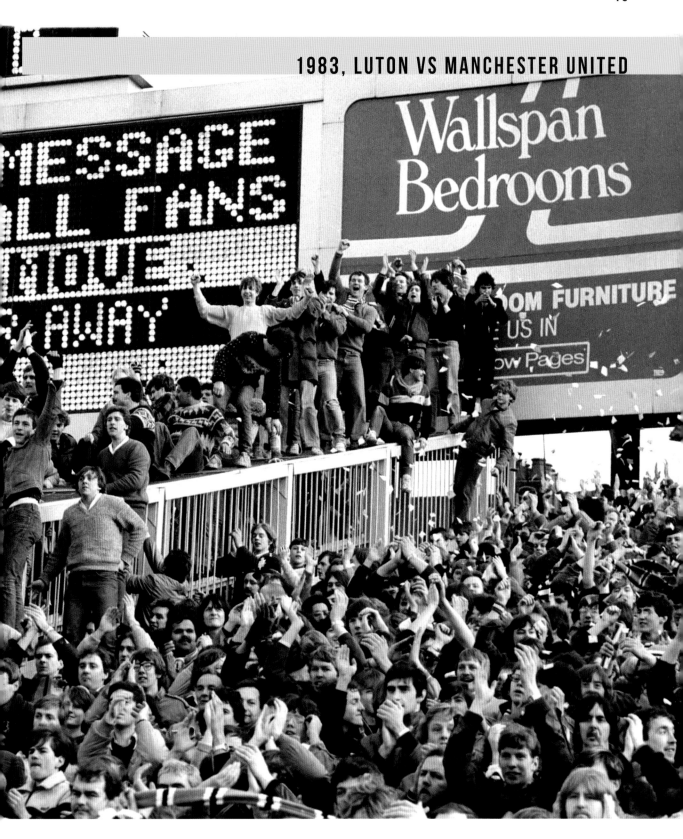

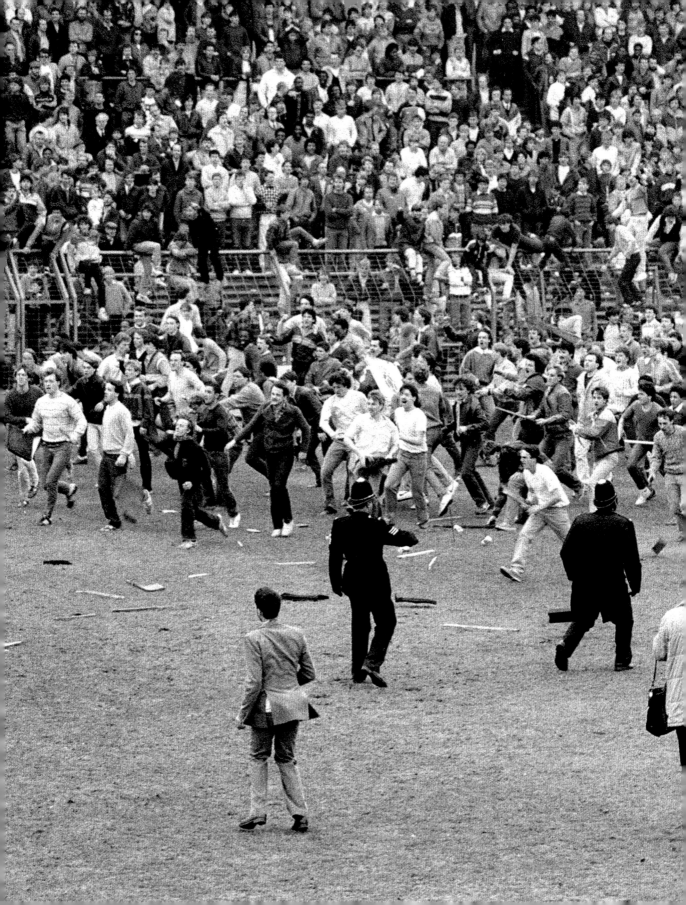

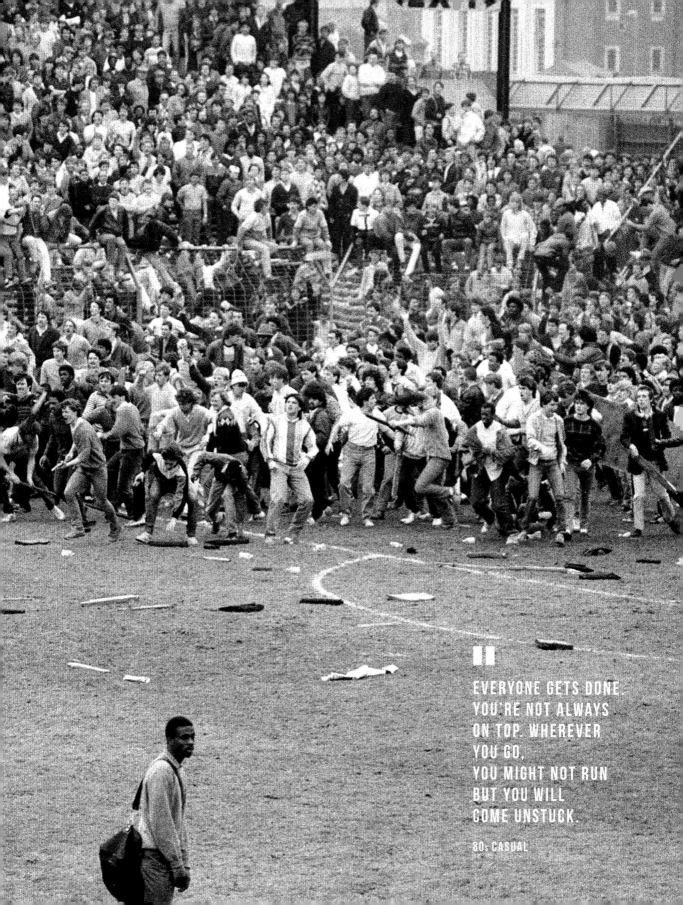

EVERYONE GETS DONE.
YOU'RE NOT ALWAYS
ON TOP. WHEREVER
YOU GO,
YOU MIGHT NOT RUN
BUT YOU WILL
COME UNSTUCK.

80s CASUAL

Liverpool was flooded with stolen designer clothing, and in 1981 the culture was sufficiently established for Peter Hooton to launch a fanzine 'The End' giving voice this new subculture of clued up working class lads who liked football, fashion and music all at once. The 'casual' was born, the hooligan in casual sportswear who fooled the police by not wearing hobnail boots and a football scarf, then caused more trouble in the ground than any bonehead.

It didn't take long for London to start trying to pretend they had done it first, and from there everybody was doing it. Casuals kept flipping the script, changing the style and engaging in a game of one-upmanship not only with other firms but also with each other. And as the 1980's progressed many casuals got more involved in organised firms, travelling in small, focussed groups to look for violence, occupy enemy pubs, kick off in town centres or arrange brawls in car parks away from the ground's security.

THE FIRMS

If the 1970's Italian Ultras were inspired by radical political groups, then the 1980's British Firms were more inspired by big business. Calling their organisations 'firms' evoked the yuppy alpha male vibes of the decade, these were slick, well organised and aggressive little corporate entities, more like startups than guerrilla armies.

The most infamous firms were attached to teams that represented tough, industrial working class neighbourhoods in cities like London, Birmingham, Portsmouth, and Leeds. Names like the Chelsea Headhunters, the ICF, the Bushwhackers, The Zulus, the Aston Villa Hardcore, Portsmouth 6:57 and Man United's Red Army are still remembered today. And then there were firms that were notorious not simply for violence but also for their cutting edge terrace styles such as Aberdeen's Football Casuals, Hibs' Capital City Service and Liverpool's Urchins.

WITH CHELSEA IT'S NOT JUST ABOUT THE FOOTBALL, ITS INTER-GENERATIONAL. FAMILY CONNECTIONS. YOU DON'T CHOOSE THE FOOTBALL TEAM, THE TEAM CHOOSES YOU. IT'S IN YOUR DNA.

NO POLITICS, NO RACISM, JUST CAMARADERIE AND THE CRACK.

CARLO, CHELSEA

Firms were fantastic fuel to the tabloid press, a ready supply of sensational headlines stoking a moral panic which led to PM Margaret Thatcher identifying the football hooligan, alongside the striking miners, as one of the nation's 'enemies within'.

> *"to destroy working-class culture, to destroy working-class unity, to destroy the unions, to destroy the mass participation sports that people went to. The sense of community and the sense of togetherness, one of the keys to the whole Thatcherist philosophy was to destroy that."*

https://www.the42.ie

The mobility of these firms meant that they terrorised European fixtures and tarnished the nation's image on the continent (while inspiring a new generation of Ultras abroad, especially in Poland and Russia) eventually leading to a ban on clubs playing in Europe.

Today, like most public places in Britain, the football stadium bristles with CCTV cameras. There is no tolerance for drums, flares, tifosi or even standing up in British Premier League football. There ain't no Curva Nord in the prem, no Ultras at the London Stadium (but maybe Crystal Palace have something going on).

Ultras around the world have been inspired by British fan culture - and for some the Casual style is synonymous with being an Ultra, for others the Skinhead look is still the very thing. Italian's could argue that the British Casual's stole their look in the first place, but that's a long argument for a boozy afternoon.

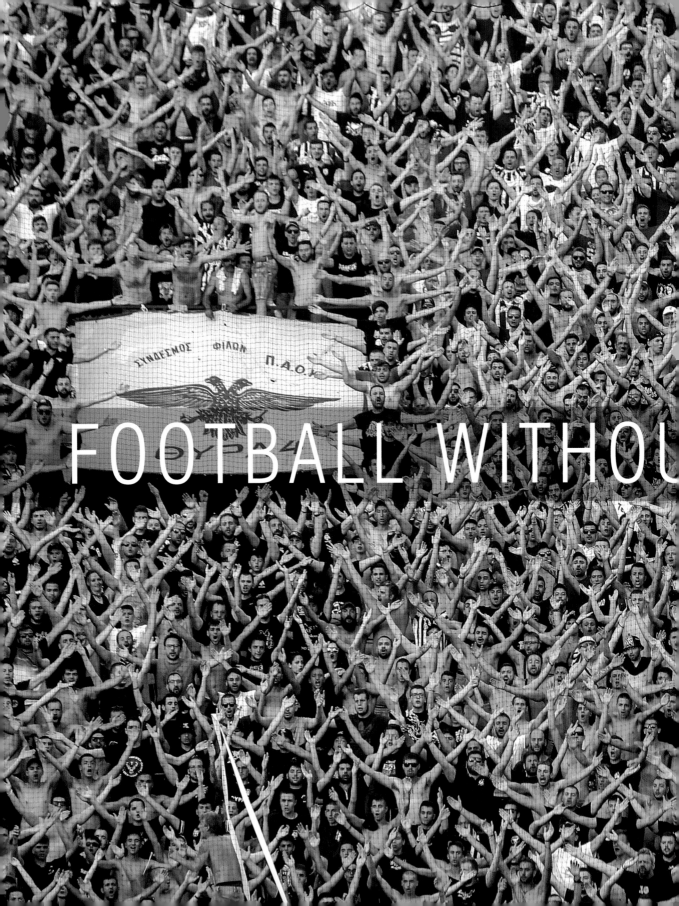

FOOTBALL WITHOU

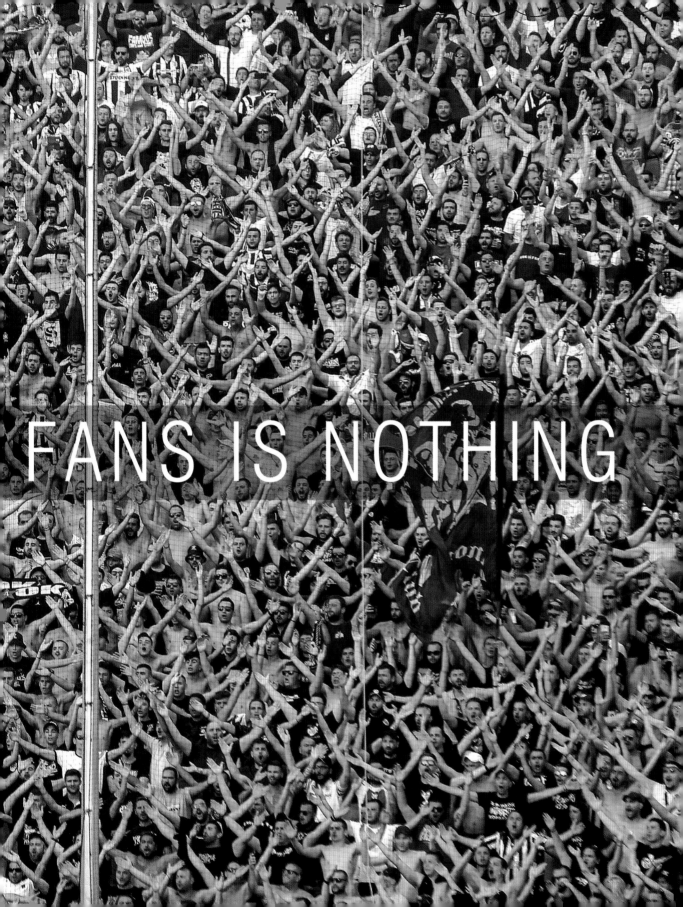

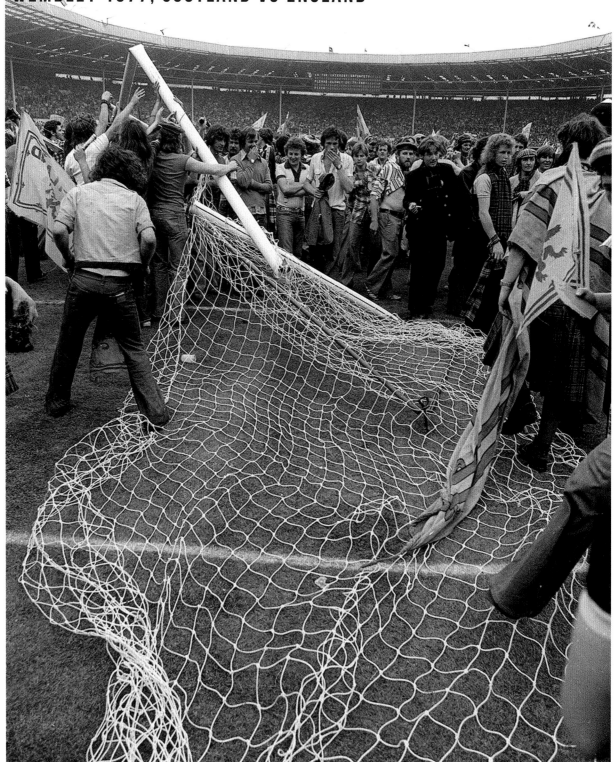

FOOTBALL WITHOUT FANS IS NOTHING

WHERE IS THE LINE BETWEEN THE FANS AND THE TEAM?

In 1977 England lost 1-2 to Scotland in the final of the British Home Championship at Wembley Stadium. The delirious scottish fans invaded the pitch en masse in front of the BBC's live broadcasting cameras. The nations middle classes watched horrified as the boisterous but good spirited fans snapped the crossbar, tore up the pitch and generally had a fine old time.

The Scottish fans had eradicated the invisible line between the consumer and the producer of the 'football' experience. It was a flashback to Football's roots in anarchic and carnivalesque outpourings of community spirit. It scared the squares, and contributed significantly to a new political will to treat the football fan as 'an enemy within'. And the strategy employed by the establishment, which you can hear in the live commentary of the match itself, was to begin to draw a line between the 'real fan' and the 'hooligan'.

Of course, this is one story of the many hundreds of pitch invasions that have occurred in football history at every level of play. But it raises the central question, where is the line between fan and team? It is a contested line, a policed line and in most stadiums it is a very physical barrier as well as a series of enforced rules and regulations on what constitutes valid fan behaviour.

FROM A RIOTING MOB TO ELEVEN PLAYERS

Football went from being 'a game played by a mob' to 'a game watched by a mob' in the Victorian era. The adoption of public school rules and the standardisation brought by football associations created the first real divisions between team and fans. But early in the development of British football, working class players became dominant in the sport, and the sense of ownership felt by the fans, who were their co-workers and friends, was one of the defining features of the sport.

In early football history, the fans were stood watching, with no barrier at all, players who they quite possibly knew from work. The line between fan and teamed was nothing like the relationship today's Premier League teams have with their 'customers'. But the 1970's brought changes to British football culture as clashes between fans and increased police repression started a moral panic, driven by the sensationalist British press, which led to a backlash against the traditional fans.

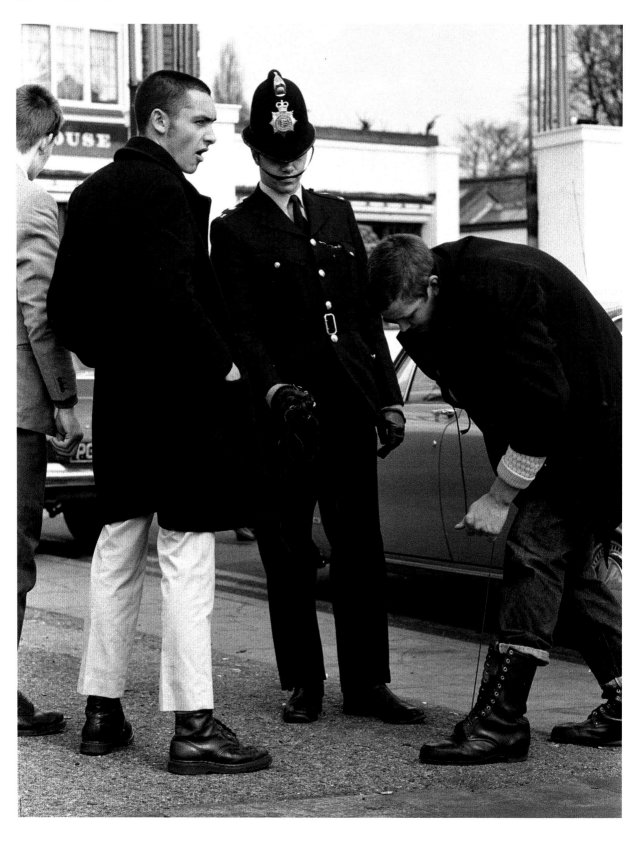

NOT A REAL FAN

In the 1960s and '70s British Football fans were demonised, and repressed with ever more humiliating police measures, such as the forced removal of boots, or the confiscation of laces prior to entering a stadium. They responded by playing up to the perception, and growing more strategic about how they planned to cause trouble, taking the 'ordinary' trains instead of the football specials.

This vicious circle fed into the press narrative that these people were 'not real fans' because the true football fan was the man who appreciated the technicity of play, the man who evaluated the strategy and tactics of his team, not the man who sang ribald songs till his throat was hoarse for the pure passion of belonging to his tribe. Not the man who might get so carried away with that passion that he might climb over a barrier and run onto the sacred pitch, one who erroneously believed that he was part of his team and they were part of him.

So the 'real football fan' was the man who accepted that the team did not belong to him, that it was a product for him to consume, a thing to be appreciated the same way you appreciate a well made car or a good bottle of wine, with analysis, appraisal and technical awareness - the mindset of the factory foreman, not the machinist. Such fans do not want to blur the line between fan and team because it makes the football experience impure, it makes it more difficult to 'appreciate' the game, and horror of horrors, might distract the players from their displays of technical prowess.

In the UK today there is no question that the establishment won the battle to decide what football fan culture should be, at least in respect of the vast majority of the premiership. Football teams are brands, just like Nike and Adidas, and you pay through the nose to identify with those brands, entities that exist on a higher plane, way beyond any sense of community ownership. However, there are interesting developments worldwide, as a backlash against glossy corporate football has led people to experiment with fan ownership models.

■■

FOR ME IT WILL ALWAYS BE CLUB BEFORE COUNTRY.

THE MEDIA DON'T REALLY UNDERSTAND WHAT'S GOING ON. THERE SEEMS TO BE SOME KIND OF CONSPIRACY, THEY SAY YOU CAN'T BE PATRIOTIC WITHOUT BEING A FASCIST. MOST SUPPORTERS ARE JUST NORMAL WORKING CLASS BLOKES. WHEREVER YOU ARE, EVERY SINGLE FIRM IS MULTI-RACIAL.

CARLO, CHELSEA

WHOSE CLUB? OUR CLUB!

AFC Liverpool was set up in 2008 for Liverpool FC fans who had been priced out of watching live football matches. It is owned by the membership and run on a not for profit model with an elected board.

> *"This is not an attack on LFC or a rejection of LFC. It is here for the many thousands of Reds priced out of Premier League football. We believe that football should not be a TV show and exclusive to those who can afford it."*

http://www.afcliverpool.tv

They are one of several similar teams in the UK including AFC Wimbledon, a team set up by furious fans of the original Wimbledon team that was moved to Milton Keynes. AFC Wimbledon have been so successful they are finally getting their own stadium, far from the old one at Plough lane.

FC United of Manchester and Lewes FC are two more fan owned clubs doing well in the UK. And in the case of Wrexham AFC, a club that has existed since 1864, they switched to a fan ownership model in 2011. As did Darlington FC based in the North East of England.

There are fan owned teams across the world today and emerging grassroots leagues and tournaments, once again blurring the lines between football supporters and football teams. Like AFC Liverpool have said:

> *"Football is the world's game; it should be run for the people, by the people and affordable to all."*

http://www.afcliverpool.tv

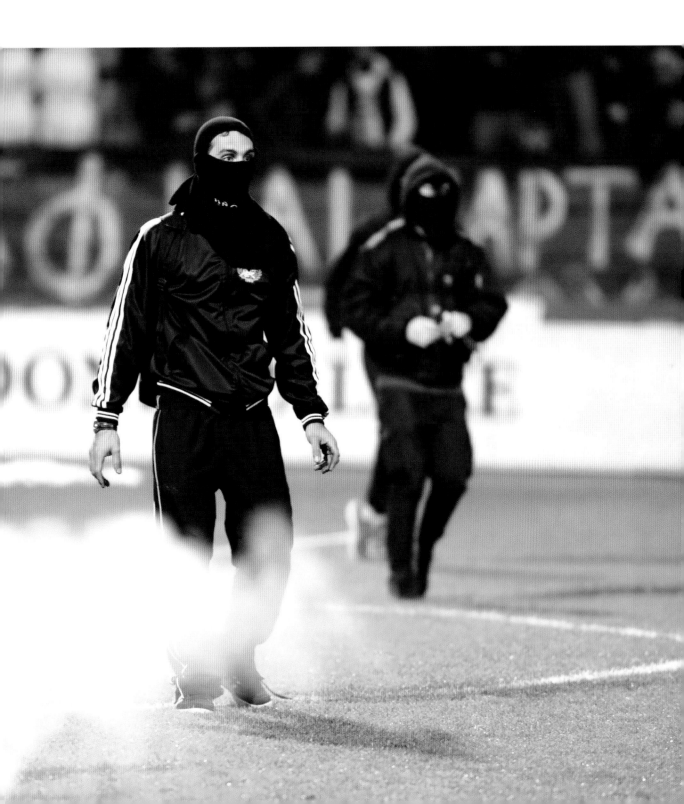

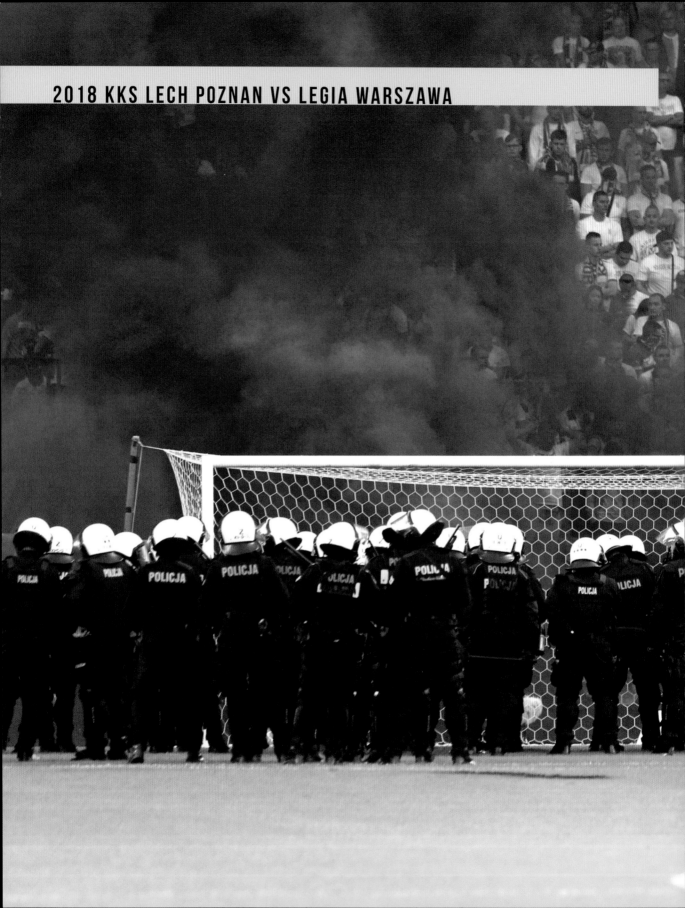

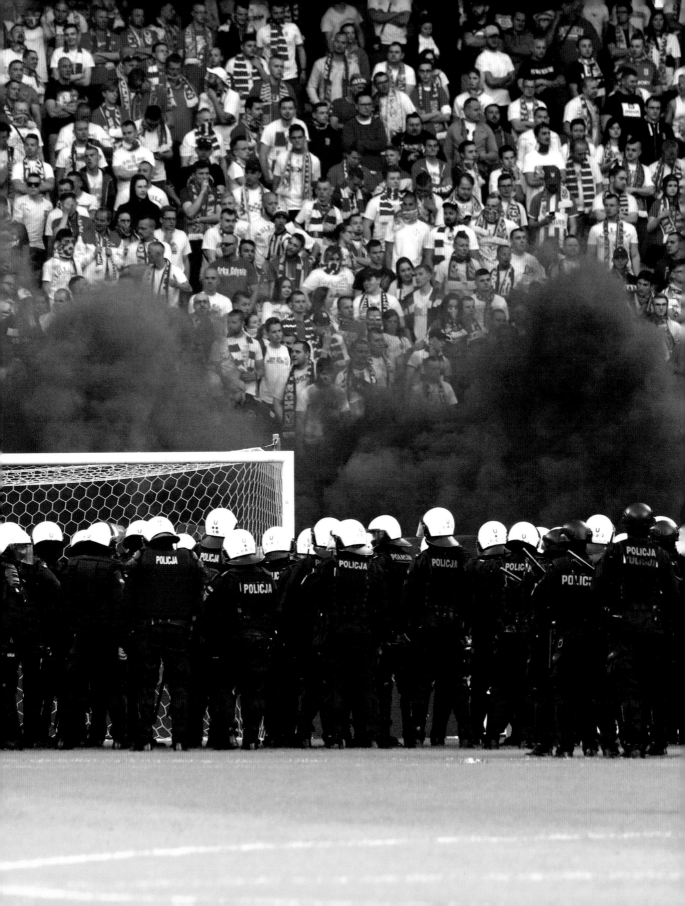

THE FIGHT FOR THE SOUL OF MODERN FOOTBALL

MONEY VERSUS THE PEOPLE

In the UK back in 1992 the FA Premier League was founded. Why? For the money. And the money came from TV RIghts, the billion pound deal struck with Rupert Murdoch's SKY and BT Group, the recently privatised National Telecoms company. Nowadays the TV rights in the UK and around the world are worth over two billion pounds a year.

The money made the Premier League into a showcase for top football talent from around the world, making it a global entertainment product watched by billions. However, it also gave SKY an incredible amount of control over the future of football.

Only last month, Sky announced a deal that equates to around £100m per English Premiership game. This represents an increase of over 70%. I wonder, will the fans see a 70% reduction in their season ticket prices? They probably deserve one, seeing as Sky will be making them attend games at odd times like 12 noon on a Sunday to accommodate another two or three games per channel, per day.

https://hitthebyline.com

This is a story familiar to football fans the world over where you find similar top level leagues controlled by multinational corporations haggling over TV rights. But the war on traditional football, a game that was unique in the sense of ownership that fans felt, goes deeper than simply awkward scheduling. Corporate culture bleeds into every aspect of a modern football club. The handful of super brands that dominate the top leagues are run like brand assets, which to their owners is exactly what they are.

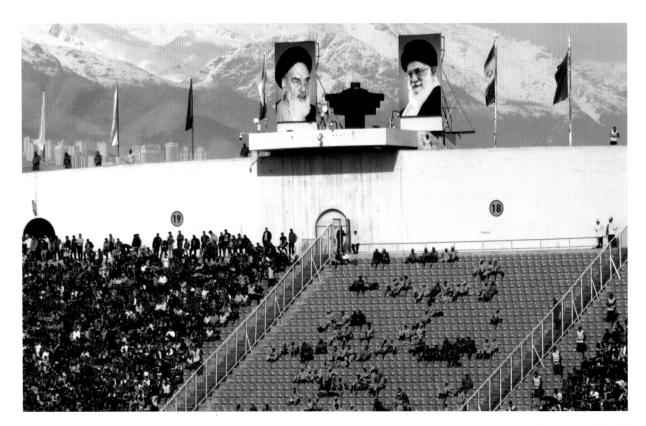

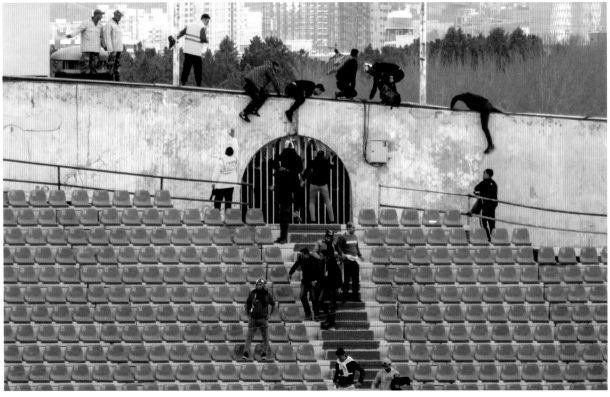

The mis-match between the fan culture and the corporate culture is jarring, in the case of Manchester City it blew up when their new 'Fan Relationship Manager' accidentally tweeted the truth about his role, excitedly boasting his passion for 'monetising' the fan base. Men like Claudio Borges genuinely see no mis-match between being passionate about football and revenue. So he must have spilled his latte when he saw the fan responses.

TV is not the only way to extract money from football fans of course. There are soaring ticket prices, new strips to buy, overpriced food and drink in the stadiums, laughable merchandising ideas (like the £350 engraved plates at Man City) and of course - gambling. The betting companies are in bed with the media firms, and the whole process is trickling down into the first division.

> The bookmakers have got their sticky fingers on the Football League, which is now sponsored by SkyBet in a deal which highlights their incestuous relationship with the television company.

https://www.independent.co.uk

In this super corporate climate there is no space for anything that looks like the old football. The glossy product that clubs are trying to sell does not include rowdy or unpredictable fan behaviours, indeed anything that might make a club look like a community that you cannot simply purchase membership of. The very idea that you have to earn membership of a fan community, by showing dedication and passion for a team over time, doesn't fit with the modern concept of football. And any spectre of fan power, such as the pitch invasion at Villa Park in 2015, now potentially damages the appeal of football to the more affluent shoppers required to purchase the more expensive tickets. But

is every pitch invasion a horrifying act of hooliganism?

> At a glance, you could see that those who ran on the pitch were ordinary football fans, not thugs. Even young kids got involved. A rare moment that they'll be talking about for years to come.

https://www.independent.co.uk

The resistance to this process has always existed but in 1999 it was given a manifesto by the Ultras of AS Roma who published il Manifesto Degli Ultras at http://www.asromaultras.org/manifesto.html. This had a huge impact on the way that Ultras around the world began to lead the protests against the commercialisation and sterilisation of the game. In the UK a new fanzine called STAND took up the struggle asking the question:

ARE YOU SICK OF WHAT WAS ONCE THE WORKING MAN'S GAME BEING SYSTEMATICALLY TURNED INTO A BUSINESS, WITH A BLATANT DISREGARD FOR THE FANS WHO FORMED THE TRADITIONS THAT MADE IT SO GREAT?

STAND Against Modern Football (2012)

STAND was warmly received, proving that football fans in the UK were ready for their message, which was always intelligently put, not some aggressive rebel yell. However, it was all too easy for the football establishment, and their mass media allies to characterise this movement as a nostalgia for hooliganism and racism. But the fight for the soul of modern football is relevant to all fans of the game. Ultras are just the ones who are not shy of making a noise when everybody else is telling them to shut up.

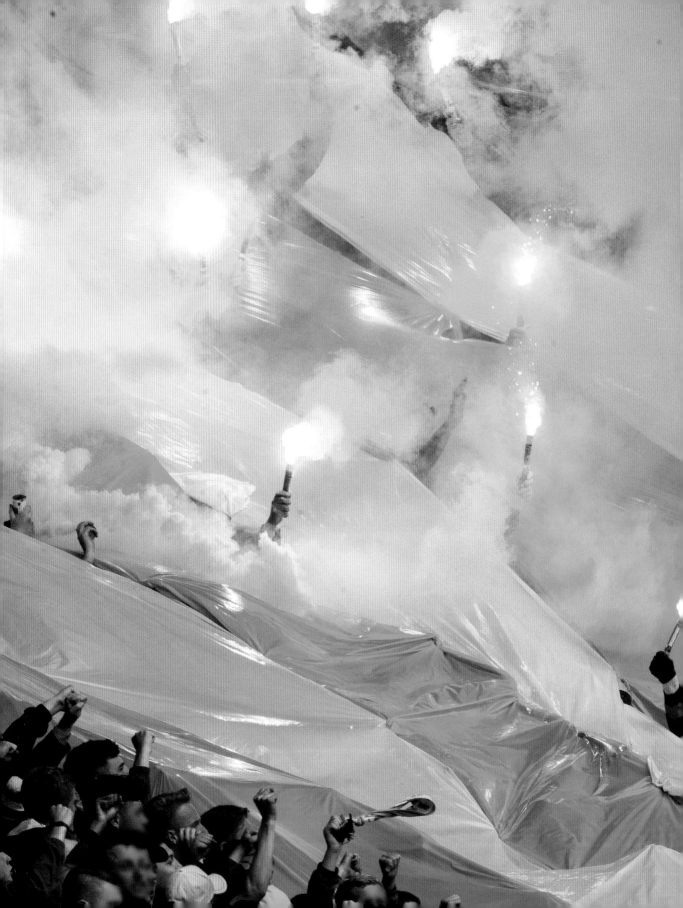

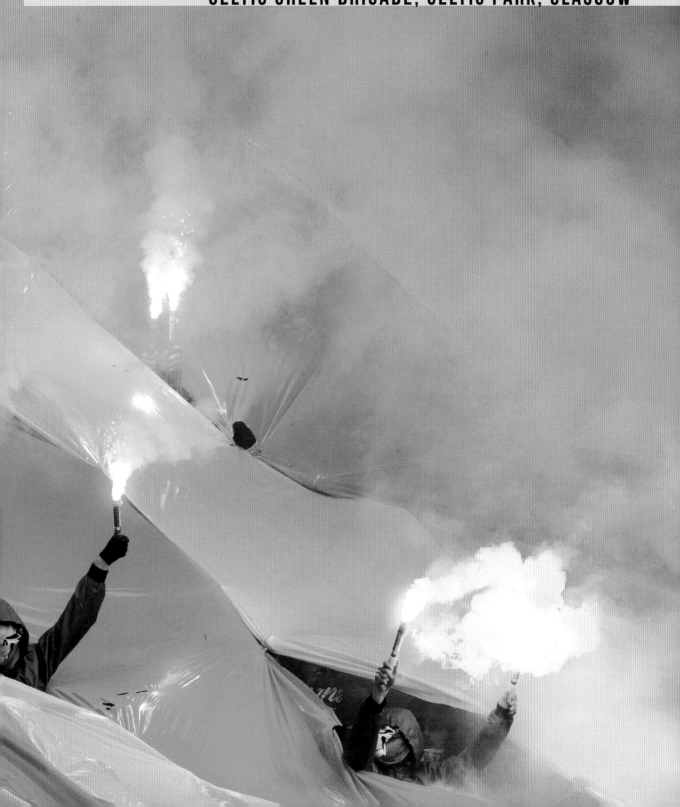

I SAY FÚTBOL YOU SAY FUTEBOL

SOCCER CULTURE IN THE AMERICAS

THE PASSION OF SOUTH AMERICAN FOOTBALL FANS IS LEGENDARY. FOOTBALL ARRIVED IN LATIN AMERICA IN THE LATE 19TH CENTURY, BROUGHT BY EUROPEAN MIGRANTS. IN THE SPACE OF FIFTY YEARS IT BECAME SO CENTRAL TO LATIN AMERICAN CULTURE YOU'D BE FORGIVEN FOR THINKING THEY'D INVENTED IT. PERHAPS THEY DID REINVENT IT AS THEY GAVE IT A DEVOTIONAL FERVOUR THAT ELEVATED IT TO THE STATUS OF A SECULAR RELIGION.

Even now, football is so tied up in Argentine life that their Barras Bravas (Ultras) claim to be able to control the outcomes of elections. Nowhere is the culture of organised football fans more dangerous than in Argentina, the only nation in which away fans are banned from all games. (AFA banned away fans in 2013 after a Lanus fan was killed in La Plata following a match).

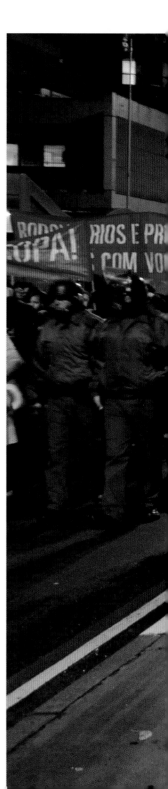

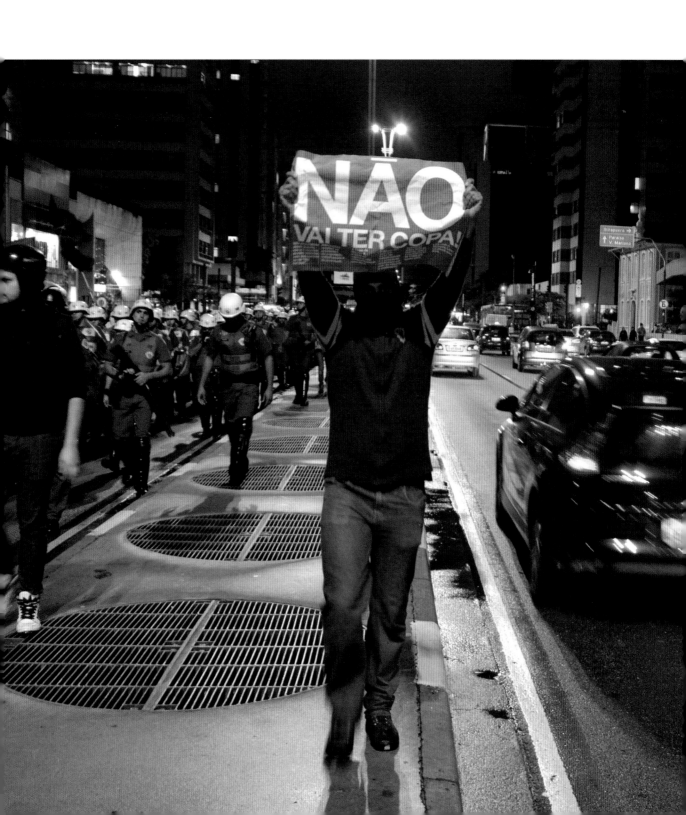

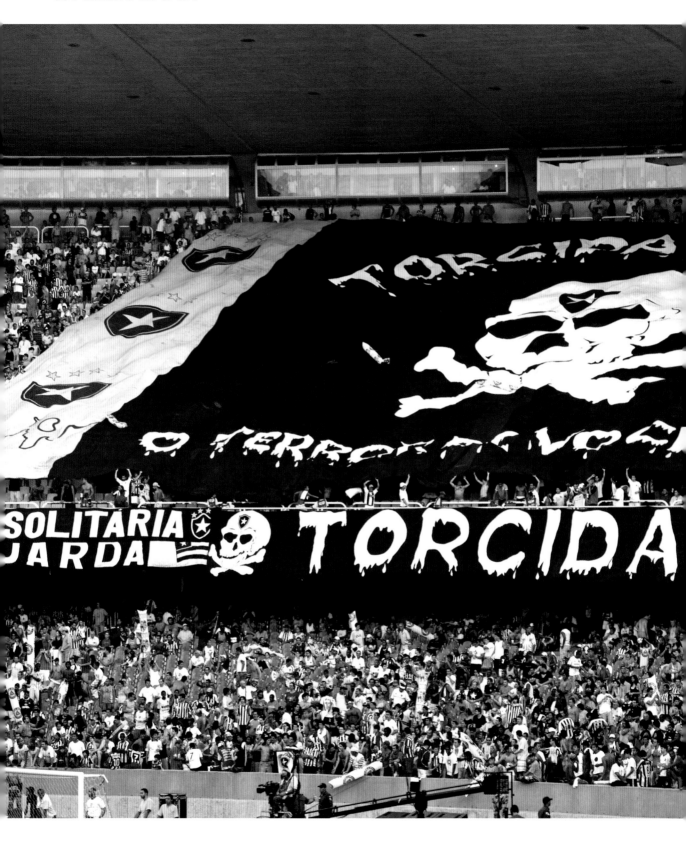

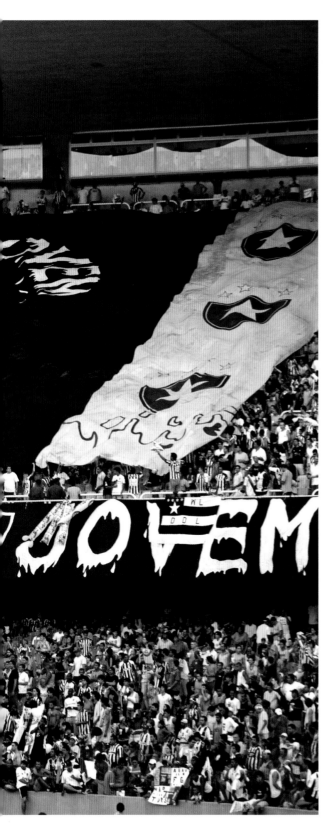

"*El fóbal* fue creado por los ingleses, pero el show del fútbol fue inventado por los rioplatenses." - *'Football' was invented by the English but the Football Show was created by the people of River Plate.*

https://www.lanacion.com.

So, how did this game come to mean so much, so fast, to so many people in the region?

It was picked up largely by the workers, Latin America had more teams founded by groups of workers than Europe. Football associations popped up rapidly; Argentina 1893, Chile 1895, Uruguay 1900. CONMEBOL, the South American answer to FIFA arrived in 1916 and during the 1920's Latin American football was already considered the best in the world as Uruguay dominated early Olympic matches. The style played in Argentina and Uruguay was named rioplatense *(River Plate Style - 'River Plate' being a crap translation of 'Río Plata' which really means Silver River).*

Los rioplatenses took a game that had been civilised by the English public school system, and they applied a totally distinct attitude towards it - the spirit of 'La Viveza Criolla' or the *lively creole.* This was the spirit of society's underdogs, the descendants of Spanish immigrants and the indigenous peoples of the region, who thumbed their noses at the higher status immigrant groups from Old Europe that were arriving at the time.

'La Viveza Criolla', applied to football was about breathtaking cheek, stealing victory by any means possible, it contained no gentlemanly chivalric notions of fair play, it was about bending, or breaking rules without getting caught. It was also about flair, dramatic play and taking any opportunity to humiliate the opposing player. Why simply pass a defender if you can nutmeg (caño) him on the way? The crowds went crazy for the brilliantly executed bit of foul play, the stylish demonstration of contempt.

Perhaps Maradona's 'Hand of God' in 1986 is the perfect illustration. Anglo Saxon football fans, no matter how naughty they thought themselves, could not imagine celebrating such a dishonorable win with so much gusto - because of a foundational difference in ideology. That fist, that touch, is part of Maradona's legend in Argentina, not a stain on his record, it is a Robin Hood-esque bit of chicanery, flinging mud in the eye of Old World snobbery.

Right from the beginning, the *rioplatense* fans thought themselves a part of this process. They were involved in trying to bag the win and 'mug off' the opposition. They brought home-made confetti, balloons and streamers. They shouted and sang until their throats were hoarse, both to cheer on their team and *to distract or intimidate the opposition*. (Which is still a key strategy for many Ultras groups today, wherever they can get away with it.) This is where the concept of the 'twelfth player' originates.

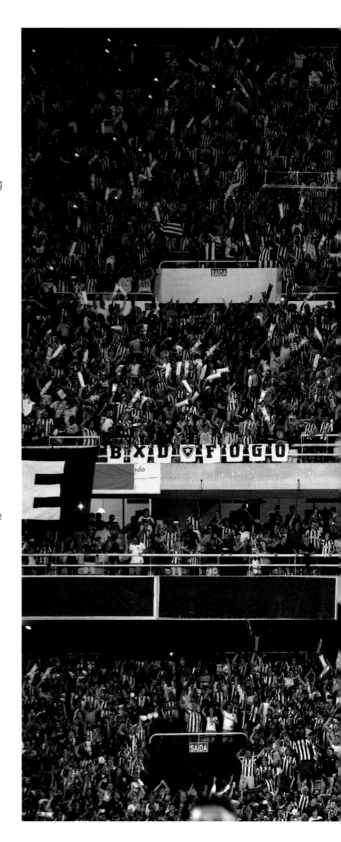

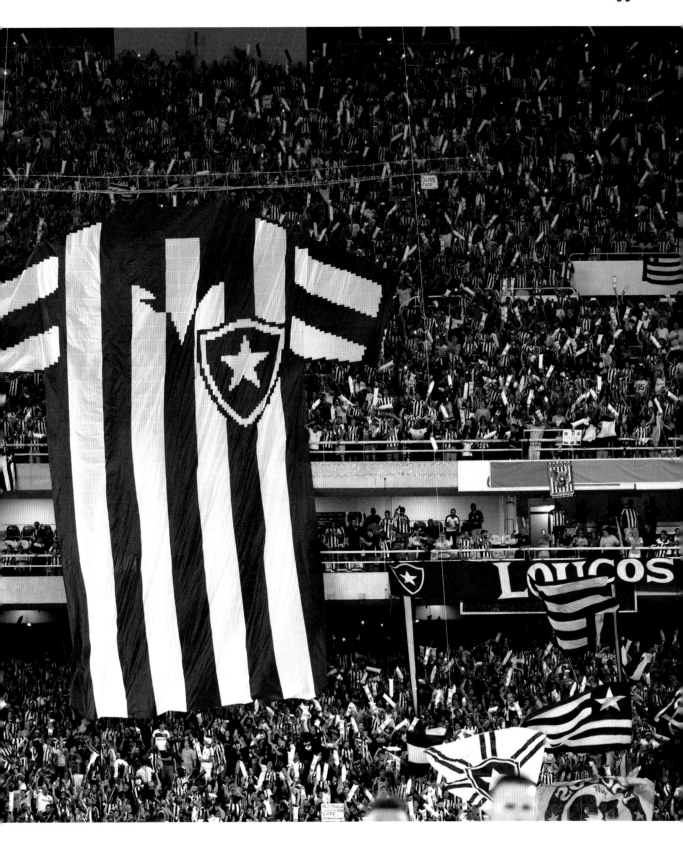

In Argentina, the atmosphere that the fans create is called 'fiesta' which simply means 'party' and the fans themselves are involved in a competition to prove which side can demonstrate the most 'fiesta'. This is party as a competitive sport.

Just like in Europe, the elites saw football as an opportunity to build ties with their workers and give them space to let off steam. Factory owners patronised teams and the sport grew with the influx of sponsorship. But again, as in Europe, football remained a game played and watched by working class people. The left despaired that in Argentina workers 'danced Tango on Saturday and played football on Sunday' and never came to political meetings!

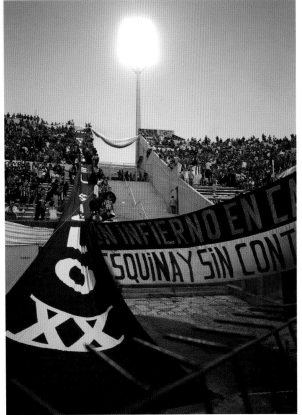

JUGADOR TWELVE

WHY YOU'LL NEVER SEE A BOCA PLAYER WEARING THE NUMBER 12

What is the meaning of the number 12 in Ultras culture? Hadjuk Split retired the number twelve shirt as a mark of respect for the fans, who are honoured as the twelfth player in the team. It's a move that is often repeated, and you'll find that many clubs in the Bundesliga, like Borussia Dortmund to name one, reserve the number zwolf for the fans.

This is a symbolic gesture that originated with Boca Juniors way back in 1925.

On the first ever Argentinian football tour there was a celebrated superfan called 'Quique' who travelled with the players and their entourage, after which he was awarded the honorary number 12 shirt. From that day on, the number 12 took on its legendary significance in football culture.

1920s SAINTS AND ANGELS

EARLY IN THE HISTORY OF SOUTH AMERICAN FOOTBALL, THE PLAYERS WENT FROM BEING LOCAL HEROES TO SUPERSTARS.

"Spectators no longer came to just watch their teams, they came to watch their idols."

In Latin America the potent mix of Spanish and Portuguese Catholic dogma blended with local pagan traditions to lay the foundation for a society where worship, adoration and idolatry are a big part of everyday life, particularly for the working classes. Perhaps this goes some way to explain the matchless fervour they have for their heroes, while Northern Europeans love their footballing heroes, South American people worship theirs, without irony or criticism. A photograph of Maradona is up there with an image of the Pope as a talisman for good luck in some Barrios of Buenos Aires.

Another aspect of latin football that is distinct from anglo-saxon football is the sense of beauty. Football is considered an art form, and footballers are the equal of artists and poets in the cultural constellation. Pele is up there with Michelangelo.

Back in the 1920's, Argentina saw the rise to glory of now legendary big clubs like River Plate, Boca Juniors, Huracán, Racing, Independiente, San Lorenzo, and Club de Gimnasia y Esgrima. In 1928 Independiente built the first modern concrete stadium with a 100,000 capacity.

The football genie was out of the bottle, the stage was set for the emergence of the supporter clubs knowns as the Barras Bravas, (Brave / Fierce Gangs). At first they were simple organisations to share the costs of fan displays, but as their tactics became more aggressive - football clubs began to transport teams of away fans to protect their teams at away matches. They were given control over aspects of their clubs in exchange for their services. This set the stage for the Barras Bravas to emerge as powerful interest groups in their own right, *but that's another story...*

The problem with passion is that is so often gets out of control.

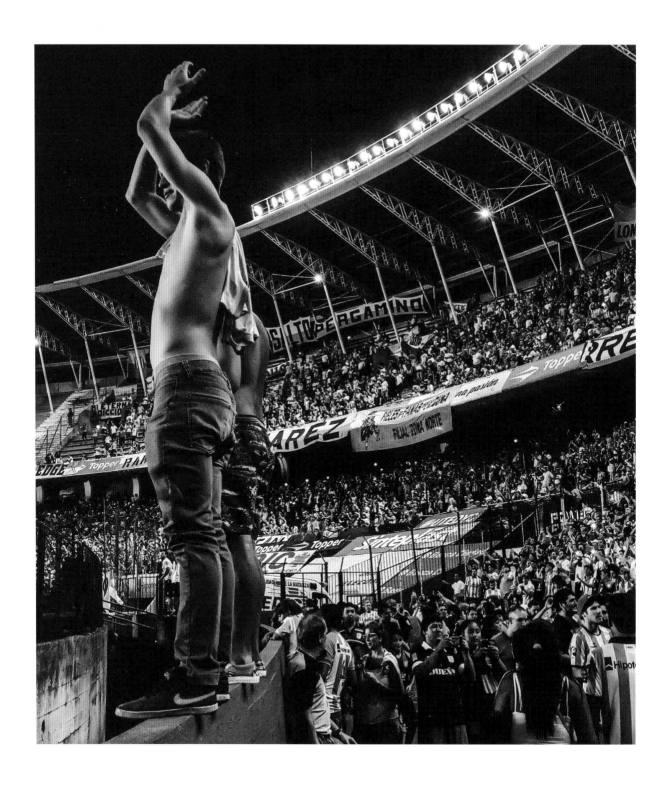

LAS BARRAS BRAVAS
THE ULTRA FANS OF ARGENTINA

"BE CAREFUL WHAT COLOURS YOU WEAR" THEY WARN THE TOURISTS.

IF IT'S BLUE AND YELLOW YOU'LL BE FINE BUT IF NOT IT BETTER BE PLAIN BLACK OR GREY, SOMETHING NEUTRAL. NOT BLACK WITH STRIPES OR WHITE WITH STRIPES. WEAR BLOCK COLOURS. SO IF YOU HAVE THE MONEY, YOU HIT THE SHOPS AND GET YOUR BLUE AND YELLOW. BETTER STILL, YOU BUY A BOCA JUNIORS SHIRT.

They won't challenge you, they'll love you for it. They'll grab you by the shoulders and jump up and down chanting *bocabocabocaboca* directly into your face. Not as an act of aggression mind you, as an act of exuberant, raging love. You'll be accepted into the Boca army for the day, you'll be part of the surging mass of blue and yellow that lives and dies for Boca Juniors.

La hinchada is so fanatical that they hardly notice that they are the only fans in the stadium.

We don't need away fans to have a party. We can fill our stadium ourselves, with fiesta, with a noise like a revolution.

Every game. Every single game. Nobody could ever say they only sing when they're winning. It's an awe inspiring level of commitment. These fans have inherited their team from fathers and grandfathers.

These barrios are built on Boca Juniors and even if there is a shadowy side to the Barras Bravas, here in the midst of it all, the vast majority of supporters seem to be having a positive experience, a moment of joy in an unstable and difficult lifetime, in a country of volatile economic fortunes, in one of the most famous capital cities in the world, the big apple - Buenos Aires.

This is the happy face of Argentine football, but it cannot entirely obscure the elephant in the room. Violence is so endemic in their fan culture that away fans are simply not allowed into the games anymore. Argentine football culture is the most violent in the world, and the Barras Bravas in the Big Apple operate like fully functional capitalist enterprises with employees, management structures, enterprises of varying degrees of legality and plenty of good old fashioned violence.

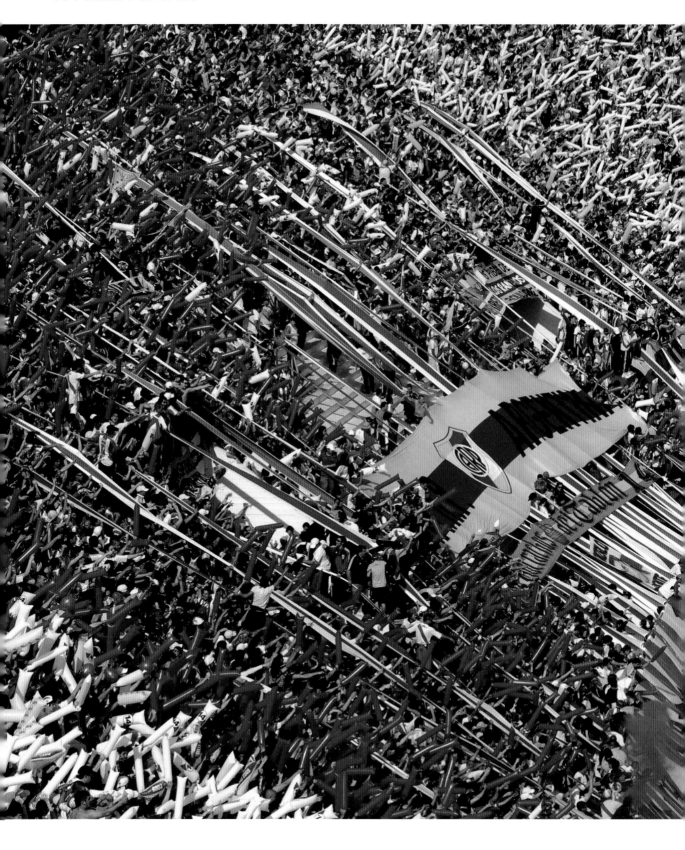

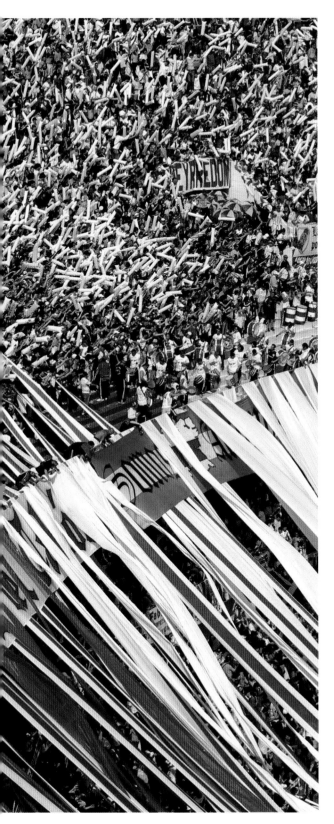

The story of the Barras Bravas starts in Argentina in the 1920's and spreads across South and Central America through to the present day. These supporter organisations are nowhere more powerful than in today's Buenos Aires, where they have a reach far beyond the football terraces and deep into every aspect of Argentine life. Back in the beginning, however, it was all about the football...

The earliest references to Las Barras come from the Argentine press in the late 1920's. At the Club de Fútbol San Lorenzo de Almagro groups of fans were noticed using an improvised weapon to attack away fans. These were rubber bicycle inner tubes, stuffed with sand and tied off with wires, forming a long cosh.

The press called these groups the 'Barra de la Goma' or the Rubber Gang. They were allegedly defending their goalkeeper against the common tactic of away fans throwing missiles at the keeper to distract him at key moments of the game. There was not yet an established culture of travelling to away games mob handed looking for action. It was all about influencing the result, or protesting the result when things went wrong. Pitch invasions were common before fences went up.

It was in the 1930's that this culture evolved into something more organised. Clubs were sick of getting bullied by home fans when they played away, so club management actually funded fan organisations to travel with them to defend the honour of their team and tip the balance in away games. This created strong links between clubs and their Barras Bravas that would later prove extremely difficult to break.

In the stadiums the Barras created many of the cultural elements that European Ultras would later emulate. They took ownership of particular areas of the stands. They organised huge banners and flags. They wrote songs and had leaders conducting singing within the stadium, often with drummers helping to whip up the crowds. Today they use webs of extremely long team scarves crisscrossing their zones of the stands, a style more unique to South America.

As the gangs grew in power and influence they would have paid memberships. Members paid into a growing war-chest which the leaders could use to increase the power and reach of the gang and even as capital for business ventures, both legal and otherwise. The Barras Bravas also had key members who were often paid salaries by the clubs themselves. The club owners recognised that the product they were selling included the intoxicating atmosphere created by the Barras.

It was in the 1980's that the Barras evolved into organised criminal gangs. The leadership extorted money from players and staff. Some set up 'foundations' to do 'charitable works' as vehicles for money laundering. Some groups took hold of their club's merchandising rights. With money came political influence, as the gangs and politicians found ways to use one another for advantage.

From the 1980's to the present day violence escalated and the death toll has reached a level unequalled in world football. Nowadays 'La Doce' (The Twelve) of Boca Juniors are the most powerful of the Barras Bravas in Argentina. In an interview at a secret location in Buenos Aires with VICE TV the two leaders of the gang claimed to be able to pick the winners in city elections and opined that the true Ultra is in love with the fans of his team, not the team.

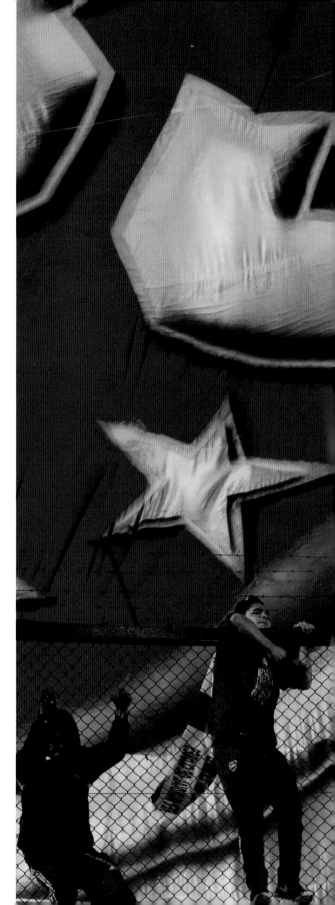

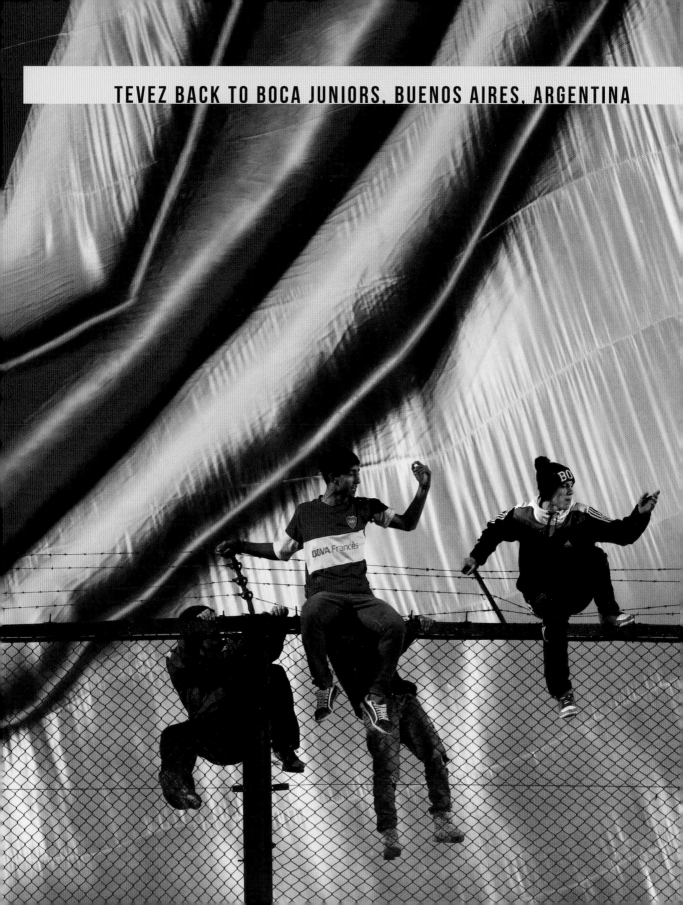

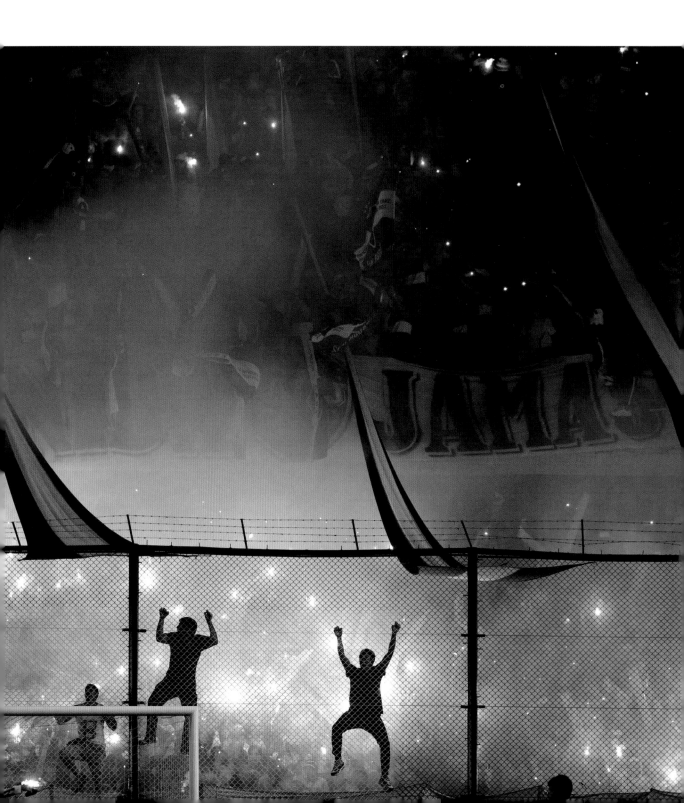

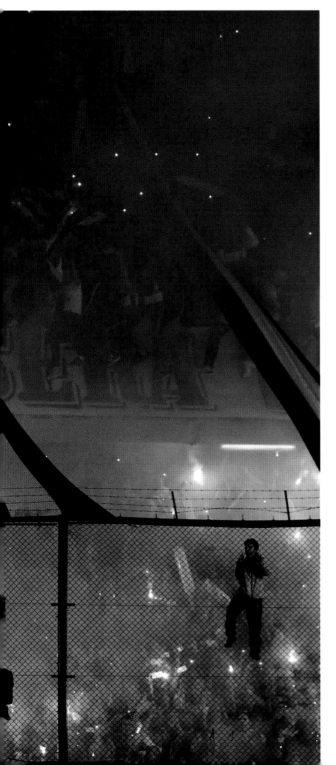

El superclásico, recognised by the Sun Newspaper in the UK as 'the most intense sporting experience in the world' is the derby between the two Buenos Aires giants - Boca Juniors and River Plate. These are the two most popular teams in Argentina, and it is a game that raises such violent passions that they cannot even play it in their home nation.

In 1994 a group of sixty Boca fans attacked and killed two River Plate fans and left three more seriously injured. The fans were attacked with stones, knives and bullets in an ambush on a vehicle staged outside the stadium.

The journalist Amílcar Romero put the death toll in Argentine football violence at 103 between 1958 and 1985. The BBC registered 70 deaths between the year 2000 and the away fan ban put into place by the AFA in 2013.

In the Superclásico May 2015 Boca fans threw homemade mustard gas canisters into the players tunnels at the beginning of the second half, injuring several players and ending the match, which was awarded to River as a result. In 2018 River fans attacked the Boca player's bus with rocks resulting in the game being suspended and moved to Madrid.

Europeans fail to understand the Barras Bravas because we tend to equate it with hooligan culture, not grasping how intrinsic to the function of Argentine society the Barras have become. Although there are many journalists covering the culture - there is no current movement of any political weight in Argentina to change the situation, (as far as can be gleaned at present). And how would you even begin, in a country where access to political power itself is brokered by organised football fans?

CAIRO'S ULTRAS AND THE ARAB SPRING

FOOTBALL FANS ON THE FRONT LINE OF A REVOLUTION

The story of Cairo's Ultras is an astonishing and tragic tale of football fans acting as a political force in a dangerous time. From the foundation of the first Al-Ahly Ultras group in 2007 to the battles in Tahrir Square in 2011 it took only four years for a group of enthusiastic young football fans to become both a revolutionary street fighting force and a propaganda machine, producing the songs and the street art that defined the spirit of the Arab Spring.

And after the initial euphoria of the Arab Spring turned to betrayal and disappointment the Ultras continued to play a vital part in the counter revolutions that followed. So, how did Cairo's football fans help to take down a president?

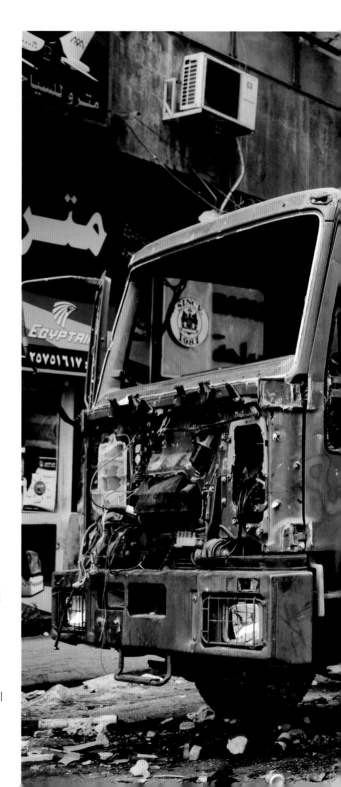

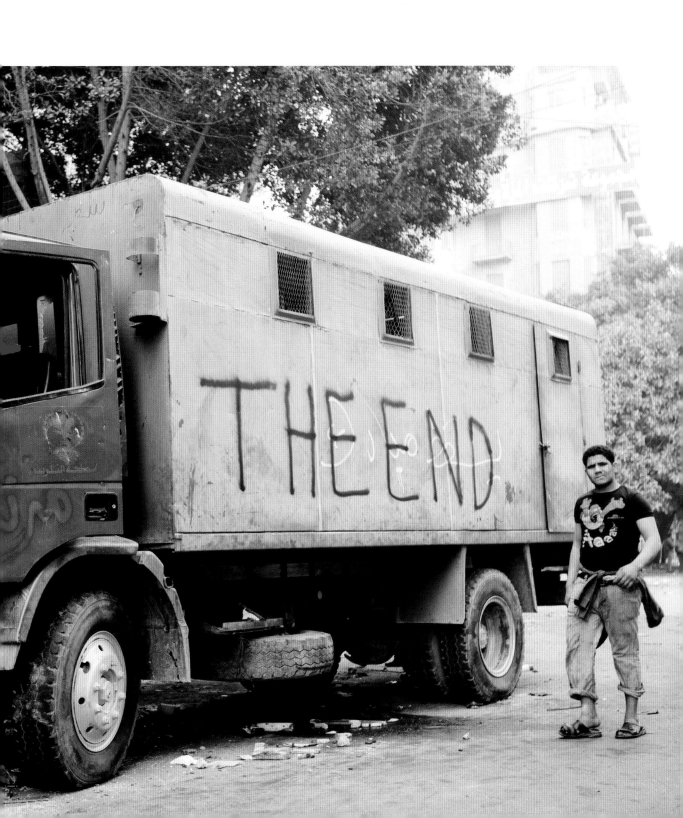

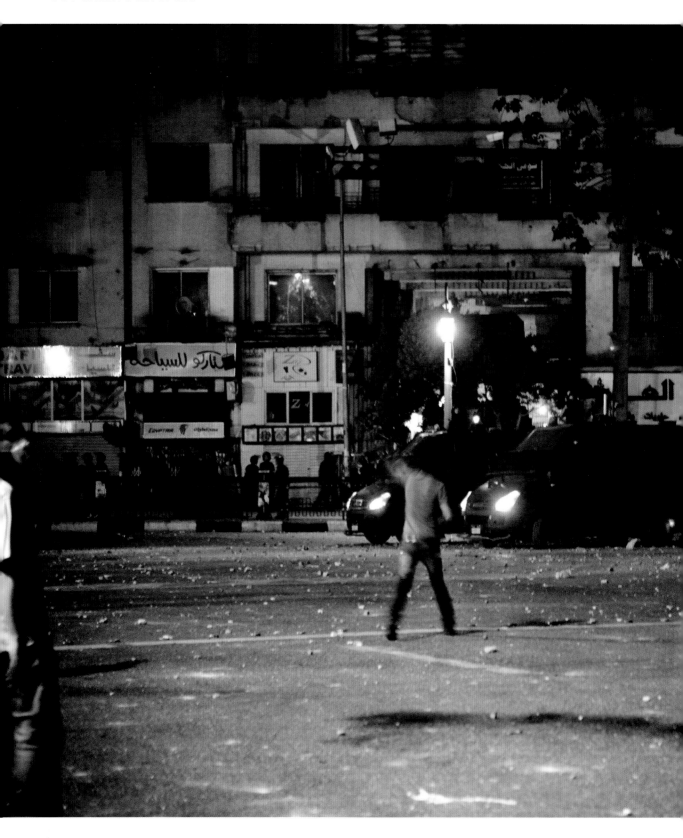

Hosni Mubarak was one of the all powerful Presidents of the Arab world, who ruled over Egypt from 1981 to 2011, enjoying the support of western powers in return for providing 'stability' in the region by ruthlessly oppressing any political opposition. His elections were rigged, his institutions were corrupt and the everyday life of his citizens was becoming unbearable towards the final years of his regime. In particular, the brutality of the Egyptian police produced a generation of young men who were well accustomed to violent clashes with the authorities. And when the revolution finally came, taking the world by surprise, it was football fans who were on the frontline in Tahrir Square.

Cairo is a city divided between two teams. Al-Ahly is the team of the working class, supported by almost everyone who still lives in the city proper. Zamalek, is the team that was originally the middle class team, as Zamalek Island was the enclave of the liberals, the bohemians and the English expatriates. Nowadays Zamalek has a more diverse support, and the wealthy have long since left Cairo to live in new developments outside the city. However, it remains fair to say that the fans of The Pharaohs and the White Knights are hostile to each other.

The teams' rivalry was old but the Ultras were a new invention in Cairo, 2007. The Al-Ahly Ultras group attended their first derby match as an official organisation in May of that year. The match was played in Cairo's international stadium because the clashes between fans were so intense that they had not been permitted to play against each other in their home stadiums since the 1990's.

It was a time when Mubarak's government was defending itself against the public backlash after a sham election. Mubarak was keeping a lid on things

through the application of heavy handed police oppression. Policing of football matches was aggressive and corrupt. Ticket sales were manipulated, people were randomly beaten and turned away from games with or without tickets. The Ultras were targeted, but any fan could receive a random battering with a billy club on match day. The Ahlawy soon found themselves more often fighting the state police than Zamalek's White Nights.

Although the group had no political agenda, and it had stated on it's Facebook page that it had no official involvement in Tahrir Square, the membership had values somewhat in line with the liberal activist groups who started the protests.

"The hardcore were all university educated with good jobs and liberal views on women, religion and drugs."

-James Montague, 'ULTRAS: How Egyptian Football Fans Toppled a Dictator' (2013)

What the Ultras brought to Tahrir Square was experience of fighting back against the police. They threw the tear gas back. They used missiles and fireworks, they used coordinated attacks, they got used to the tear gas and exchanged tactics with other groups. They had also written their own set of revolutionary songs and were responsible for a wave of revolutionary graffiti in the city. So in one sense they taught the liberal activists how to fight, but they also created the visual identity of Cairo's revolution.

Tahrir Square was an alliance of Muslim Brotherhood supporters, Liberals and Ultras from both Al Ahly and Zamalek, who had an uneasy truce while they occupied the square demanding the fall of Mubarak. On the 2nd February Mubarak supporters tried to clear the square by force. The Ultras were well-used to being attacked by mounted police, and they

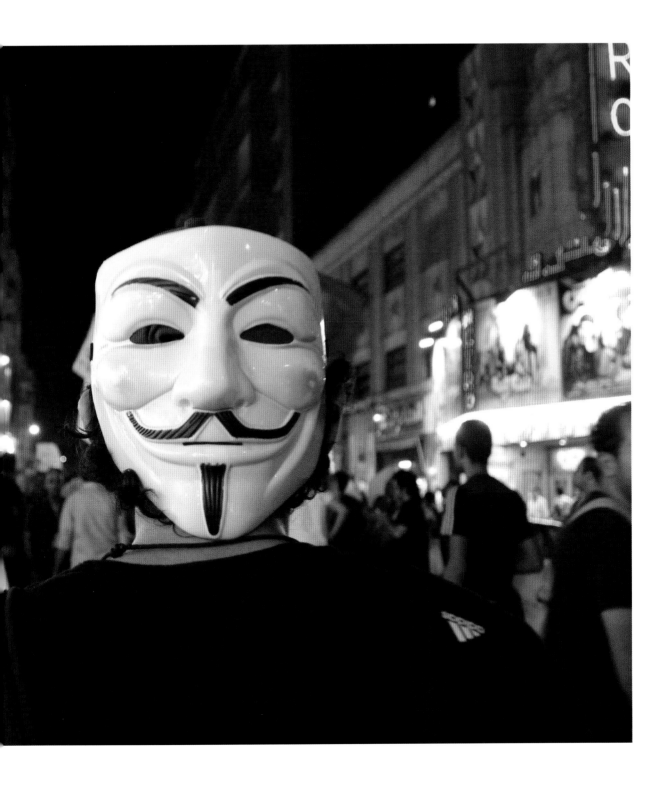

turned the tide of the struggle. It was not a *Facebook revolution*, as the western media claimed, it happened with real bodies in the real world, and the Ultras risked everything to take part. (Later on, the army and the police would contrive an awful revenge.)

After the fall of Mubarak, and in spite of a free election returning a Muslim Brotherhood government under Morsi, Egypt was still experiencing repression by the Army and the Police, both agencies which were scarcely under Morsi's control. The Alahwy were continuing the fight against SCAF oppression, and were now hugely popular, way beyond the influence of a simple football supporters group. It isn't known exactly what happened at Port Said, but it clear that some kind of conspiracy took place to punish and subdue the Alahwy at a match in Port Said, February 2012.

The Port Said massacre was one of the worst episodes of violence in football history. In what looked like an organised ambush, the Police stood by and watched while Masry fans charged into the Al-Ahly fan area, chasing them into a tunnel with a locked gate at the end. The fans were attacked from the rear while they piled up atop one another, seventy two were killed and around five hundred injured.

If there was a conspiracy, it failed to subdue the Alahwy who were galvanised by the campaign for justice, cementing their status as a political force in Egyptian society. Such was their power that they shut down the Egyptian league in protest. The players were traumatised, one fan had died in the arms of the team captain Aboutrika, and they were deprived of a league to play in - but the supporters pushed for participation in the African Cup of

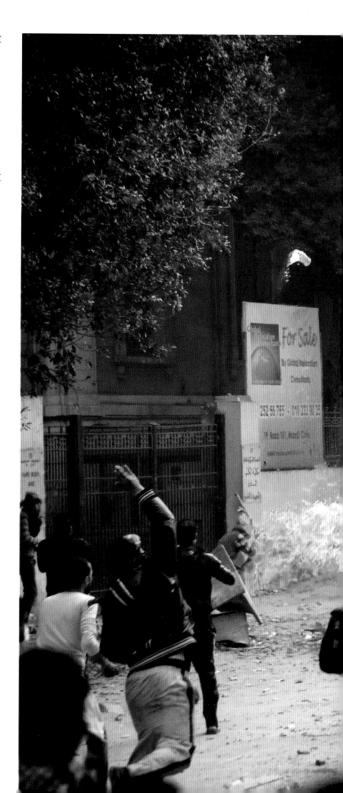

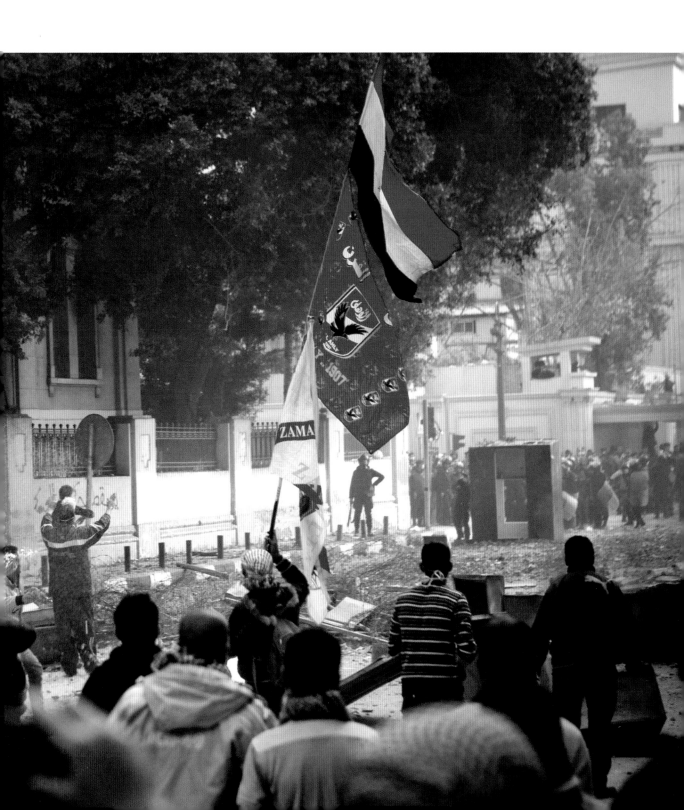

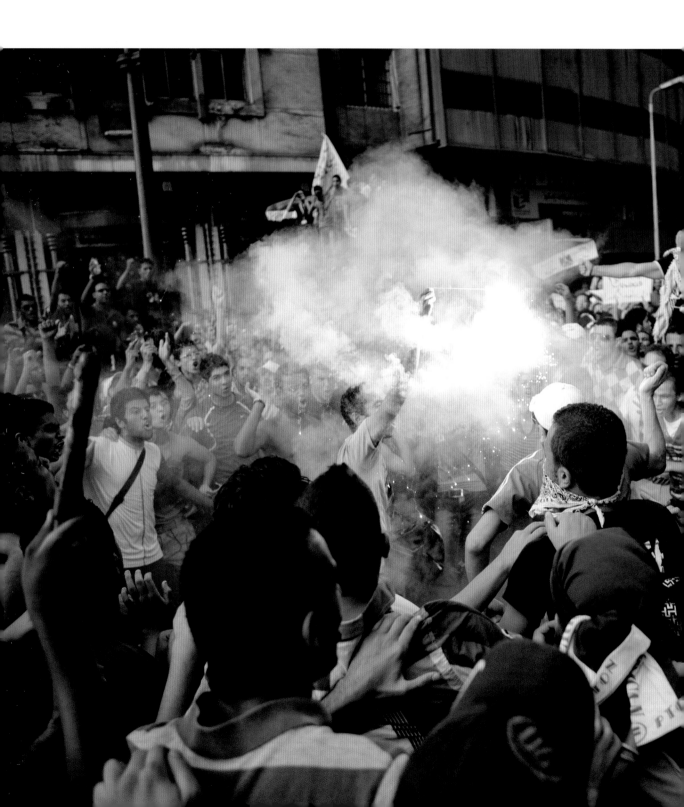

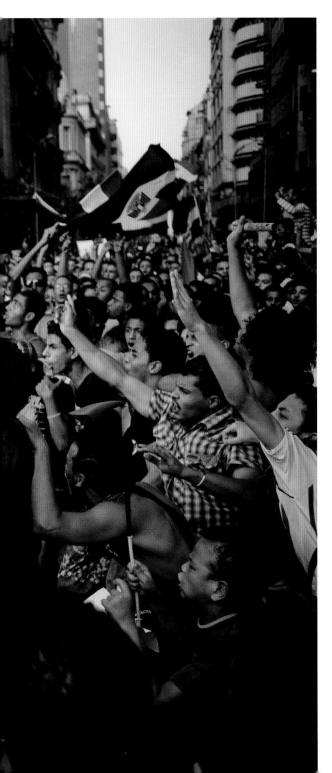

Nations. They were galvanised by a fervent belief that the team would win the cup, in spite of playing no league games that year, in honour of the dead.

Unbelievably, Al-Ahly did win the CAF in 2013. The trials over the Port Said massacre returned death sentences for twenty-one Masry fans and prison terms for many more including two police officers and two security officials. It was more than the Alahwy fans had expected but not what they had hoped for in terms of an admission of conspiracy from the army and the police.

By that time the original leadership was tired of all the struggle, wanting to get back to football. The Alawhy belonged to a new generation of fans who kept it going under the increasing repression of Sissi's military regime, until finally giving up the ghost in April 2018 as their members were being picked off and arrested by the police.

There are Ultras groups in every Egyptian team now and who knows what the future holds for them and for Eygpt. The Alahwy and the White Knights proved themselves to be incredibly brave, but ultimately Egypt fell back into the hands of the military, politically outmaneuvered, for now at least.

Cairo shows that poverty makes football into a matter of life and death. And violent repression can make the black eagle of a football club emblem into a symbol of revolution. But football fans are not soldiers, and nobody can live on revolutionary zeal forever.

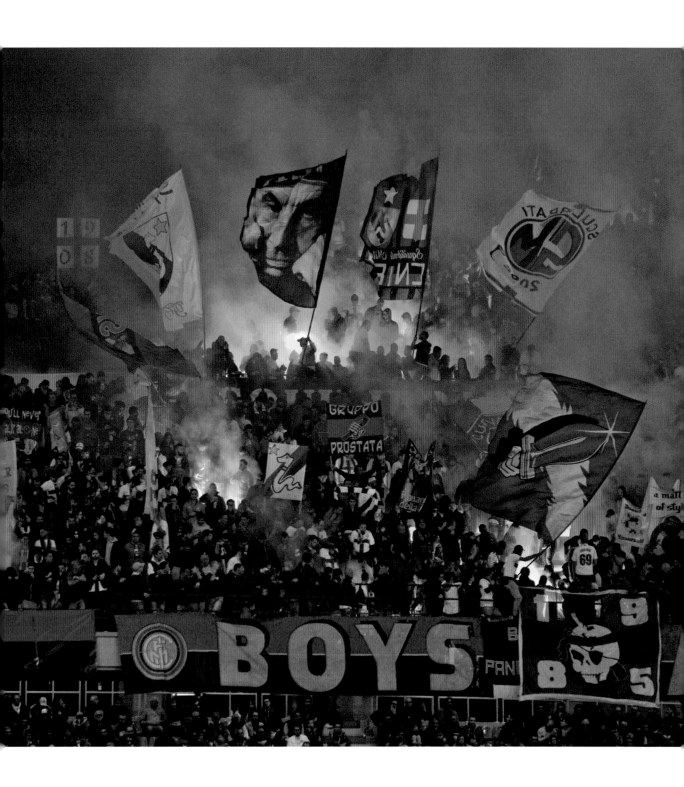

ULTRAS ITALIA
"NO AL CALCIO MODERNO!"

THERE ARE STREETS IN ROME WHERE ANCIENT ROMAN STREET GANGS FOUGHT WHILE EUROPEAN CIVILISATION WAS BEING FORGED. WHEN YOU COME OUT OF ROMA TERMINI LATE IN THE EVENING, FRESH OFF THE TRAIN FROM FIUMICINO YOU ARE HIT NOT ONLY BY THE ELEGANT CLASSICAL BEAUTY, BUT ALSO THE FIERCELY EDGY UNDERCURRENT OF ROMAN STREET LIFE. THE ETERNAL CITY HAS LONG BEEN A PLACE OF STARK INEQUALITIES, AND THE PEOPLE LIVE AMONG THE UNIMAGINABLE TREASURES OF ROMAN HISTORY, IN A PLACE WHERE WHO YOU KNOW DETERMINES ALL OF YOUR LIFE CHANCES - LIFE IS TOUGH, AND YOU GOTTA HAVE HUSTLE. YOU GOTTA REPRESENT YOUR FAMILY, YOUR NEIGHBOURHOOD, AND NOT LEAST OF WHICH, YOUR TEAM.

The history of Ultras in Italy is as scandalous and complex as everything else about the country, involving hardcore left and right wing politics, mafiosi, corrupt politicians, undercover cops and blood feuds. It's a miracle that Italian football has remained so technically brilliant, in spite of all the surrounding drama.

Today the Italian Ultras are organisations in every sense of the word, with club houses, policy meetings, rule books and hierarchies. Their actions are coordinated, not spontaneous and their focus is on the fans, not on the pitch. And in spite of the government crack down in recent years they remain an active force.

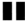

"WE DIDN'T AGREE WITH IT (THE TESSERA), BUT IF WE STOPPED GOING THAT IS WHAT THEY (THE AUTHORITIES) WANTED, A PERFECT ANSWER FOR THEM."

DAVIDE, CURVA SUD VERONA

PLANETFOOTBALL.COM

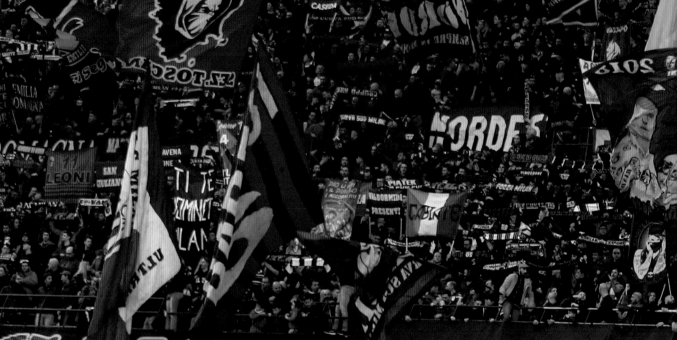

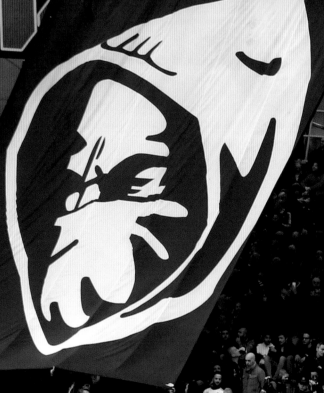

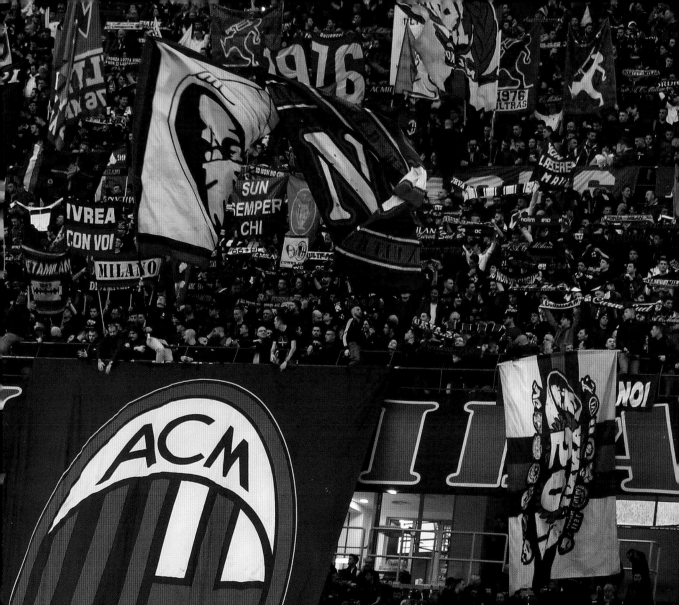

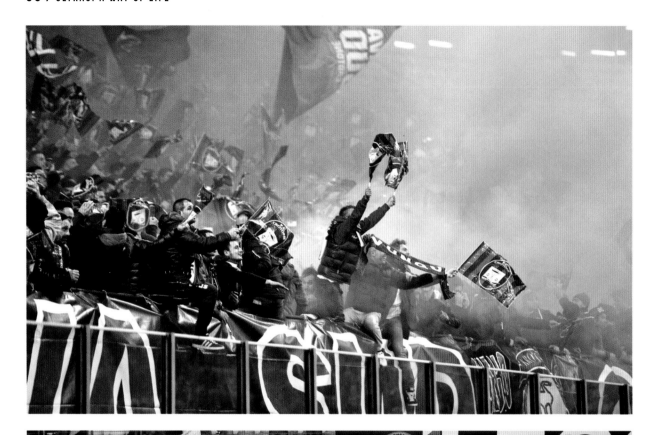

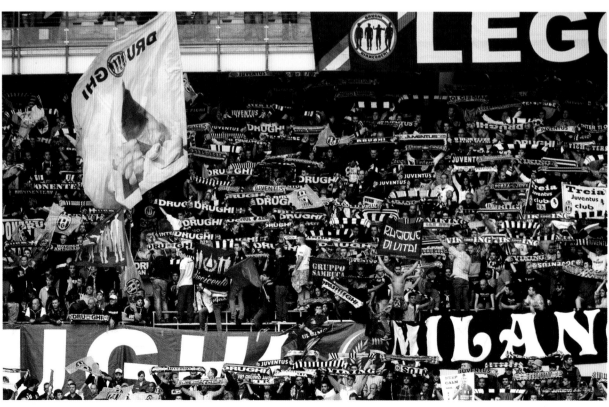

"Italy's ultras are uber-organised, hierarchical and calculating. They started, in the late 1960s and early 1970s, as wannabe paramilitary groups. They gave themselves names that made them sound like insurgents: Commandos, Guerrillas and Fedayeen."

Tobias Jones, The Guardian

So, where did they come from and how did they end up becoming so infamous?

Back in the 1960's when some people were living the Dolce Vita, splashing about in the Trevi Fountain, others were discovering football. A drop in ticket prices brought in a wave of young fans who changed the fan culture of the game, they wanted excitement and catharsis. They were influenced by the liberalising birth of pop culture but it was a moment in history when young Italians were polarized along extreme political lines, the new football fans were often affiliated to fascist, communist or anarchist groups.

One version has it that the first official Ultras group was formed to support Associazione Calcio Milan. The Fossa dei Leoni (The Lion's Den) colonised Ramp 18 when Milan moved into their new stadium in 1972, bringing the flags, banners, confetti and wearing the club colours; they laid down the basic elements of Ultras culture that would soon spread across Italy.

They were left wing and carried a banner of Che Guevara at every match. As the FDL grew, the police repression increased, and the group grew in popularity and got more violent and better organised as a result. This pattern of demonisation and repression creating organised resistance - is common throughout the story of Ultra groups.

It seems that there was a moment when the Italian Ultras were largely fans, driven by the desire to support their teams and represent their wider communities. At some point in the late 1970's the culture evolved into something else, an extreme lifestyle full of sex, drugs and territorial violence.

There is also an argument that the political idealism of the 1970's was replaced by the influence of British organised hooliganism in the 1980's. The names of Ultra groups changed from being inspired by political militia's to names more associated with the joys of an extreme lifestyle - such as The Droogs, Italianicised to 'Gli Drughhi' (A reference to Anthony Burgess' novel about violent delinquents 'A Clockwork Orange' - a major influence on hooligan culture in the UK.)

But throughout the long story of Italian Ultras, the majority of Ultra Fans evidently cared more feverishly about the football than their quasi-mafiosi leadership. After all the Italian word for football fan is 'tifoso' - literally Typhoid Sufferer.

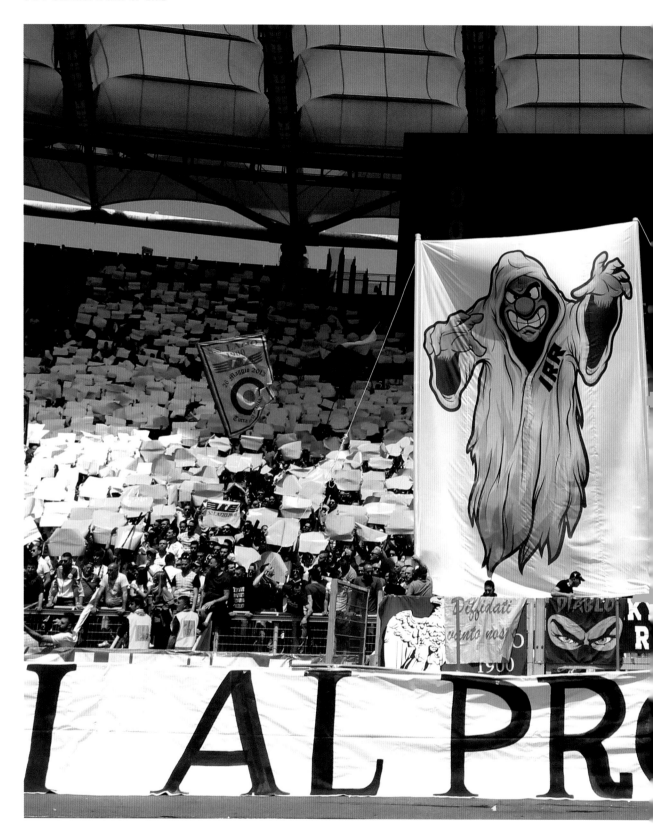

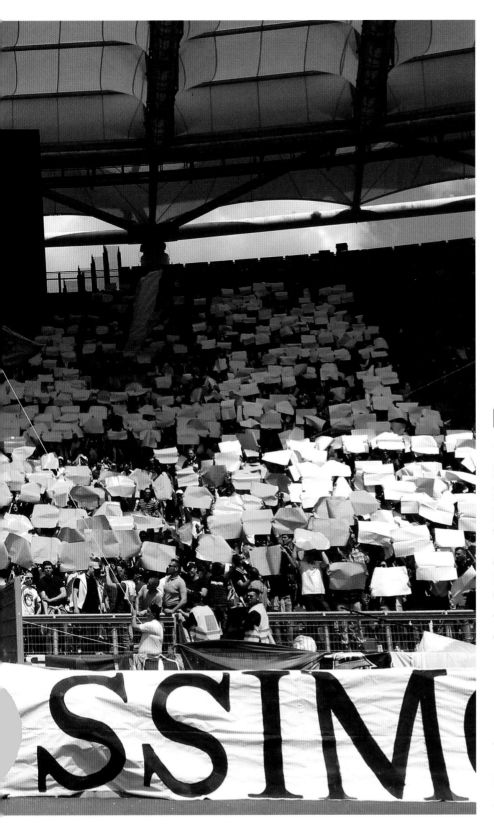

■■

"WE WILL NEVER DIE. THEY'VE TRIED MANY TIMES AND MANY DIFFERENT WAYS, USUALLY AFTER A SERIOUS INCIDENT. BUT WE WILL ALWAYS BE THERE FOR OUR TEAMS AND CITIES, NO MATTER WHAT RESTRICTIONS THEY IMPOSE. THEY DON'T UNDERSTAND THIS WAY OF LIFE."

MATTIA, LAZIO

WWW.PLANETFOOTBALL.COM

THE SWEEP ACROSS EUROPE

Serie A is the fourth most watched league in the world with 600,000,000 viewers worldwide. Italy boasts three of the biggest superclubs in European football; Milan, Inter and Juventus teams that like Manchester United, Borussia Dortmund and Barcelona have become multinational corporations, superbrands, glossy and distant, and really expensive to follow.

Such clubs epitomise the 'modern football' that Italian Ultras protested against when they invented the slogan 'No to Modern Football' (No al Calcio Moderno). And the Ultras of Italy have done more to characterise the style and methods of Ultras groups worldwide than any other European nation can claim, in spite of clampdowns in recent years. Indeed the very name 'Ultra' comes from Italy.

"In 1999 the AS Roma ultras released their manifesto against modern football, which pretty much shaped the whole european ultra scene."

Reddit

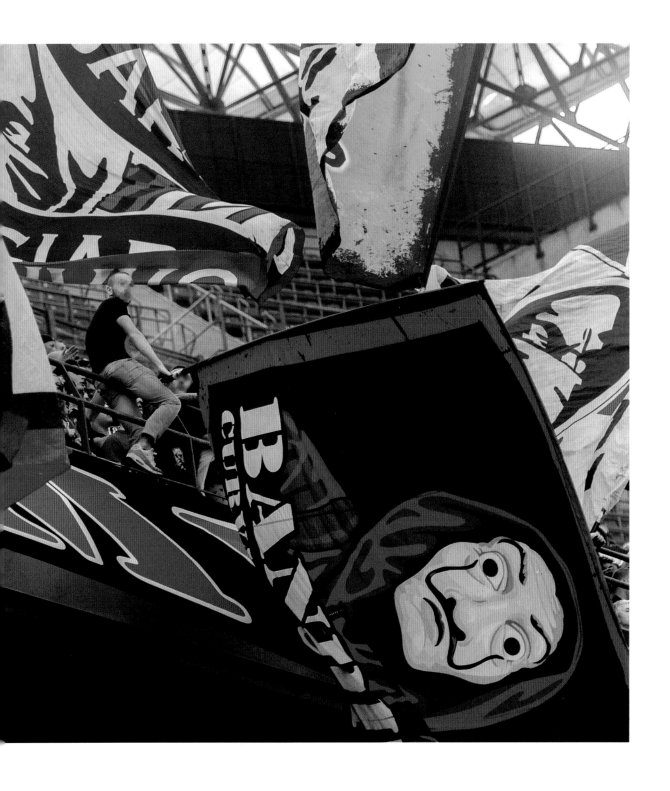

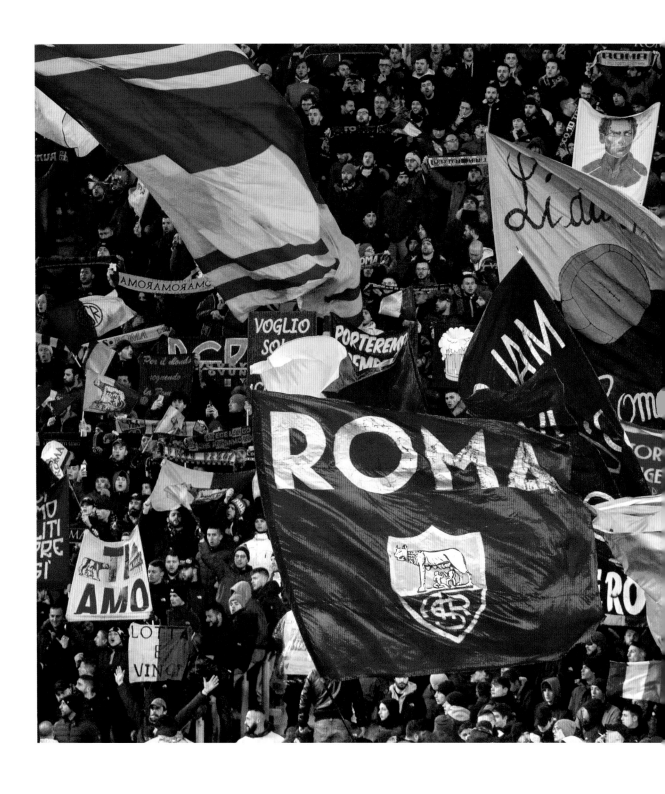

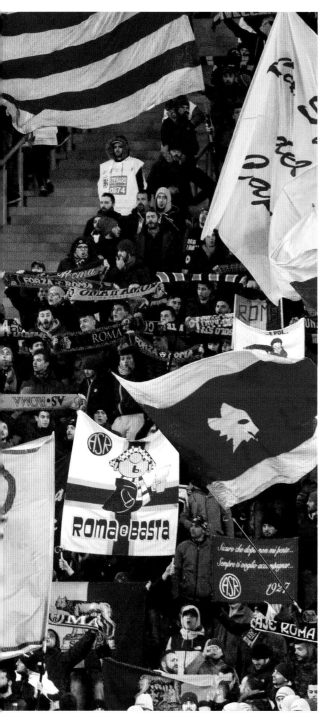

THE DERBY ALLA CAPITALE

The Derby alla Capitale between Roma and Lazio is one of the most bitter in football. Such is the teams' mutual hatred that Lazio fans once turned up to help Liverpool fight Roma. *They hate each other more than they hate Liverpool.* Let that sink in. And in past years what made the Derby the most important, and the most bet upon in Italy were the lavish efforts of the teams' Ultra Traditional Fans.

Friendly competition turned into blood feud when in 1979 a Lazio fan was killed in the stadium by an emergency flare which had hit him in the face.

The death of Vincenzo Paparelli was a turning point in Italian football culture.

The Roma fans formed the Ultra Commandos of the Curva Sud. The CUCS were one of the first large scale alliances of smaller fan groups that created the modern idea of Ultras as organised groups. Today, the AS Roma Ultras group is hugely influential, having written a manifesto that launched the 'against modern football' movement.

> *"The curva is every bit as territorial as a drug dealer's corner, and ultras stake out their turf in similar ways: fights, stabbings, shootings and, sometimes, by making alliances and business deals."*

Tobias Jones, The Guardian

There is something distinctly medieval about Italian culture, the pageantry, the banners the local colours, the competition between districts all hark back to Renaissance Italy. The Palio horse race in Siena is visually similar to a Curva in full Tifosi display. They have the term 'campanilismo' meaning loyalty to your local church bell, reminiscent of the definition of a Cockney, born within earshot of the Bow Church Bell.

These micro-patriotisms are often more important to Italians than any national patriotism, as is evidenced by the number of political separatist movements, the number of regional dialects, this youngest of the European nations can boast. In Venice there is a bridge called the Bridge of Fists, and there is a painting showing the War of Fists between two neighbouring districts of Venice back in the 1600's.

It's easy to draw a link between the loyalty to clan, to neighbourhood in Renaissance Italy and the present day Ultra with their cherished colours. Ultras sometimes call themselves 'Ultra Traditional' and a nostalgia for medieval ways is visible in Italian fan organisations, as it was in Mussolini's fascism. Lazio fans displayed pro-Mussolini banners as recently as April 2019.

FORZA ITALIA

In spite of being knocked out by Argentina on penalties, Italy had a great run in the 1990 World Cup, and hosting the event boosted the brand of Italian football worldwide. After Italia '90 football had never been more popular in Italy.

And, riding the wave of popular football culture, Silvio Berlusconi built his political career with a battle cry taken directly from the terraces 'Forza Italia!'. However, Berlusconi, owner of AC Milan and most of Italian mass media, was also one of the major players in the commercialisation of Italian football, and it was the Ultras that led the backlash against that throughout the 1990's.

CONTRO IL CALCIO MODERNO (AGAINST MODERN FOOTBALL)

You can still find the original manifesto posted by AS Roma Ultras at http://www.asromaultras.org/manifesto.html along with a long list of international Ultras crews who signed up as official supporters of the movement that it ignited. The key injuries cited by the manifesto were, the lack of player loyalty to the team, the excessive focus of attention and resources on a handful of European superclubs, the prioritisation of TV audiences over stadium audiences and the excessive commercialisation, leading towards players plastered with sponsorship like F1 racing cars.

The heart and soul of this cry of outrage is the idea that the active participation of supporters, for whom their club is a *faith* (not a product), is being forced out in favour of a passive spectatorship similar to the behaviour of a cinema audience. (This rage against FIFA can be justified by the slew of corruption scandals in recent years.)

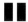

"VIOLENCE AT ITALIAN FOOTBALL STADIUMS DID NOT BEGIN OR END WITH THE CASE OF VINCENZO PAPARELLI. BUT HIS DEATH MARKED THE POINT WHEN THE HATRED BETWEEN LAZIO'S LAZIALI SUPPORTERS AND ROMA'S ROMANISTIS BECAME ORGANISED."

VICE MAGAZINE

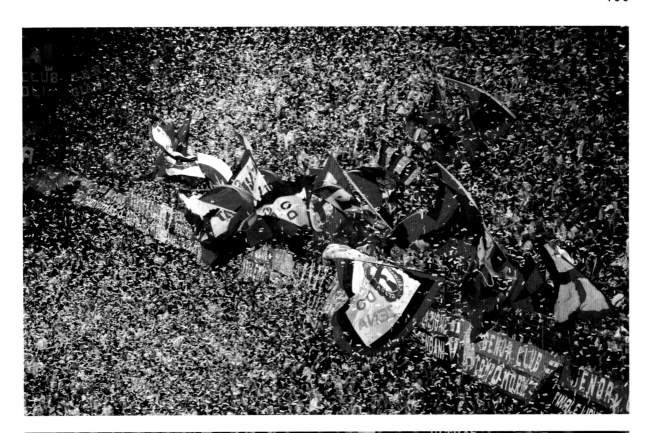

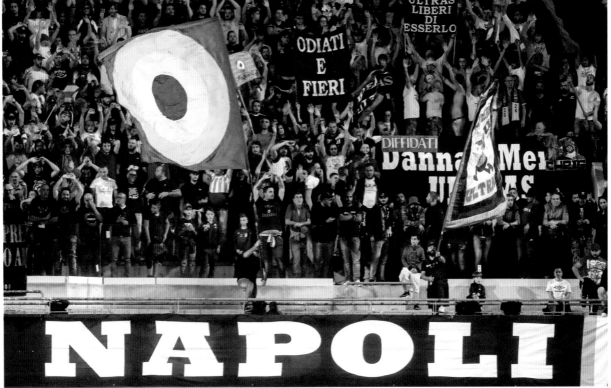

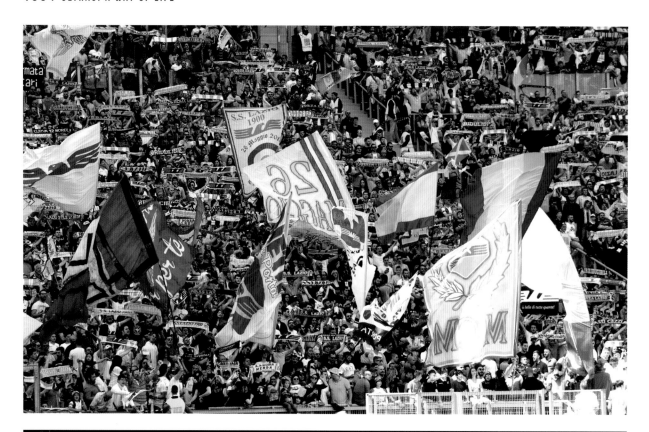

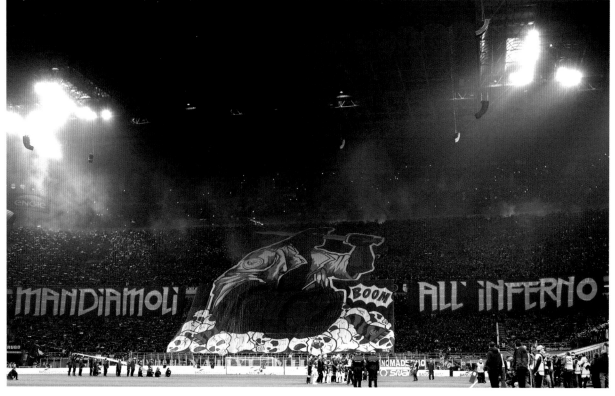

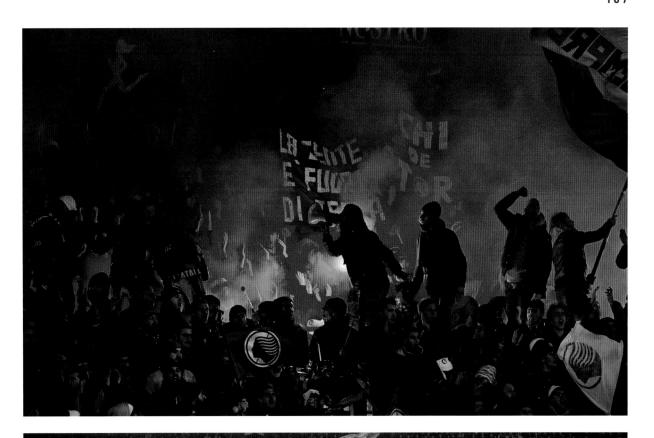

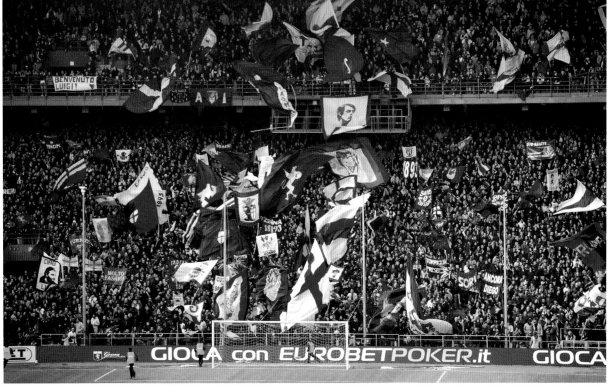

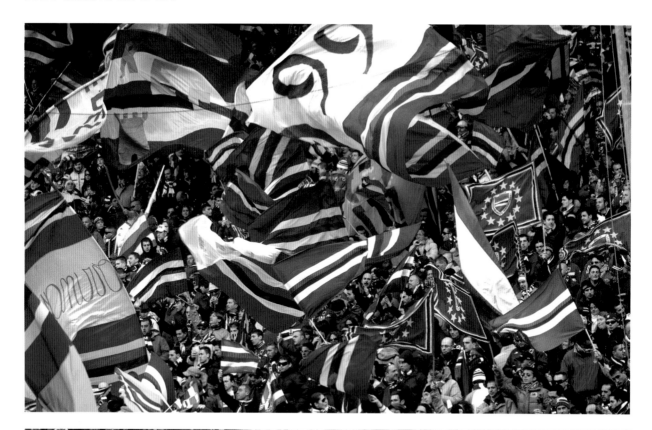

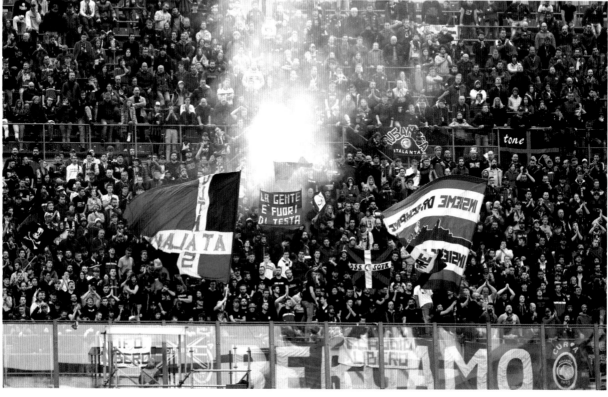

All of which is easy to empathise with, apart from a few uncomfortable details. The AS Roma fans campaign against *foreign players*. And they campaign for 'The violation of every limitation imposed by authority.' Remembering that such limitations would include the banning of racist chants, a common feature of Italian football.

NOT ALL ULTRAS

The press response to the Italian ultras has largely fixated on the criminal element, the cynical manipulation of the culture by organised crime and the evidence of political extremism and racism. While all these things are clearly happening, the hardcore cannot represent the whole culture.

The majority of Ultras are football fans first and foremost, and the majority of their organisational efforts are about creating a carnival atmosphere on match days, an explosive and exciting, celebratory and aggressive atmosphere that makes a match feel like something epic, something legendary. It allows people to experience something denied to them in the grind of daily life - a heroic dimension to their lives.

For every cynical Ultra who sees football as nothing more than a business opportunity, there are a hundred more who believe in their team as fervently as a religious fanatic. And when they sing *'we don't give a fuck about the match'* maybe what they really mean is that their fervour, their faith and their passion for their team is not dependent on the score, or the board or even the players - it is irreducible.

It's been eight years since most Italian Ultras stopped going to away games to protest the Tessera fan card. But in Italy today there are signs that the Away Fan ID Card is no longer being enforced as strictly as it was. There is hopeful chatter online that the Ultras culture will come back to the level of it's halcyon days. It's chatter that belies something you wouldn't expect, that Ultras are actually helping each other by discussing how to respond to the waning regulations. The hate between them may be theatrical after all, because everybody knows that it's no fun being Batman without the Joker - Ultras want to see their enemy factions at the match - it's part of the game.

Still for many, football is not a political sport. Around half the Ultra groups are not politically affiliated. And as for the faithful foot soldiers of the crusade against modern football, their hopes for the future of fan culture in Italy are clear.

"We will never die.
They don't understand this way of life."

Беда́ никогда́ не приходи́т одна́

TROUBLE NEVER COMES ALONE

THEY CAME FROM THE EAST. IN 2016 A NEW BREED OF FOOTBALL HOOLIGAN UPSET THE APPLECART AT THE EUROPEAN CUP. THESE RUSSIAN ULTRAS HAD CLEARLY NOT READ THE RULEBOOK OF TRADITIONAL HOOLIGANISM. WHILE THE BRITISH AWAY FANS PRACTICED THE TIME HONOURED ART OF COLONISING A BAR IN TOWN, GETTING VERY DRUNK, TAKING THEIR SHIRTS OFF AND OCCASIONALLY THROWING PLASTIC CHAIRS - THE RUSSIANS AMBUSHED THEM.

Saturday 11th June, 2016 England played Russia in Marseille, France and an army of 150 Russian Ultras, some equipped with MMA gloves, gumshields and truncheons roamed the city laying into England fans with what witnesses described as 'military organisation'. During the match the Russians set off flares, hurled racist abuse and finally invaded the English end of the stadium at the end of play.

Overnight the Russian demonstrated a type of violence thought long gone from European football. UEFA fined the Russian Football Federation and deported 29 Russian supporters. Responses from Russian officials stoked international indignation. Some were proud of Russian machismo and blamed the French police for not knowing how to cope with 'real men'.

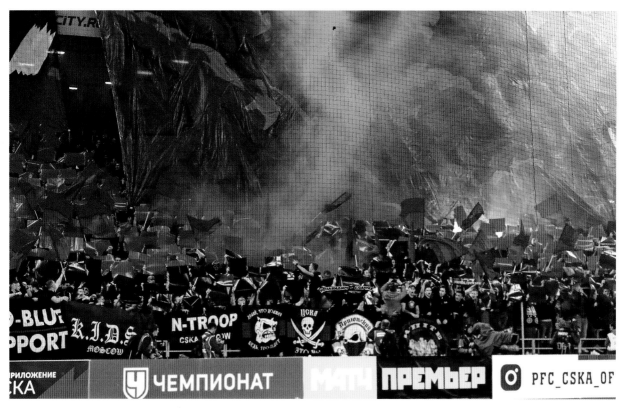

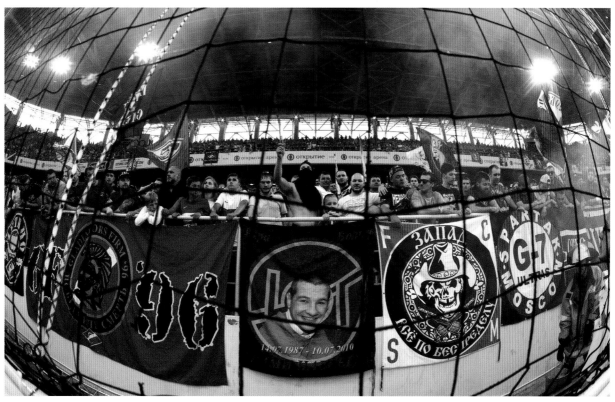

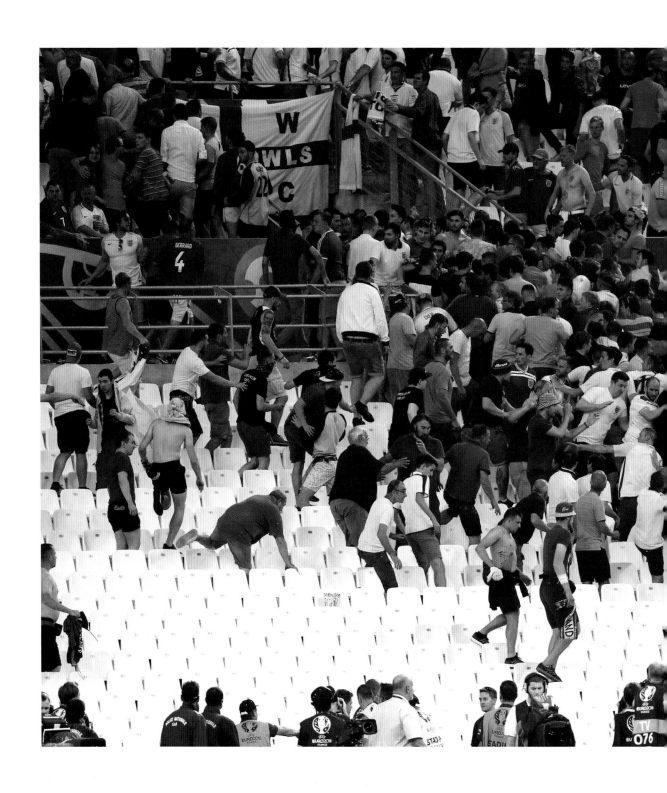

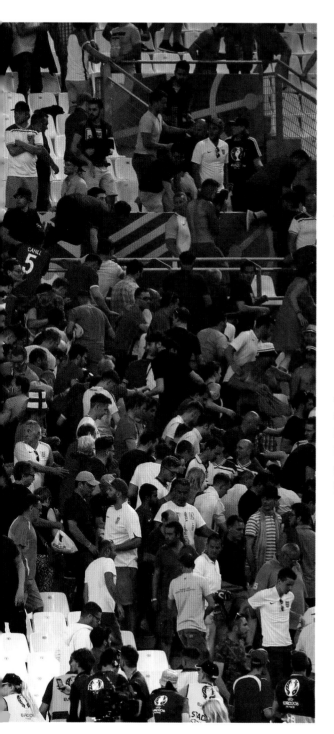

"I don't see anything wrong with the fans fighting. Quite the opposite, well done lads, keep it up! In nine out of 10 cases, football fans go to games to fight, and that's normal. The lads defended the honour of their country and did not let the other fans desecrate our motherland. We should forgive and understand our fans."

- Igor Lebedev, Russian MP & Executive of RFU, 2016

Around the same time, a Russian supporter interviewed by Kim Sengupta in the Independent (2016) claimed that inside Russia the police have the hooligan gangs under control.

"There isn't much fighting in the stadiums and in the cities. They now have to arrange fights outside, in the woods. They train for these fights, they do boxing, martial arts, that is why they move in formations and can carry out ambushes,"

And there a some Russians who claim that the Ultras and the hooligan gangs are not the same thing at all. But this is hard to sustain when groups like the Orel Butchers who are in every sense a typical Ultras style supporters group, made no secret of being involved in the 'Battle of Marseille' because of course...

"When we are good no-one remembers us, when we are bad no-one forgets us."

- Masked Orel Butcher, Interviewed by the BBC

Another Ultras group from Yekaterinburg, the Steel Monsters, posted a blood splattered English flag, stolen as a trophy, on social media soon after. Russian Ultras claimed in interviews following Marseilles that the English fans were 'an inspiration' to them, and that they had initially styled themselves on British hooligan culture. Some said the attack on the English was about 'winning honour' by attacking a 'highly respected enemy'. Others were more derogatory, calling Marseille a clash between 200 professionals and 2000 amateurs.

> *"You can be like a girl...or you can be a person who fights everywhere and stands up for himself. It's your own choice."*
>
> - Vova

For the Russian hooligan fighting is a normal part of being a Russian man, and there is a sense that it his duty and an expression of his patriotism. He feels that he is honouring a tradition and a history of Russian toughness. It is not seen as subversive or perverse, rather as natural. Because violence is a natural behaviour for a man, it is better to express it out in the woods than in the street, it is an essential catharsis.

NIC SIE

UJE NASZ WIELKI LECH

KKS LECH
POZNAN

NDIA

UL

JORZA

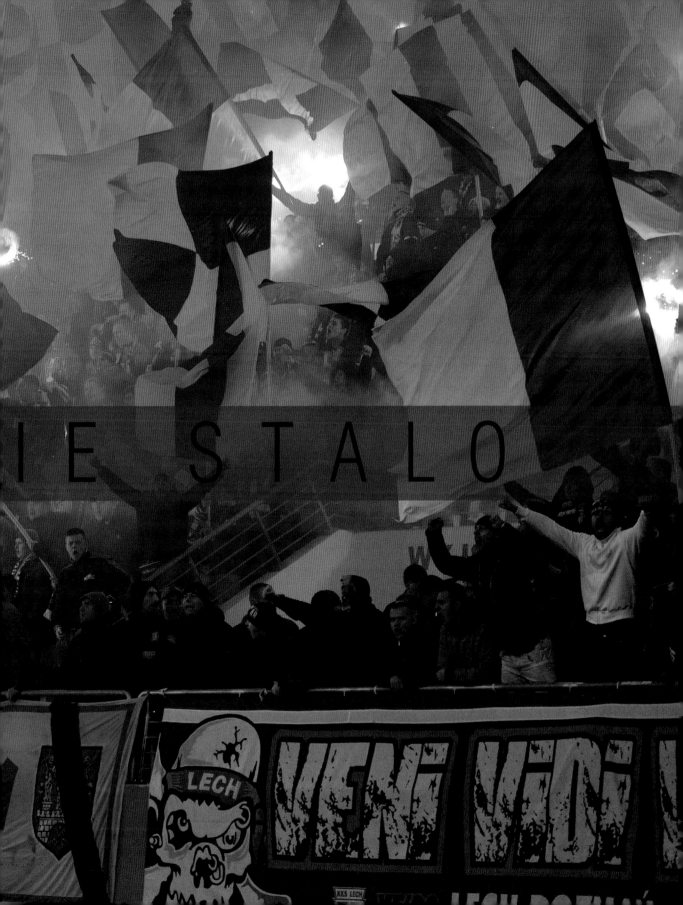

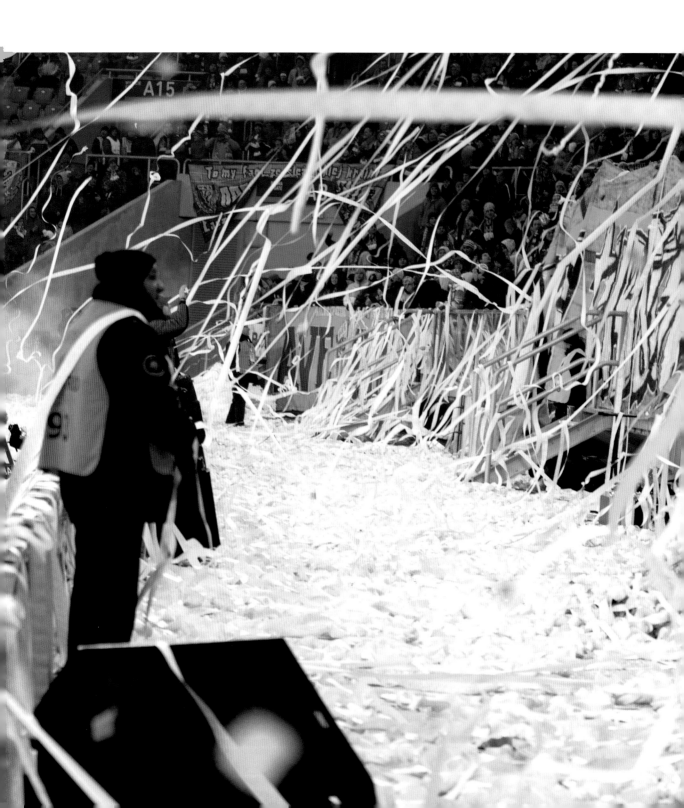

NOTHING HAS HAPPENED

POLAND'S ULTRAS

"NIC SIE NIE STALO" (NOTHING HAS HAPPENED) IS A POPULAR POLISH CHANT SUNG TO THE TUNE OF GUANTANAMERA, MEANING BASICALLY "GET ON WITH IT YOU LAZY PACK OF BASTARDS". THIS TO SERVE AS A GLIMMER OF THE POLISH CHARACTER, 'SARKY', IN A WORD. AND THEY LIKE A BIT OF ACTION.

"As a young man, I was a typical hooligan. We would roam the streets, you know, cruising for a bruising, often returning home bleeding from football matches."

- Donald Tusk, President of the European Council and ex Prime Minister of Poland (Lunch with the FT)

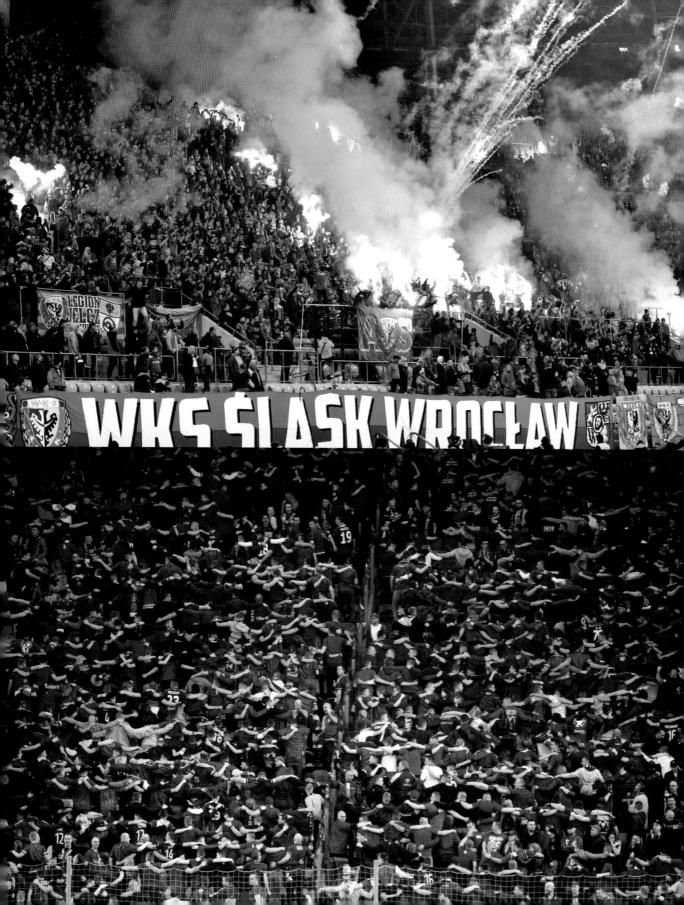

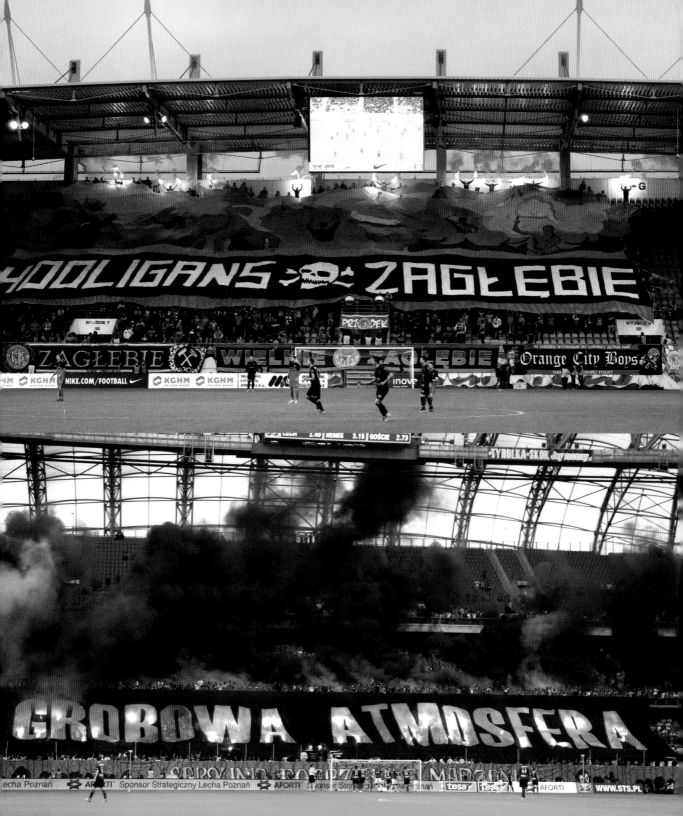

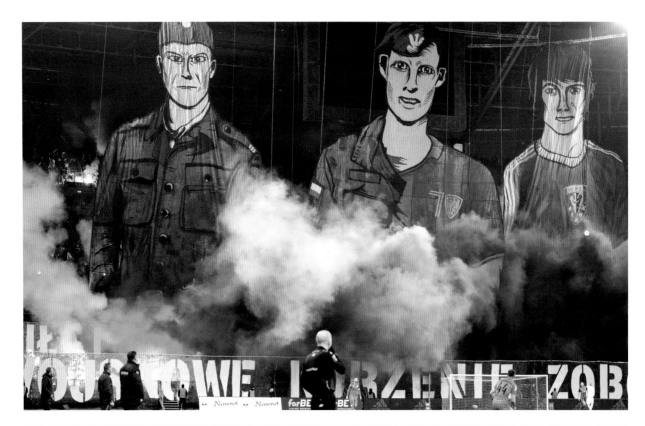

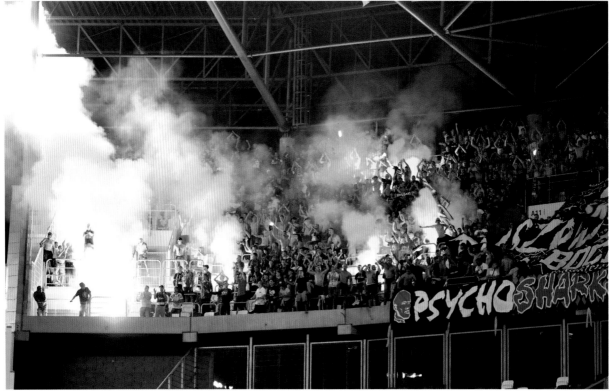

A match day in Poland can look a bit like a bit like an apocalyptic showdown between the state and an army of shirtless psychos wearing halloween masks over their balaclavas. Nowhere in the world do riot police look more like terminator robots.

Poland do the Ultras thing in a big way, with all that 'No Pyro No Party' swagger. Capturing flags, burning flags, waving flags, pitch invasions, attacking players, stadium riots and kicking off outside of the stadium - none of them are rare in Poland. As the hooligan element has been driven underground in recent years, they tend more towards organising *'ustawki'* (fights) away from stadiums these days.

Even so, as recently as 2015 a young fan was killed by rubber bullets during a pitch invasion at a fifth division game in Knurów. A gang of some 200 Ultras attacked the Knurów police HQ in a riot lasting several days as a result.

Back in December 2017 there was a huge co-ordinated pyro display to commemorate the Greater Poland Uprising of 1918-19. Ultras Lech Poznań used over 2000 flares to make the whole city light up.

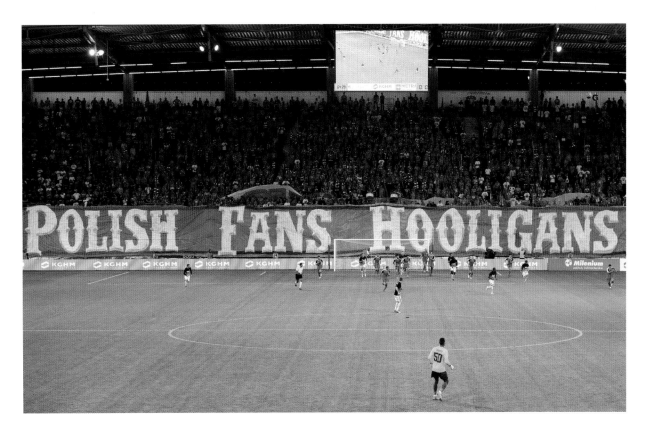

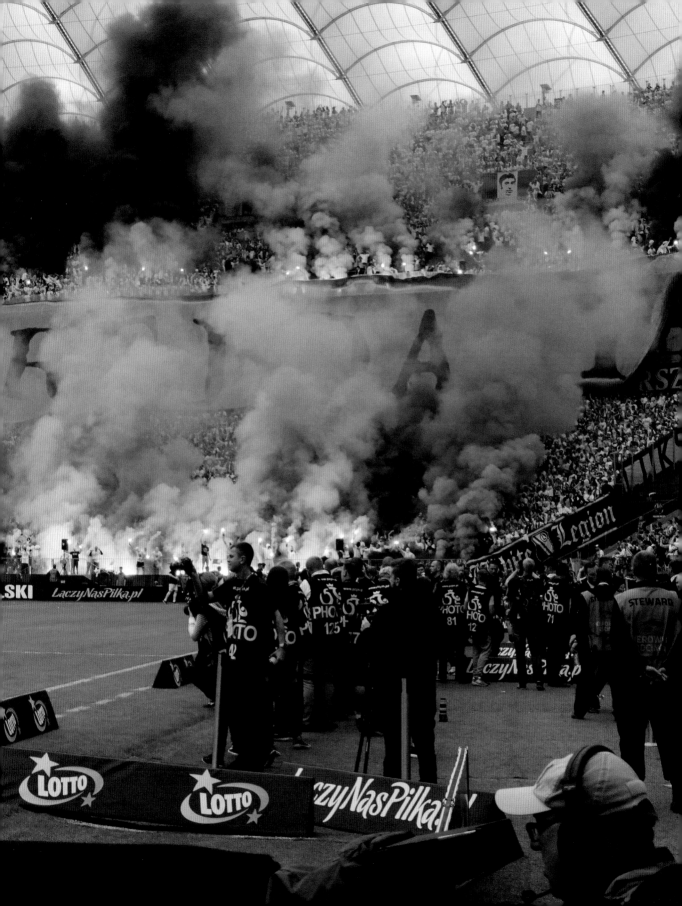

THE STORY OF TORCIDA

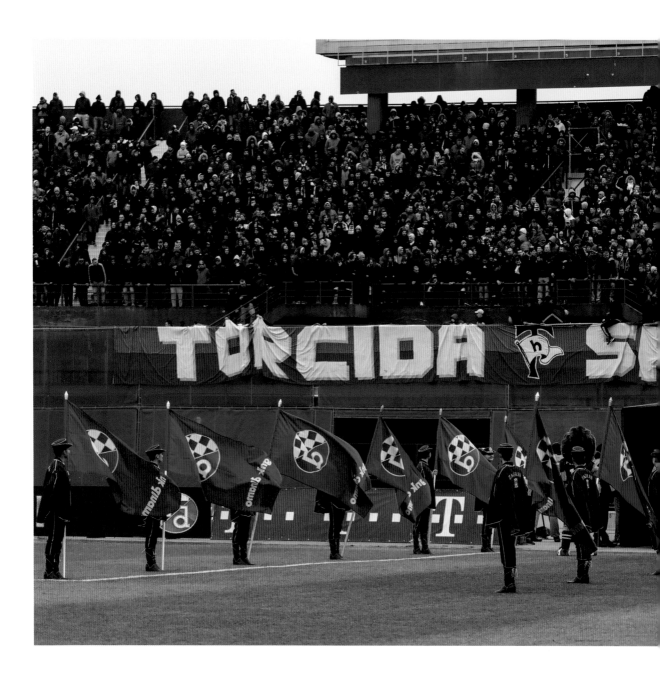

PLIT

FIRST OF THE EUROPEAN ULTRAS

THE CITY OF SPLIT ON THE RAGGED SOUTHERN COASTLINE OF CROATIA WAS ONCE THE MOST IMPORTANT PORT IN YUGOSLAVIA. SITTING ON THE SHORES OF THE ADRIATIC SEA, OPPOSITE ITALY, A GATEWAY TO THE MEDITERRANEAN, IT HAS ALWAYS BEEN FOUGHT OVER. IDENTITY IS A BIG THING IN A CITY THAT HAS BEEN CONQUERED SO MANY TIMES, THAT HAS SURVIVED THE RISE AND FALL OF EMPIRES FROM ANCIENT ROME TO COMMUNIST RUSSIA.

Back in 1950, when the fourth World Cup was held in Brazil, Yugoslavia had just narrowly avoided a Soviet Invasion to depose General Tito, they were the only Soviet State to successfully defy Stalin. Even so, his rule was repressive and Croatian nationalism was considered a threat to stability - which was later proved only too true in the horrifically violent Balkan War of the 1990's. Long standing rivalry between repressed national identities exploded when Yugoslavia fell apart. But back in the 1950's the only way to express that fierce pride in regional identity, under the gaze of the Communist secret police, was through football.

It was Croatian sailors who first brought the 'Torcida' to Europe. They took advantage of some layover time in Brazil to catch some of the World Cup games, 1950. They were overawed by the behaviour of Latin American

fans. They witnessed the power of fan organisations called 'Torcidas' that could supercharge the atmosphere of support in a stadium with coordinated actions. They brought the word 'Torcida' back to Split, where their home team Hadjuk Split was to benefit from this new, explosive style of fan support.

Hrvatski Nogometni Klub Hajduk Split was formed by students in Prague in 1911 after a boozy conversation in a famous beer hall, U Fleku. They had just watched a football match between two Prague teams, and were inspired to start their own club, not only to play football but also to further their distinctly political ambitions.

It was a defiant move to name the team 'Croatian' while under Austro-Hungarian rule as part of the Kingdom of Yugoslavia, and to underline this by including the red and white checkerboard flag of Croatia in the team shield. Their Professor suggested the name 'Hadjuk' which referenced Croatian folklore, the name of a group of Robin Hood style bandits who raided their Ottoman overlords back when Croatia was under Turkish rule. Initially the Yugoslav Monarchy tolerated this, but later forced the club to remove 'Croatian' from the team name prior to WW2.

Immediately upon it's foundation, the team became a focus for Croat unionists who opposed the separation of Croatia under Yugoslavian rule. This local belief in Hadjuk as a symbol of their resistance to the wrongs of foreign oppressors went on to be cemented during World War II as the team *literally fought for the resistance* both as guerrillas and football players.

After a few golden years in the 1920's, Hadjuk suffered in the turbulent thirties. It was the teams links to Marshall Tito's resistance movement that re-invigorated them. Tito was half-Croatian, and the leader of the most successful resistance movement in occupied territory which had been focused around Split.

Past and future players for Hadjuk were members of Tito's resistance army, who managed to force Axis powers to the negotiating table, in spite of being occupied and ruled by Mussolini's fascist Italy. Mussolini tried to offer Hadjuk a place in Italian league football, which they refused. So he replaced them with a puppet team and took over their stadium. This created the opportunity for Tito and the Allies to use Hadjuk as a symbol of resistance to fascism, cementing their legend as the Balkan answer to 'Robin Hood and his Merry Men', cocking a snook at pompous fascists by going on a football tour.

May 7th 1944, during a celebration of the Patron Saint of Split, a meeting took place on the Adriatic Island of Vis. Hadjuk was reformed as the official football team of the resistance and preparations began for an gruelling 90 match tour of international friendlies. After the war, Hadjuk were heroes. Tito, under Stalin, now ruled the Socialist Republic of Yugoslavia, and he invited the team to move to the capital, Belgrade, and become the official 'People's Army' team of the new Communist State. Hadjuk, Croatians first and foremost, said no.

They chose to stay in Split, and were one of few teams who survived the transition to Communism. Many other clubs were disbanded, regional identity and nationalism being seen as a threat to Socialist Internationalism. Soviet teams were founded, like

Partizan Belgrade, a major rival of Hadjuk in later years. All of the pre-war Serbian teams were dissolved, and Red Star Belgrade was formed by young Serbian anti-fascists at around the same time. Hadjuk were only spared this fate as they were Marshall Tito's favourite club.

Once again under oppressive rule, you can begin to imagine how important the club was to its supporters, and how it was that the club was so ripe for the establishment of the first European Torcida in 1950.

July 16th 1950 in the Maracaná stadium in Rio de Janeiro, Brazil, a couple of Croatian sailors were at one of the most important matches in football history - the legendary Maracanaço. The term loosely translates to 'the massive kick in the balls at Maracaná' as the Brazilian's experienced a gutting turnaround in a final that everybody in the universe expected them to win against Uruguay.

So convinced of victory were the Brazilians that they had already been given gold medals by the Mayor of Rio, and a special song had been composed about their win! In the stands the Croatian sailors were amazed at the level of emotion displayed by the supporters. The atmosphere must have been beyond description. And crucially, they witnessed first hand the use of organised supporters groups called Torcidas to rally the troops, harass the opposition and share the costs of flags, banners and travel.

Back in Yugoslavia the young men formed Torcida Split just in time for a 2-1 win against the poster children of Yugoslav Communism 'Red Star Belgrade'. This triggered a repression that would dog the team throughout the 1950's, but even so it was a golden age for Hadjuk, who dominated the Yugoslav league in spite of political interference. The Torcida was banned almost as soon as it was formed, it's founder expelled from the Communist party and locked away, and the Torcida's name was forbidden.

This was not the end for the Torcida, which re-emerged in the 1970's as Yugoslavia gradually liberalised. Successes in the 1970's re-invigorated support and in 1979 the club moved to Poldjud, where the new generation of Torcida Split took ownership of the north stand, bringing new songs, new flags and the slogan.

"Hadjuk Lives Forever"

Which is the appropriate battle cry for the longest lived Ultras group in Europe. And after years of teetering on the edge of bankruptcy the team was finally able to report at the end of the 2017/18 season that it had 40 million kuna in the bank. With some of the most passionate fans in the world - Hadjuk may well live forever.

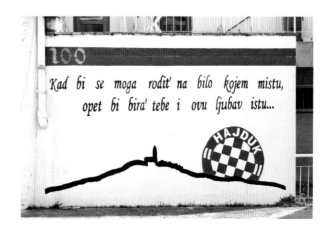

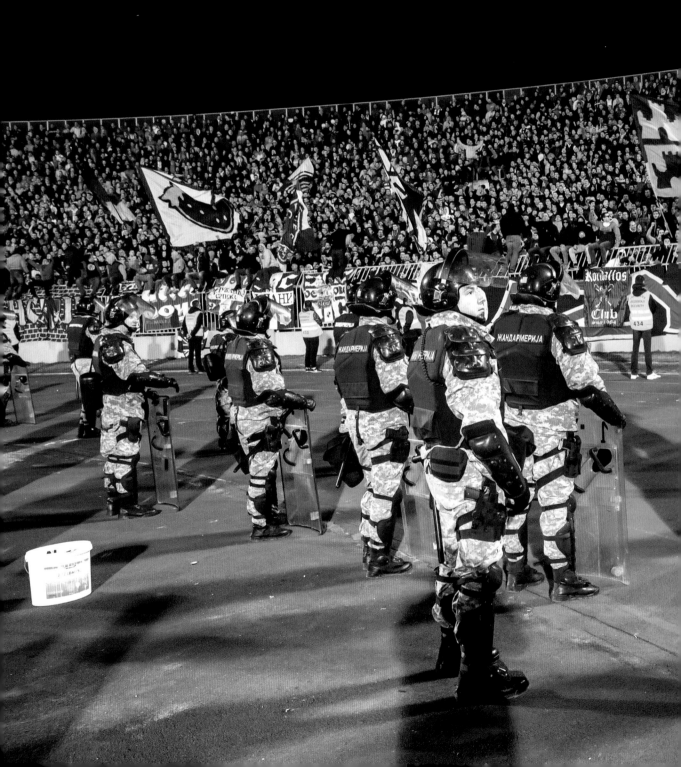

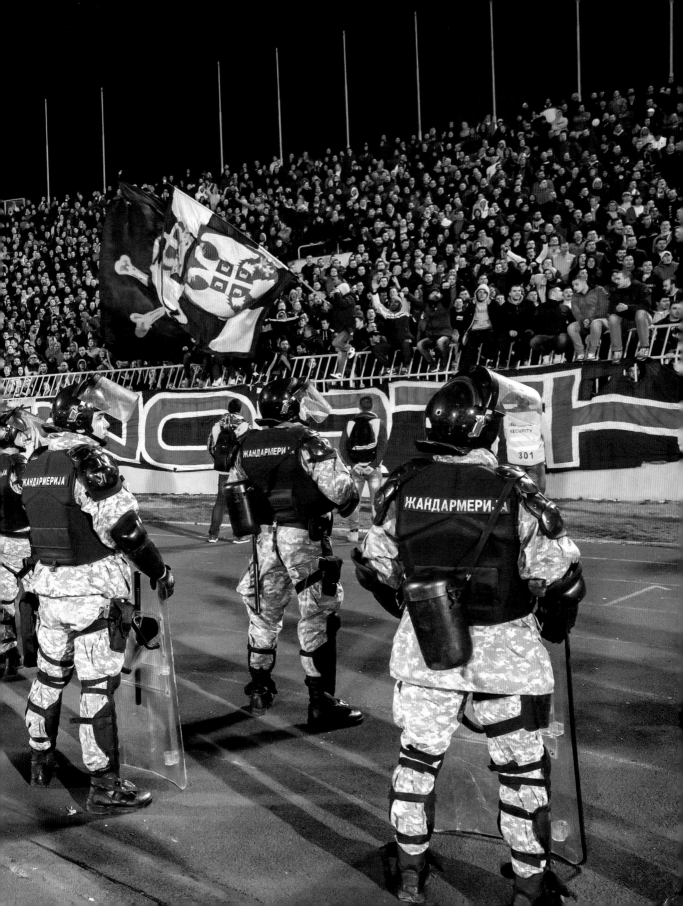

SPARTAN ATTITUDE

ULTRAS IN THE CRADLE OF CIVILISATION

ATHENS, THE BIRTHPLACE OF DEMOCRACY, THE EPICENTRE OF THE FINANCIAL CRISIS IN EUROPE, AND THE SCENE OF A NEAR COLLAPSE OF GREEK SOCIETY IN THE MADNESS OF THE YEARS THAT FOLLOWED. THROUGH IT ALL, GREEK FOOTBALL FANS HAVE BEEN RIGHT IN THE THICK OF IT.

Greek football exists against a backdrop of financial catastrophe and extremely polarised politics. Extremes of inequality characterise Greek life, and a generation of young people live on a few hundred euros a month (even graduates earn a paltry 700 euros) many taking solace only in their passion for their local football team.

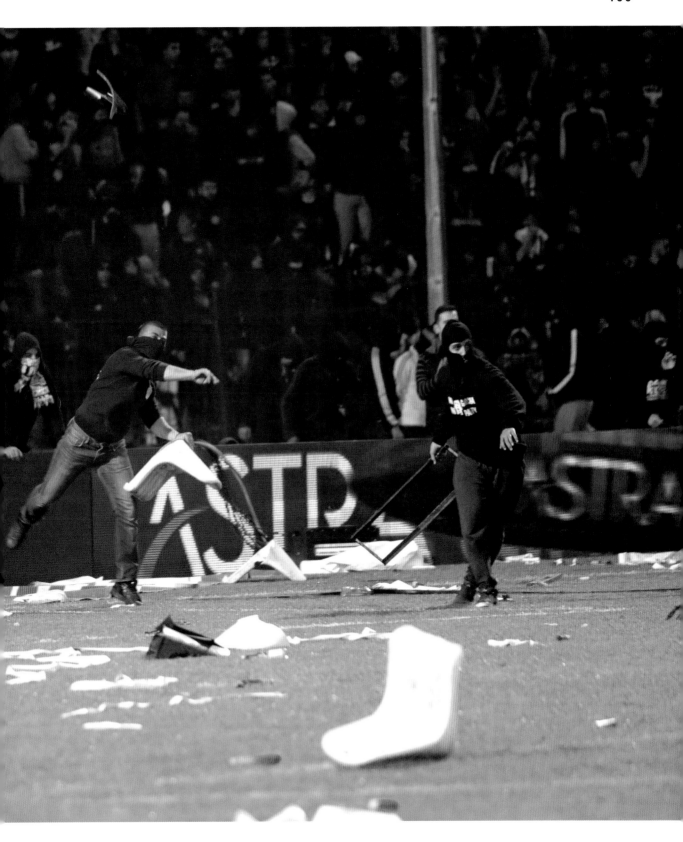

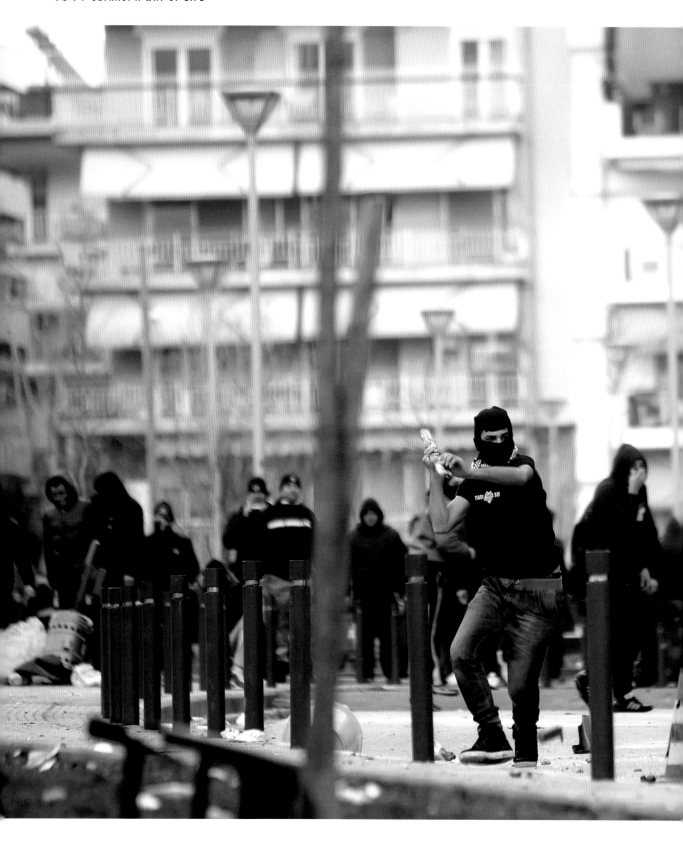

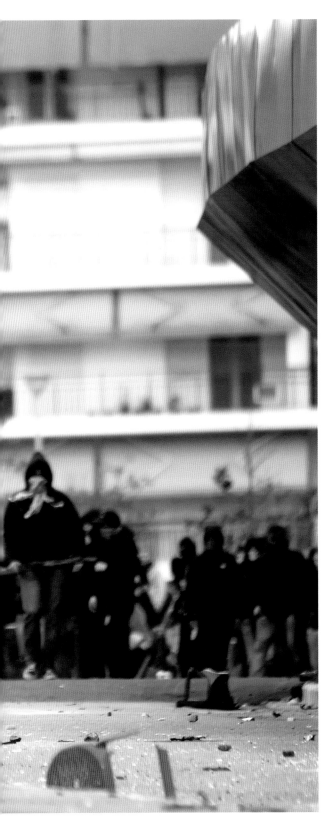

These are all the ingredients of a volatile stadium culture. The action in Greece promoted the Mirror Newspaper to ask 'Is there a more ferocious football atmosphere?'. The scenes in Greek stadiums today are stunning, an untamed and dominant Ultras culture leading to a spectacular style of support featuring showers of flares and fireworks and billowing clouds of coloured smoke. None of the gentrification of football in Western Europe has yet taken place.

The two biggest derbies in the nation are Olympiakos vs. Panathinaikos in Athens and Aris vs. P.A.O.K. in Thessaloniki. Gate 13 of Panathinaikos are one of the most organised Ultras groups, with their own, bright green, headquarters and slogan:

'Panathinaikos means fighting spirit!'

Outside of the top Greek league the Ultras of AEK represent the far left of Athens culture. Their yellow and black colours represent the flags of Imperial Constantinople, but these fans are more likely to be anarchists than imperialists. In 2008, in the anarchist Exarchia district of the city, a Greek police officer shot a fifteen year old boy (a Panathinaikos fan) through the heart. The AEK Ultras and Gate 13 were both at the forefront of the weeks of rioting that followed, described as the worst political riots in Europe since 1968.

Even before this, Greek football was rough.

> *"For prior to the December Riots, Greek football had often resembled a form of all-out civil war. In 2008 alone, there were 325 incidents of violence between fans of rival Athenian clubs."*

https://thesefootballtimes.co

After 2008 Greek football became the battleground for two radically opposing forces to win the hearts and minds of the 700 Euro a month generation. Syriza on the left versus the Golden Dawn on the right. Both parties invested heavily in strategies to recruit support from Greek football stands, and while the Golden Dawn succeeded to some extent, ultimately Syriza won the mass support required to take control of government and lead the doomed negotiations with the Troika. Greek society has calmed somewhat since 2013, and football has followed suit, but the spectre of extremism remains.

One thing is for sure, if you're nostalgic for the golden days of Ultras culture, then book a flight to Athens and buy yourself some tickets for the derby. Football is alive and well in Greece.

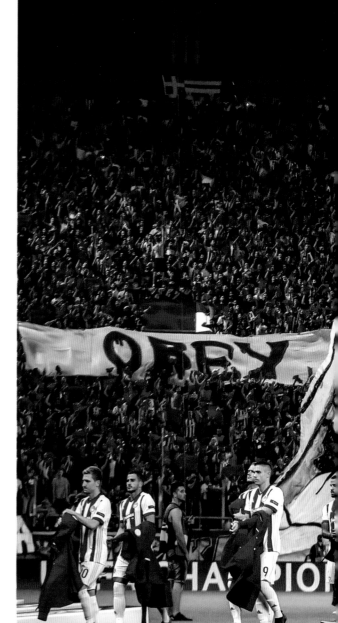

"A BELLIGERENT STATE PERMITS ITSELF EVERY SUCH MISDEED, EVERY SUCH ACT OF VIOLENCE, AS WOULD DISGRACE THE INDIVIDUAL"

SIGMUND FREUD

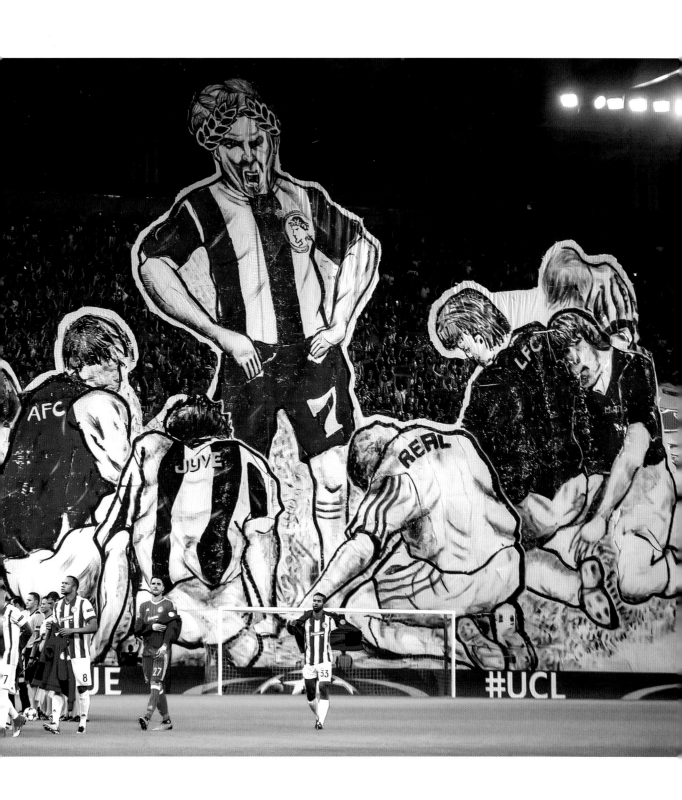

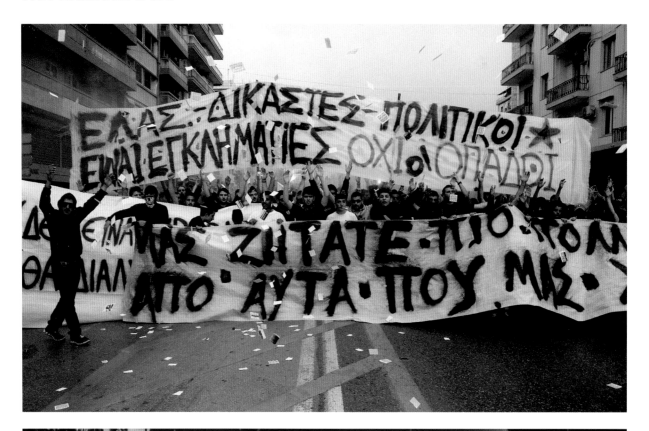

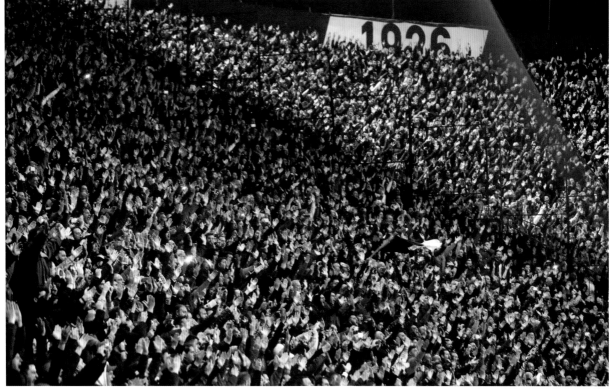

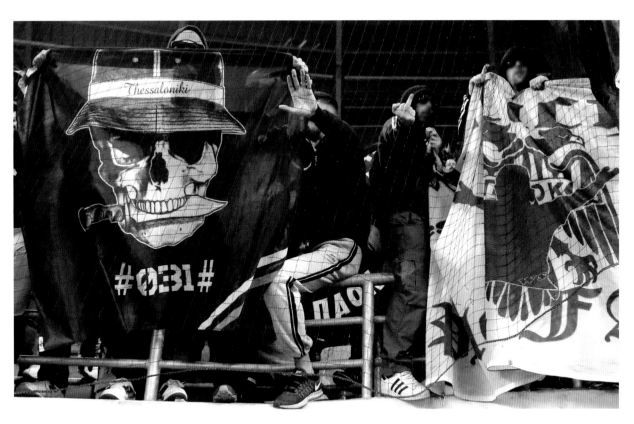

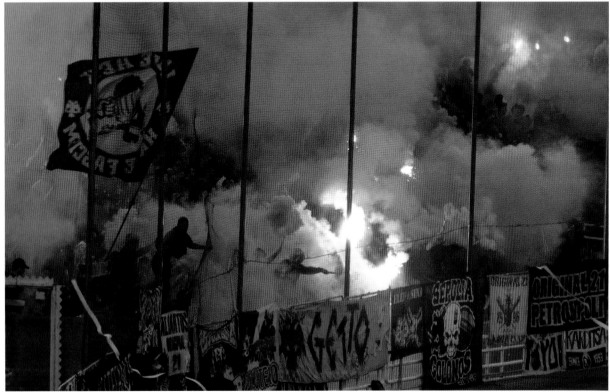

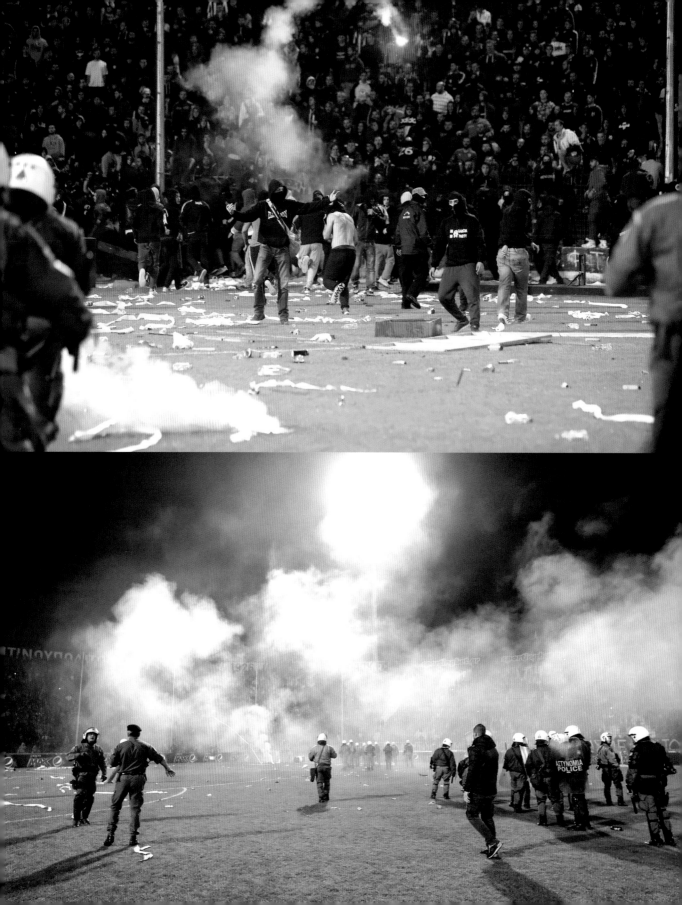

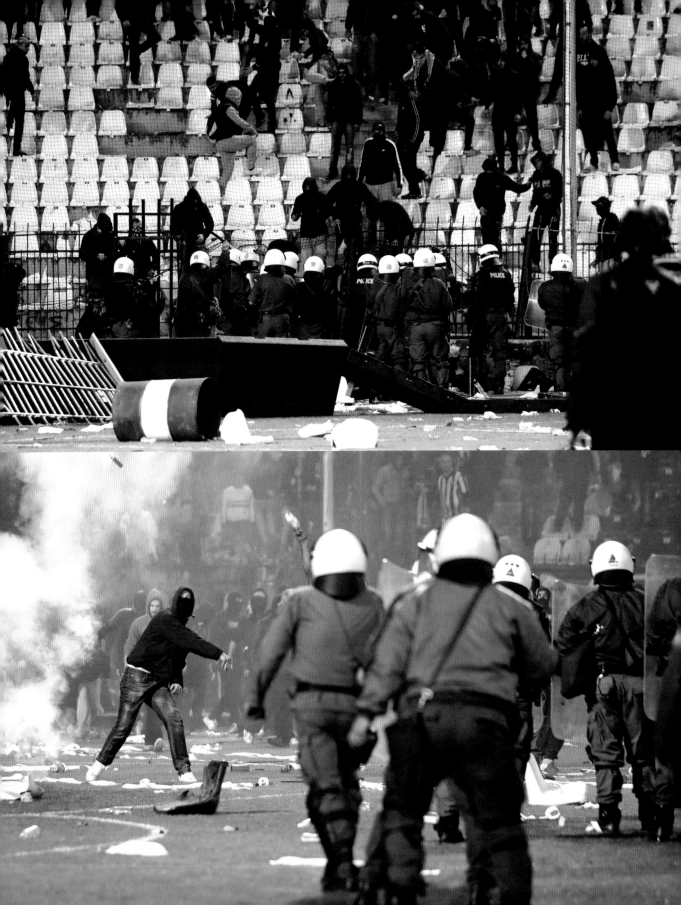

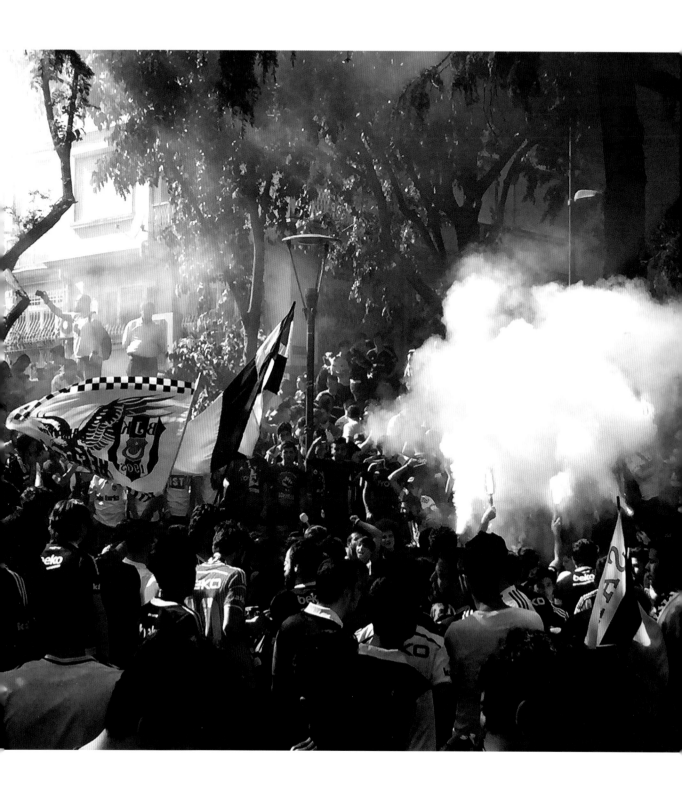

OTTOMANIA

TURKISH FOOTBALL ULTRAS

MAYBE IT'S THE HOT WEATHER, BUT ISTANBUL HAS ALWAYS PRODUCED SOME OF THE SCARIEST FOOTBALL FANS IN THE WORLD. TURKISH HOOLIGANS HAVE AN AFFINITY FOR EDGED WEAPONS. IN 2010 A REFEREE WAS STABBED SEVERAL TIMES ON THE PITCH, BUT SURVIVED. IN 2013 A YOUNG MAN WAS STABBED TO DEATH JUST FOR WEARING A FENERBAHÇE SHIRT.

Turkish football exists, like Turkey, in a state of tension between Secular and Islamic society, exacerbated by the discreet civil war with Kurdish groups in the East, not to mention involvement in the proxy imperial maneuvers of America & Russia as they tinker in the Syrian conflict next door.

Recently a match between a Kurdish and Turkish team was preceded by a big screen playing shots of attacks on Kurdish rebels and 'Ottoman war songs'. However, in spite of the occasionally mortal hatred between Istanbul's three big clubs, an incredible truce took place in 2013.

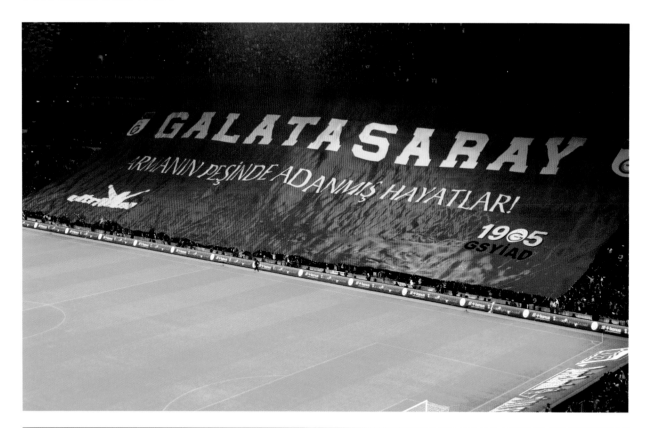

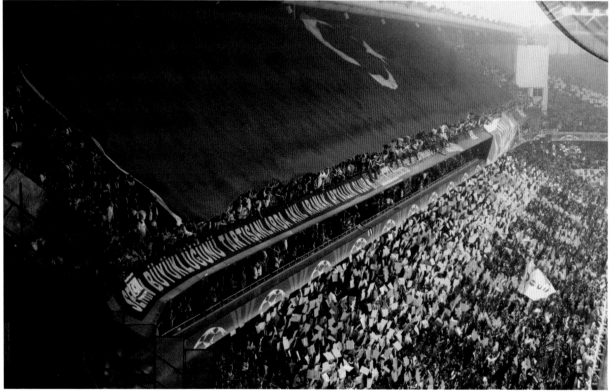

Soon after the events in Cairo's Tahrir square, The Gezi Park protests began as Turkey embarked upon her own version of the Arab Spring. What started out as a peaceful environmental protest which was violently repressed by the police, then sparked an unprecedented alliance between the Ultras of Fenerbahçe, Beşiktaş and Galatasary. Football fans moved in to defend protestors against riot police.

This alliance between Galatasary and Fenerbahçe was incredible when you consider that the murder of the young Fenerbahçe fan by Galatasary fans had taken place only weeks beforehand.

And then there is the third team in sprawling Istanbul, Beşiktaş whose main Ultras group is firmly on the left.

> The group, who frequently replace the A in their name with the Anarchy symbol, claim to be "against everything", but are in fact known for support of far-left politics and a particularly radical brand of inclusivity. Çarşı were quick to claim "We are all black!" after opposing fans hurled racist taunts at a black Beşiktaş player.

https://thesefootballtimes.co

Just like in Cairo, Ultras brought and shared their experiences of fighting the police to the other protesting groups in Taksim Square. However, the protests did not last forever and neither did the truce between the countries' Ultras. Two years later a gunman very nearly murdered the entire Fenerbahçe team.

On 4 April 2015, in Trabzon, just a few hours after the win against Rizespor, the Fener bus was shot at. Ufuk Kiran, the driver of the bus with 41 passengers on, suffered facial injuries. Drenched in blood, he somehow succeeded in keeping the bus, which was going at 100 kmph, on the road.

https://www.theguardian.com

The response to this unbelievable event was to suspend the superleague for one week. In a country where a fan can walk onto the pitch and kick a player in the head, then receive a mere one year stadium ban, football crowds are losing numbers. Who can say what will have to happen before the TFF begin to tackle the violence.

Of course, not all Ultras are gun wielding lunatics. UltrAslan, having united all the supporters groups of Galatasaray (they claim) are fast becoming a social media sensation, with 1.5 million Instagram followers, and they proudly share stories of their numerous charitable initiatives. Fenerbahçe fans are legendary for the level of support they bring to a game, with some of the loudest co-ordinated singing and utterly insane pyro displays in the business. And it's pretty clear that for the vast majority of Turkish fans - being a fan is more about celebration than it is about violence.

It's just a shame that when violence does erupt in Turkey, it is so ruthless that it colors the whole international reputation of the Turkish game.

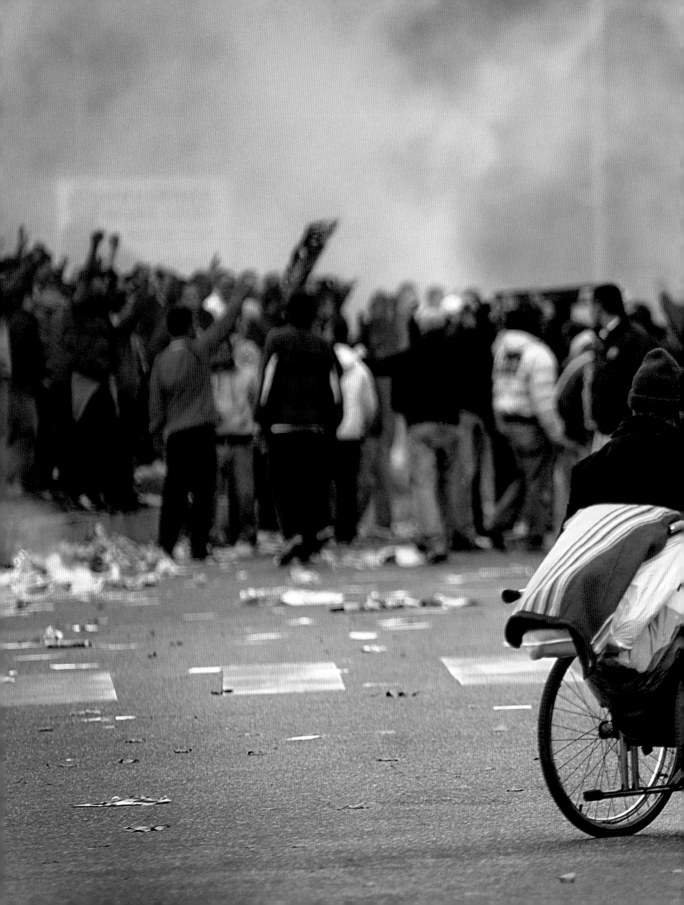

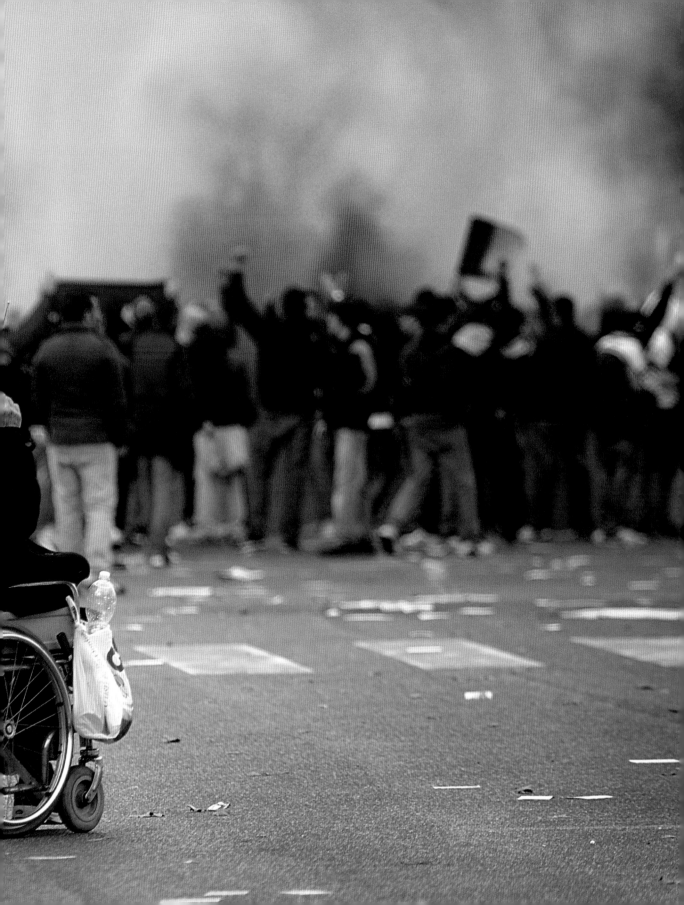

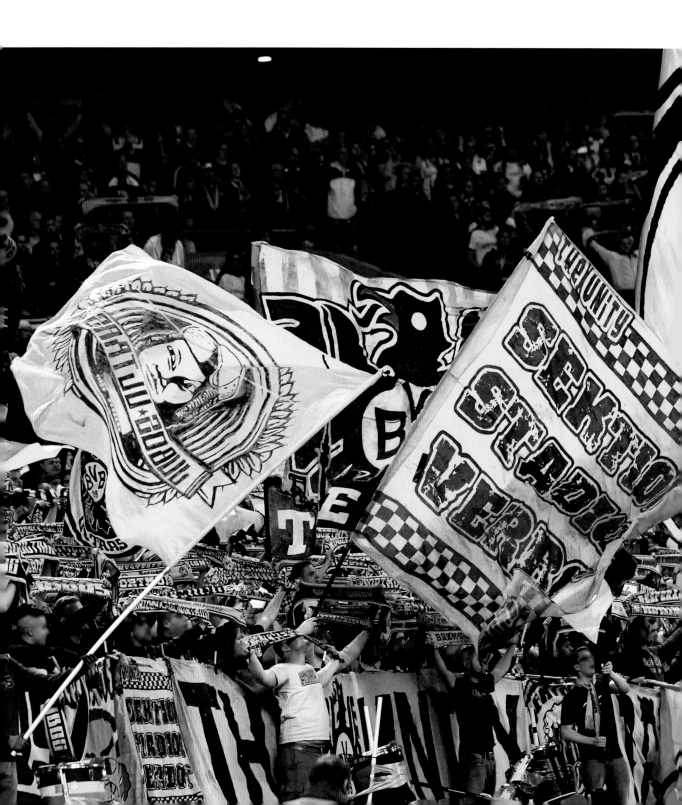

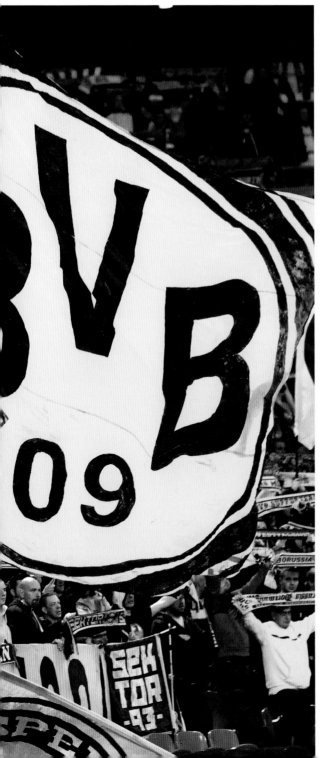

FUβBALL

ULTRAS IN GERMANY AND AUSTRIA

GERMAN AND AUSTRIAN ULTRAS ARE UNRIVALLED AT BRINGING THE NOISE. THEY ARE SOME OF THE LOUDEST CREWS IN INTERNATIONAL FOOTBALL.

The noise was relentless. 3 synchronised drummers co-ordinated seamlessly with the megaphone-conductor-general, orchestrating a deafening symphony of chants. This continued for over an hour, by which point I knew every chant in the hymnbook.

https://www.theversed.com

German Ultras survived a 2011 crackdown by reorganising and rebranding themselves. However, they soon got back into the swing of things often controlling ticket sales for their areas of the stands.

Top Ultras crews in the German leagues include supporters of FC Köln, Borussia Dortmund, FC Bayern, St. Pauli, Eintracht Frankfurt and many more. Fears over the 'unpredictable' nature of Eintracht Ultras led to a Germany vs Peru friendly to be moved

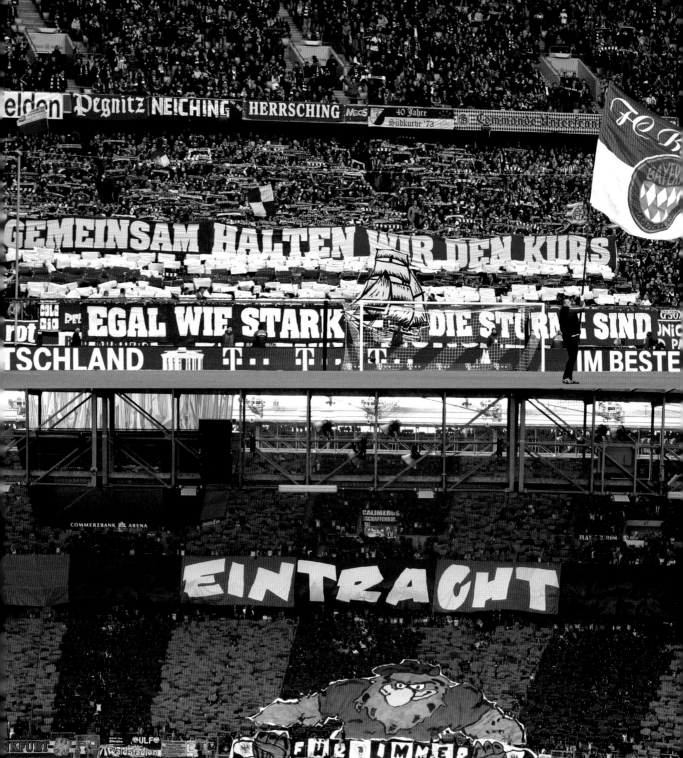

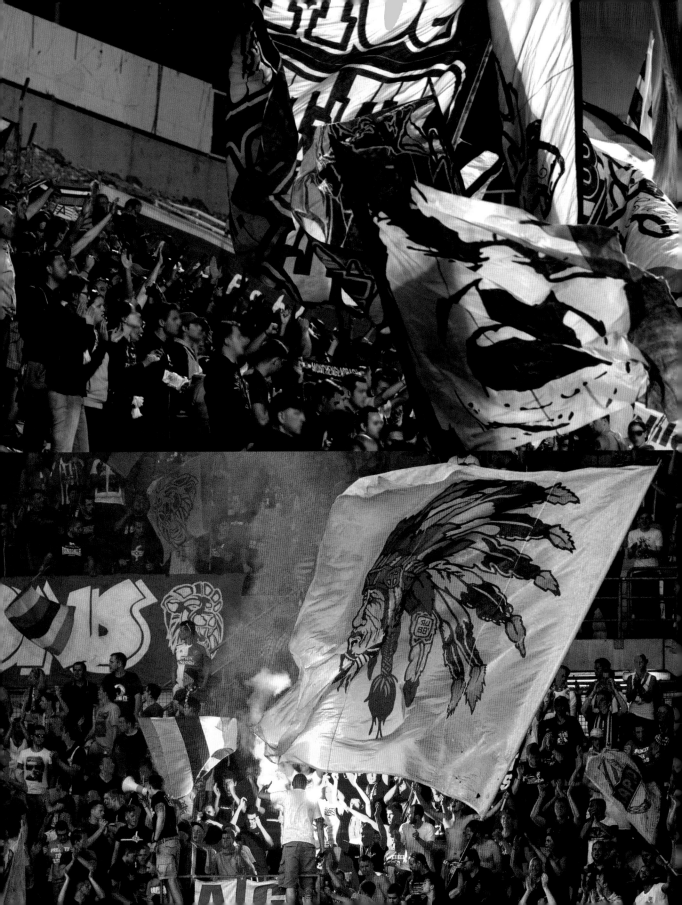

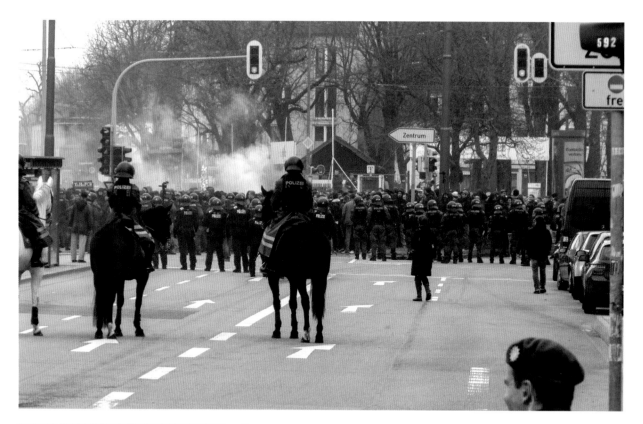

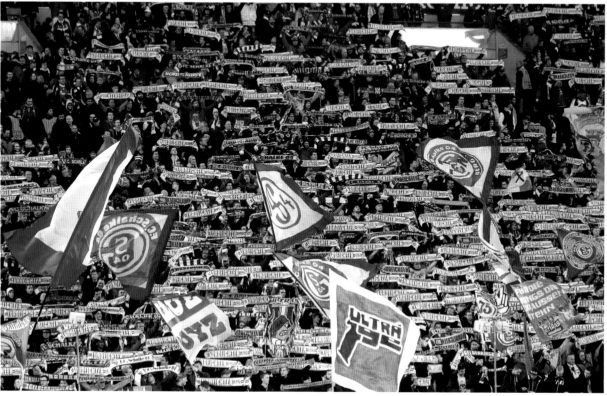

out of the city in 2018. In the Bundesliga, all clubs have Ultras and all of them are currently campaigning against the DFB for a range of reasons, triggered initially by the appearance of Monday night games.

Eintracht Ultras showered the pitch with tennis balls to protest against the first Monday night kick off in February 2018. As elsewhere, Monday night away games are seen as an attack on working people who are forced to take time off work in order to attend weeknight away games. Fan groups following Borussia Dortmund also staged strikes, not attending key fixtures leaving the stadiums half empty and unusually quiet.

The general flavour of German Ultras is more left than right. St. Pauli is one of the most famous left wing football clubs in the world. That said, the resurgence of right wing groups in Europe has not left Germany untouched. However it must be said that German Ultras are in general far less political than those in many other countries.

And they make a lot more noise than you'll ever hear in an English stadium as blogger Nick Houghton discovered at his first match supporting FC Nürnberg in 2014.

WITHIN THE CONFINES OF SECTION 7, NO ONE STOPPED SINGING. THERE WAS CONTINUOUS CHANTS, IMPLORING THE TEAM TO SCORE, SPURRING THE TEAM ON OR SIMPLY TO INSULT THE AWAY SUPPORT IN FRONT OF US. I BEGAN TO REALISE THAT THE GAME WAS ALMOST A SIDESHOW TO THE PERFORMANCE OF THE ULTRAS.

Austrian Ultras are no less passionate. The Wiener derby between SK Rapid Wien and FK Austria Wien in Vienna is as glorious a clash between enemy tribes as any in Europe. Rapid are seen as the working class club and Austria Wien represent the middle class.

Like their German counterparts, Austrian Ultras have survived stadium bans and lived to tell the tale. There is plenty of evidence to be found online and in the fanzines that their scene is in full swing this season.

NO PYRO

NO PARTY

KAПTAH

Crew of
golden
Eagle

IBERIAN BARBARIANS

ULTRAS IN SPAIN AND PORTUGAL

THE TWO NATIONS THAT SHARE THE IBERIAN PENINSULAR WERE BOTH HIT HARD BY THE FINANCIAL CRISIS OF 2007 AND AS A RESULT THEY SHARE A GENERATION OF ANGRY YOUNG MEN WHO HAVE BEEN DONE OUT OF A DECENT WORKING LIFE AND STARVED OF OPPORTUNITIES. IN SUCH TIMES, FOOTBALL IS AN IMPORTANT SOURCE OF PRIDE AND IDENTITY. IT IS NO WONDER THEN, THAT THE ULTRA FAN GROUPS OF SPAIN AND PORTUGAL ARE ALIVE AND KICKING.

Spain is one of the most divided nation's in Europe, a competing mess of regional patriotisms that is barely held together by Madrid. Spaniards are just as likely to think of themselves as Galicians, Asturians, Basques, Catalans, Valencians or Andalusians as they are to profess allegiance to the central state.

The most intense of these divisions is played out by the rivalry between Barcelona, capital city of a region that voted to leave Spain, against Real Madrid, representing the capital city, the conservative south and the nationalistic impulse. The division is rooted in a very recent history of fascist dictatorship and the looming shadow of a civil war that was one of the most horrific in European history.

Another feature of Iberian politics is a historical memory of moorish occupation - and in the present day the Spanish police two northern African territories against the desperate attempts of sub-saharan Africans to break into fortress Europe. Racism is a stubborn feature of football culture in Spain.

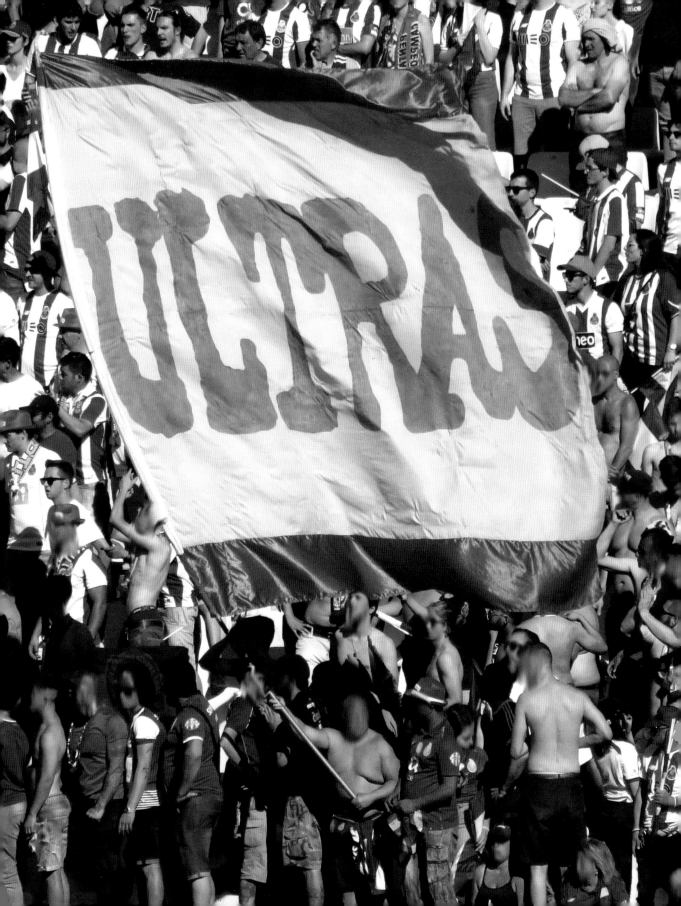

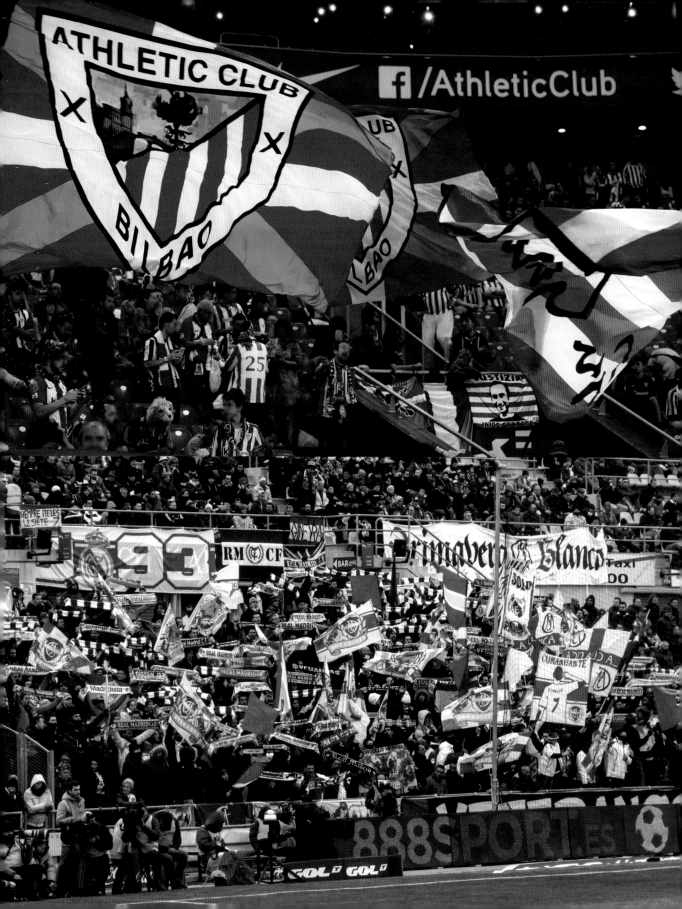

However, in 2014 the death of a fan led to a sea change in Spain's football culture. The battle prior to the match between Deportivo de La Coruña and Atlético Madrid was a highly organised affair. Right wingers *Frente Atlético* agreed to meet the antifa and Gallego nationalist *Riazor Blues* for a planned early morning brawl by the Manzanares River. When the fight ended, a forty-two year old father named 'Jimmy Romero' was dragged out of the river, already clinically dead.

Moves against Ultra groups followed. Barcelona and Real Madrid distanced themselves from the Boixos Nois and Ultra Sur. But most significantly, the Ultras themselves voluntarily registered on a list on a national register. There was a sense that it had all gone too far, and the pacification of football was partly self-regulatory.

Meanwhile in Portugal, the Ultras of clubs like Benfica are engaged in protests against repression in the stadium, like their French counterparts. The fans are defending their 'liberdade para apoiar' (freedom to support) against attempts to pacify football. And Portuguese football is anything but pacified.

As recently as 2018, fans of Club Sporting de Portugal invaded their own dressing room to beat up their own players for failing to qualify for the Champions League. The club has the oldest Ultras group in Portugal, Juventude Leonina, whose membership peaked at some 8000 in the 1990's. They have been around for thirty years and they have branches all over Europe.

Now we stand in the Curva Sul of our stadium, we bring a lot of people to away-games and we have around 40 nucleos (departments like JL Holanda).

http://www.ultras-tifo.net

It is a small nation, where most people support one of the big three clubs, Sporting, Porto and Benfica, each of which has a few fan organisations each.

Now the White Angels of Guimarães might sound a bit white supremacy, but apparently they are not...

Our policy is against gratuitous violence, we just want from each game a party, chanting our chants and doing our choreography.

http://www.whiteangels99.org

"O movimento ultra português não está morto!"

The Portuguese Ultra Movement is not dead!

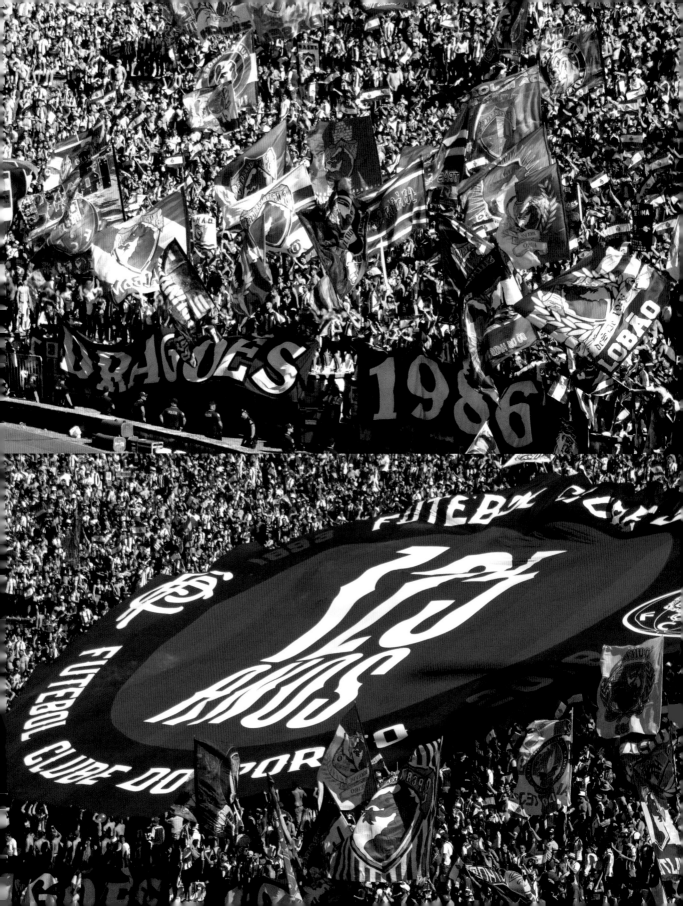

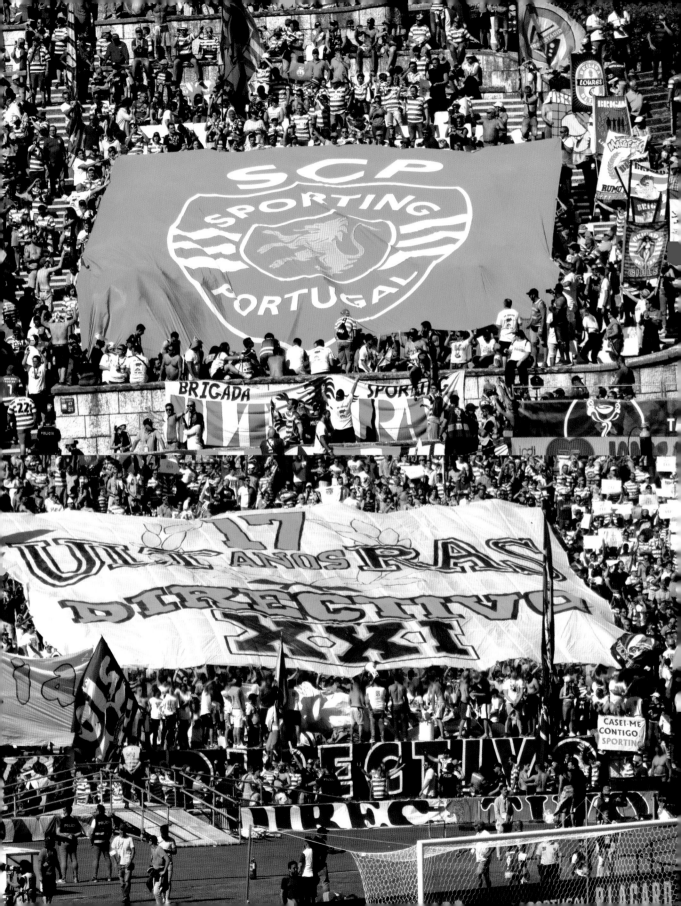

ALLEZ PUTAIN!

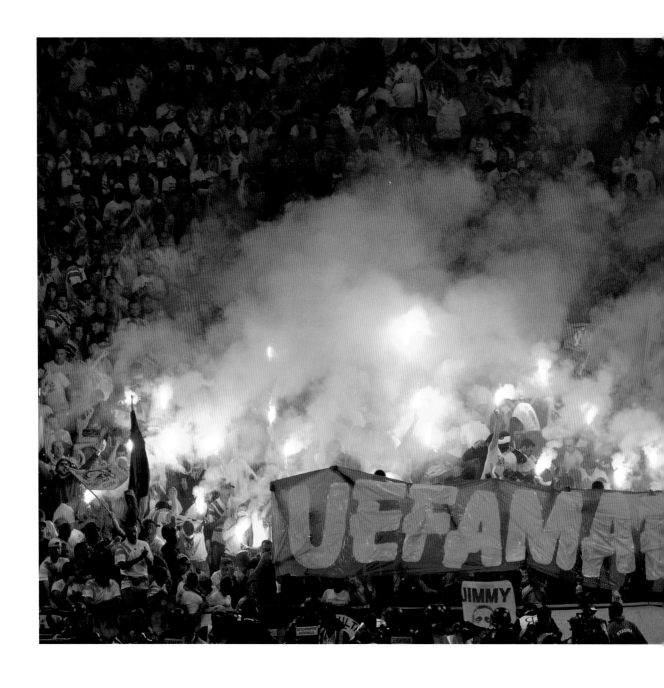

LIBERTY POUR LES ULTRAS

ULTRAS OFTEN MIRROR THE UNDERLYING DIVISIONS IN WIDER SOCIETY. IN FRANCE THE NORTH VERSUS SOUTH DIVIDE IS SYMBOLISED BY TWO GIGANTIC SUPERCLUBS - PARIS SAINT GERMAIN AND OLYMPIQUE DE MARSEILLE. BOTH TEAMS ARE SUPPORTED BY HIGHLY ACTIVE ULTRA FAN GROUPS. THE PSG VERSUS OM DERBY IS THE MOST FAMOUS IN FRANCE AND IT FEATURES VERY HEAVY POLICING, ESPECIALLY AFTER CLASHES IN THE YEAR 2000, THE PEAK OF INTER-CLUB VIOLENCE.

The Ultras of PSG brought an immense fine on the club after invading the Turkish end during a match against Galatasaray in Parc des Princes 2001. Again in 2006 the PSG Ultras were criticised for bigotry after a match with the Israeli Hapoel Tel Aviv. During an incident outside the stadium a PSG ULTRA of the Boulogne Boys was shot dead by French police while chasing a Hapoel fan.

More recently, in 2017 fans of SC Bastia invaded the pitch and attacked players of Olympique Lyonnais, causing a match to be abandoned.

The extensive use of stadium bans has had an impact in fan culture in France. Currently, Ultras groups across the country are engaged in coordinated protests against bans and fines and what they perceive as excessive repression by the LFP.

"Supporters ≠ criminals. Too much repression."

- banner, France (2018)

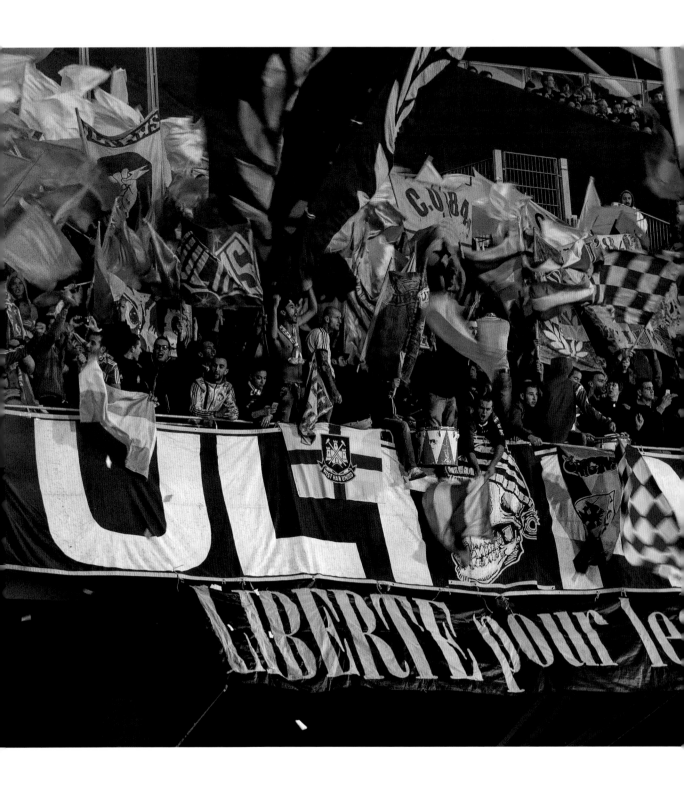

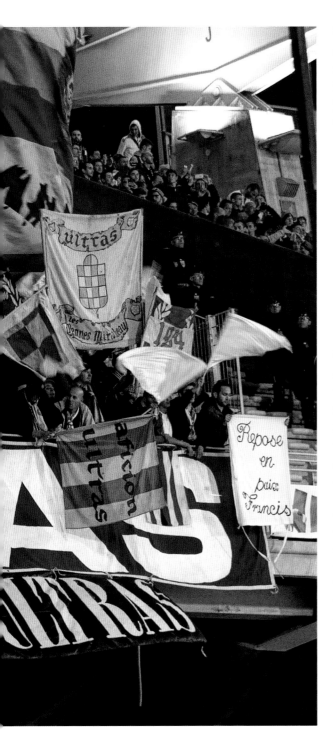

Some Ultras are using silence as a weapon, with co-ordinated silences designed to demonstrate how much the stadium atmosphere would lose without their presence. This is understandable when you look at how easy it now is to receive a stadium ban from clubs like PSG.

On 5 May 2014, Yoann Seddik attended the PSG-Monaco match at the Parc des Princes as part of his season ticket at the club. As the match entered a lull, he started singing, "Season tickets too pricey, supporters angry." Within three minutes he had been bustled from his seat by muscular stewards. The outcome? Seddik was presented with a banning order from the stadium.

https://thesefootballtimes.co

In 2015 PSG were discovered to have been collecting dossiers on their own supporters. Although it was illegal at the time the French state declared the process legal in 2016, effectively sanctioning the systematic breach of privacy conducted by football clubs. Thousands of French fans are barred from buying PSG tickets, and the club has been accused of 'social engineering' for targeting mainly working class supporters with bans.

Although supporters groups are fighting the sweeping powers that both clubs and local authorities now have to ban supporters, little has changed under Macron. It seems that in France the fight for the soul of modern football is almost lost. If there is a glimmer of hope for the traditional fan, it is the flowering of Ultras style supporters groups in the lower divisions, where the security is almost non-existent and the party still goes on.

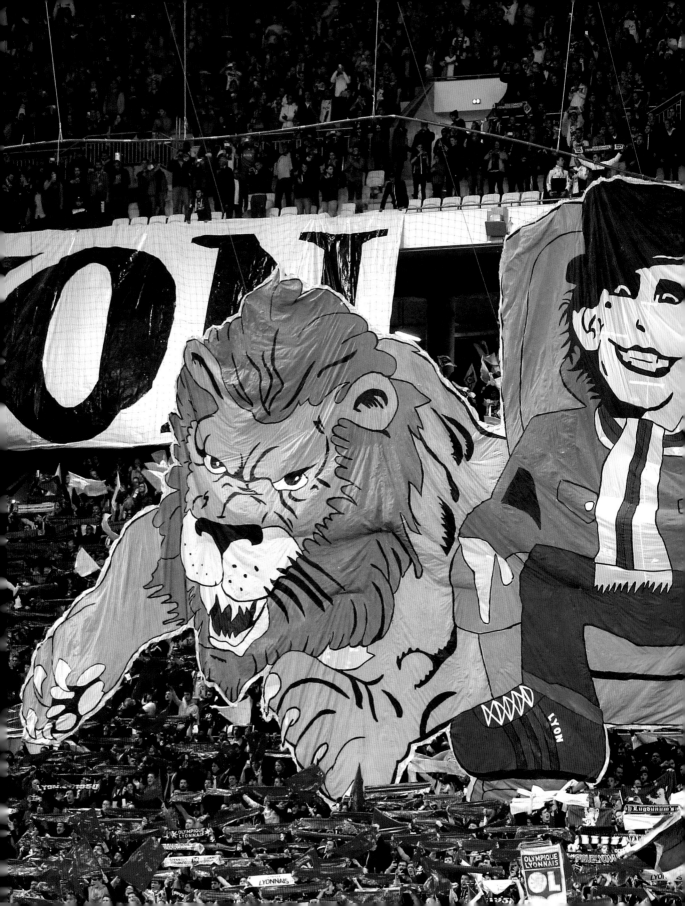

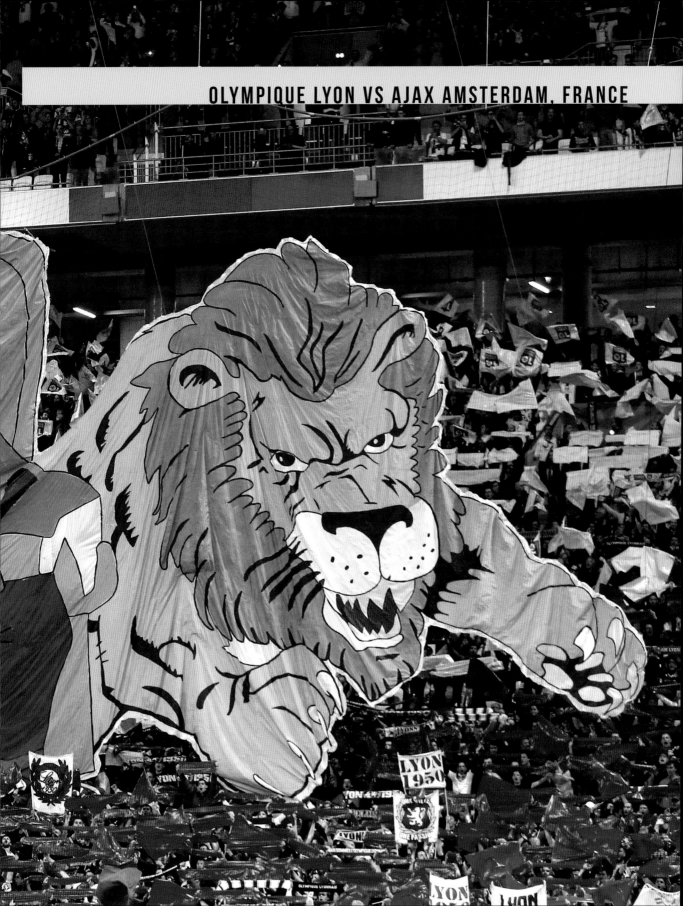

BALKANISED

SERBIA

THE CITY OF BELGRADE HAS TWO STADIUMS LESS THAN HALF A MILE APART. PARTIZAN BELGRADE AND RED STAR BELGRADE WERE BOTH FORMED UNDER COMMUNIST RULE AND HAVE HAD A FIERCE RIVALRY EVER SINCE.

Back when Croatia and Serbia were part of Yugoslavia, the two teams faced Hadjuk Split and Dinamo Zagreb with similarly intense rivalry. After the collapse of Yugoslavia, tensions between Croats, Serbs and Albanians exploded into one of the most brutal civil wars in European history.

A match between Croatian Dynamo Zagreb and Serbian Red Star Belgrade at Maksimir Stadium in 1990 turned into a riot between Dynamo's Bad Blue Boys and the Delije of Red Star. Although it did not cause the war, it was part of a chain of events that led up to it and people at the time coined the phrase 'The war started at Maksimir'. Similar to later events in the Ukraine, football Ultras went into the militia groups that would fight the war.

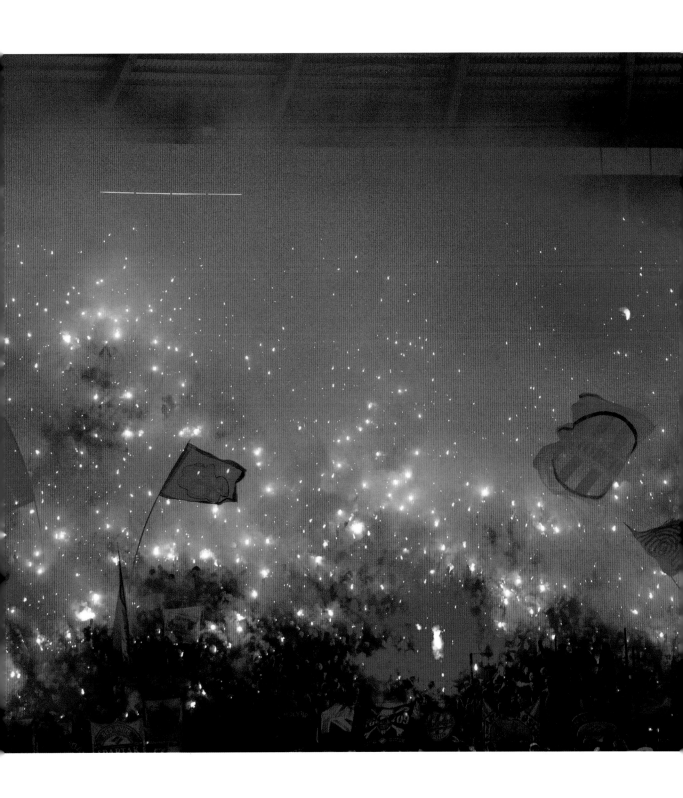

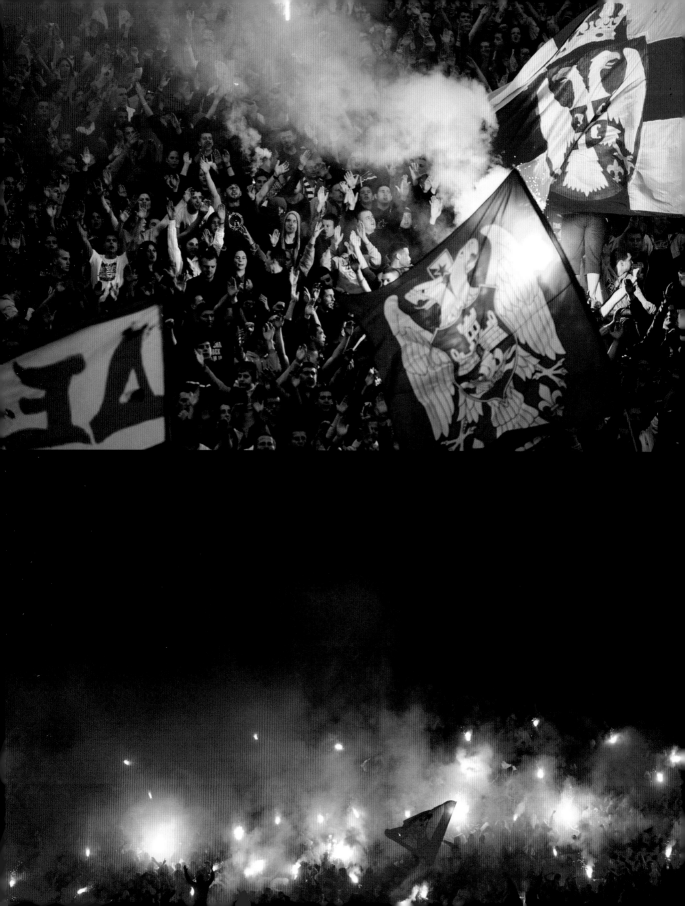

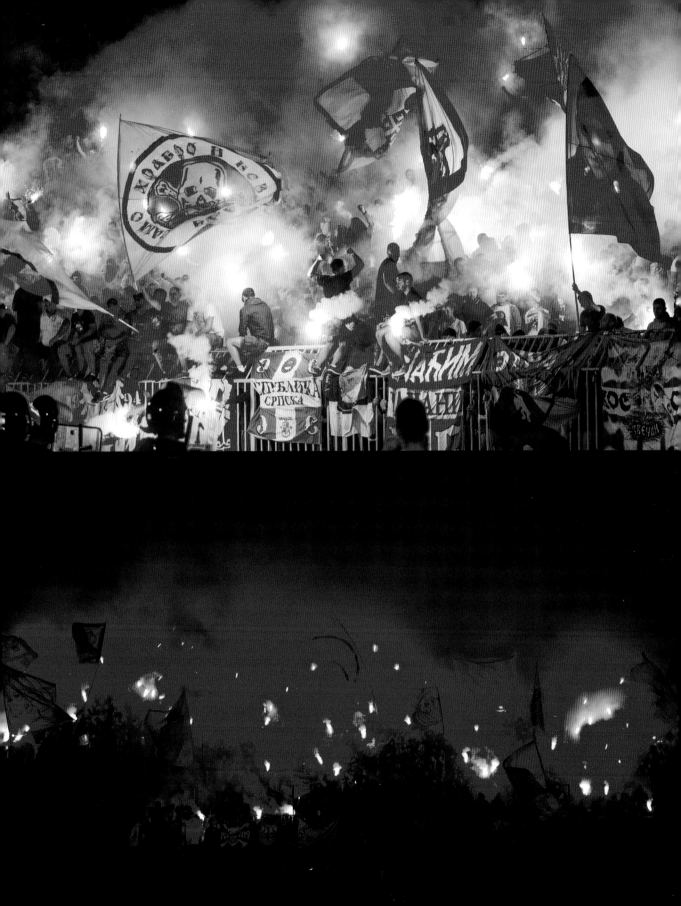

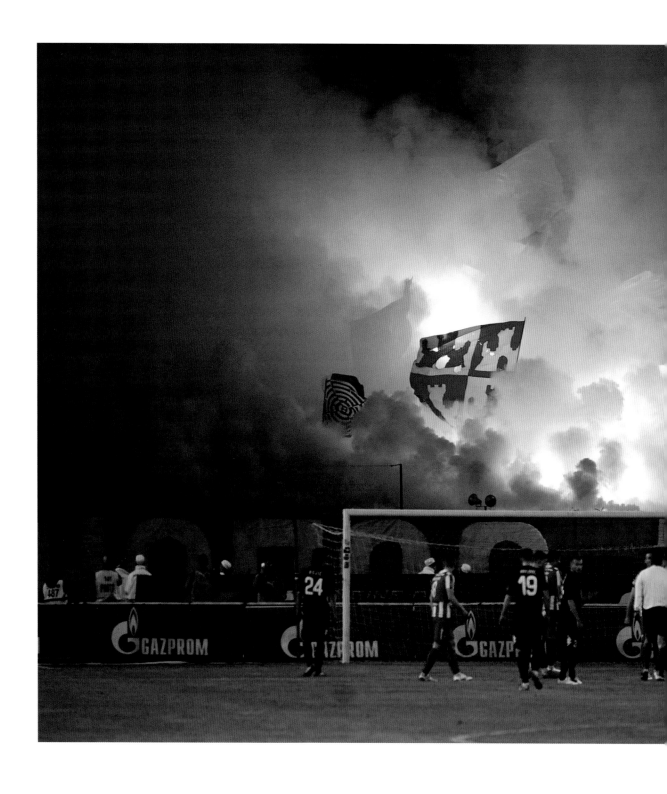

Nowadays young Serbian men look to organisations like the Undertakers (Grobari) of Partizan or the Heroes (Delije) of Red Star for their fix of honour and glory. Two Grobari were asked in a VICE TV interview (2016) if they would die for their club, and they answered yes without hesitation. This is not a hypothetical question in Serbia. Ten Ultras were murdered in Serbia that same year and twelve the year after. The lines between fan groups, far right politics and organised crime are increasingly blurred.

Serbian Ultras Obraz, also of Red Star, attacked a Gay Pride march in 2010 allowing the government to ban future LGBTQ marches in Belgrade.

Some of the worst fighting in the Balkans was between the Kosovo Albanians and Serbia and so it was that there was enormous tension when Serbia and Albania drew against each other in the Euro 2016 qualifiers. In the event something truly bizarre occurred - an Albanian fan, in protest at Red Star's top hooligan Ivan Bogdanov burning an Albanian flag at a previous fixture, flew in the flag of 'Greater Albania' attached by wires to a drone quadcopter.

The flag ended up in the hands of one of the Serbian players, who barely had time to react before the stadium erupted. The Albanian players tried to snatch the flag and the Serbs invaded the pitch, attacking the Albanian players. Later, Serbia forfeited the match and the tournament. Instrumental in the pitch invasion, Bogdanov or 'Ivan the Terrible' should never have been at the match in the first place. Having done several years for hooligan related offences in Italian prisons as well as Serbian, many were outraged that he had even been let in. But in Serbia it seems it is rare to hand out stadium bans.

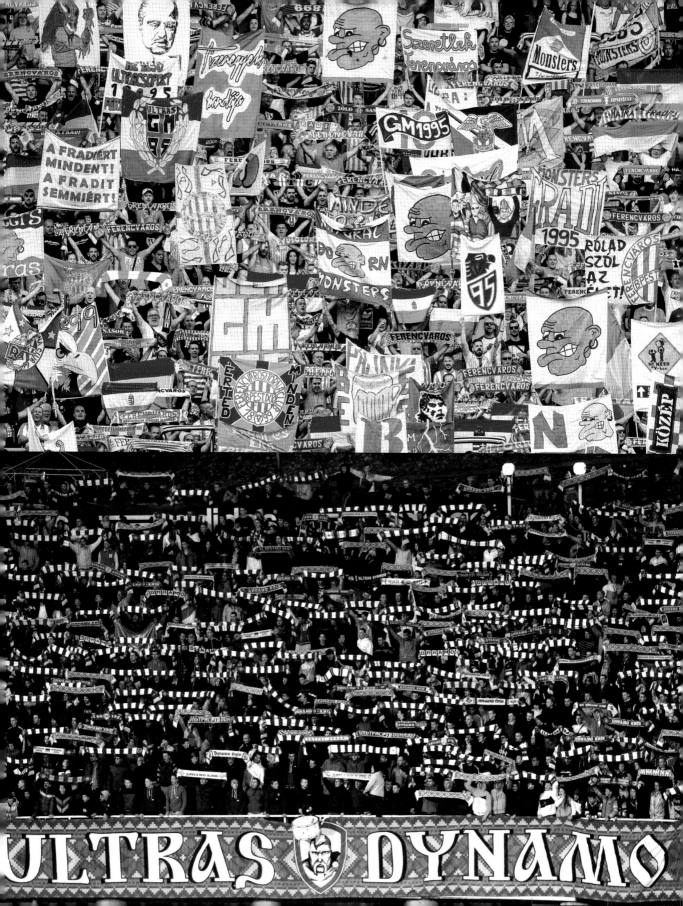

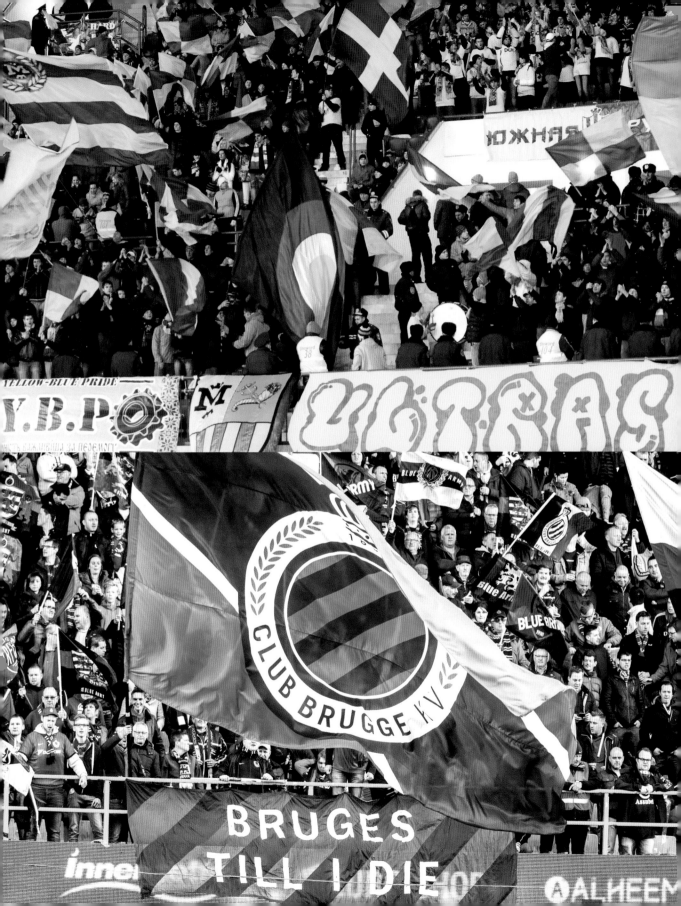

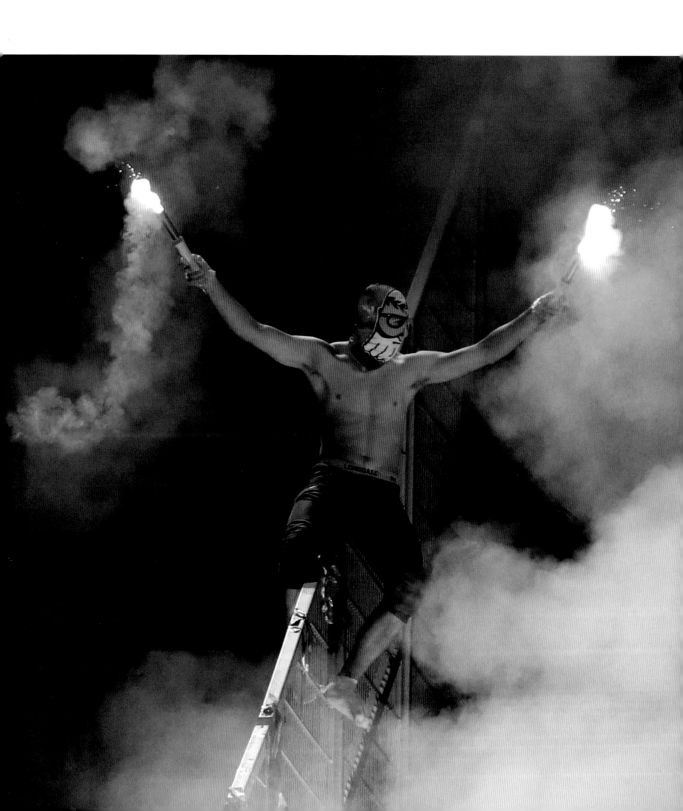

AZOV BATTALION

ULTRAS IN THE UKRAINE

UKRAINE IS MASSIVE. IT IS THE LARGEST COUNTRY IN EUROPE, SANDWICHED BETWEEN RUSSIA IN THE EAST AND POLAND, SLOVAKIA AND HUNGARY IN THE WEST, BELARUS TO THE NORTH AND ROMANIA AND MOLDAVIA TO THE SOUTH. IN SHORT, IT IS IN THAT PART OF EUROPE THAT WE IN THE WEST KNOW ALMOST NOTHING ABOUT. THAT MADE IT ALL THE MORE SURPRISING TO US WHEN IT ERUPTED INTO A POPULAR REVOLUTION IN 2014.

The mass protests and violence in Maidan Square, Kiev which toppled the president in 2014 were, in broad brush strokes, a pro-European and Ukrainian patriotic movement. The government, in hock to the Russian Federation, reneged on a promise to enter into a closer relationship with the EU, triggering the movement to depose Yatsenyuk and elect Poroshenko who then ushered in the new deal with the EU.

As in Cairo's revolution, football fans were at the front line in Maidan Square, defending the protestors against hired government thugs.

"Back in 2014 the fans of Dynamo Kyiv, Skakhtar Donetsk, Dnipro and Metalist Kharkiv football clubs united efforts against the aggressor leaving behind all football-related disputes."

http://uacrisis.org/56896-ultras-war

But in spite of the popular patriotic movement, Ukraine was revealed to be very divided between those whose loyalty is to Russia those who'd prefer a more independent and European aligned nation. Counter protests in the Crimea led to Russian military intervention - Russia annexed the Crimea. The world was, and still is really, in shock. Such things were supposed to remain in 20th Century school history books. The spectre of continental war involving major powers sent a shiver down Europe's spine.

In Ukraine the Ultras went directly into divisions of the National Guard after Maidan to defend against Russian interference in the East of the country. The Donbass war was fought by proxies, militias and football fans. Some Russian Ultras came to the area as 'volunteers'. The war has remained in a stalemate ever since, never really quite ending, never really escalating.

The Azov Battalion were formed as a Ukrainian militia April 2014 by the Minister of Internal Affairs, but the organisation that formed the original core of the Battalion was a group of Ultras, supporters of FC Metalist Kharkiv who called themselves SECT 82. These were football fans who became an army, and even went on to take towns from Russian backed paramilitaries. They were incorporated into the national guard and given training from the USA.

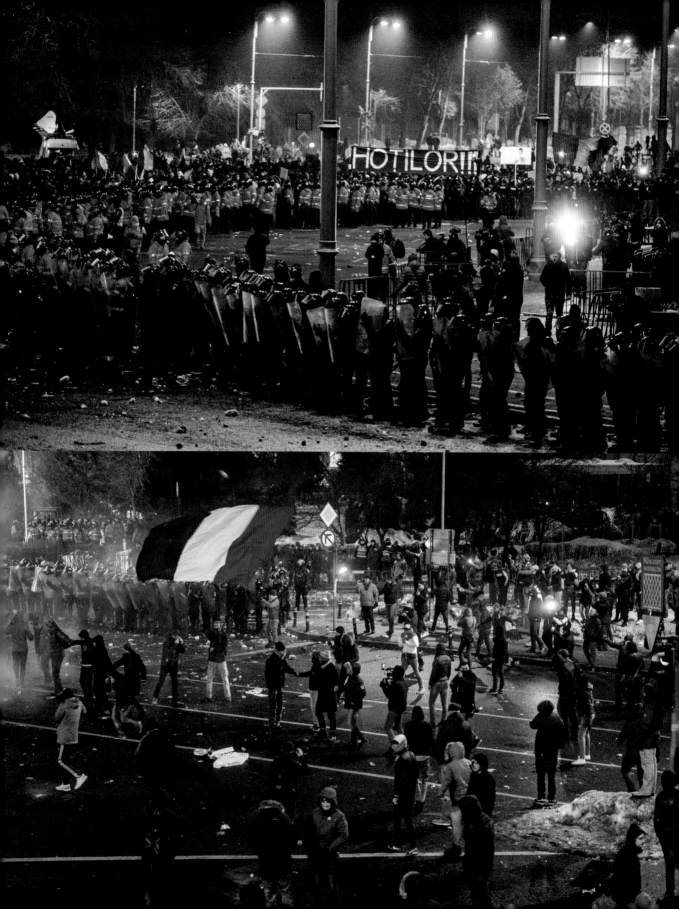

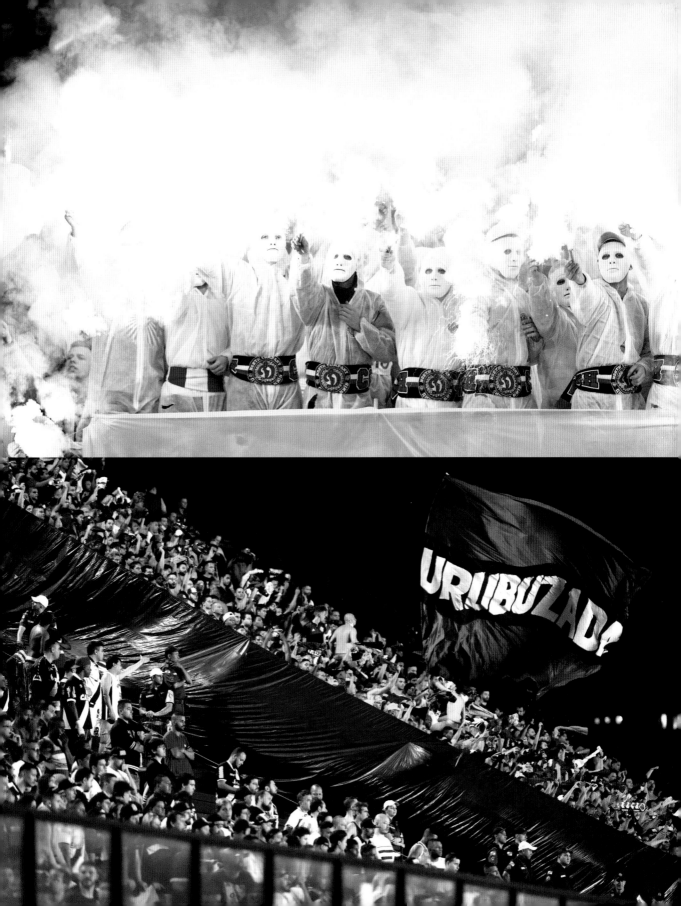

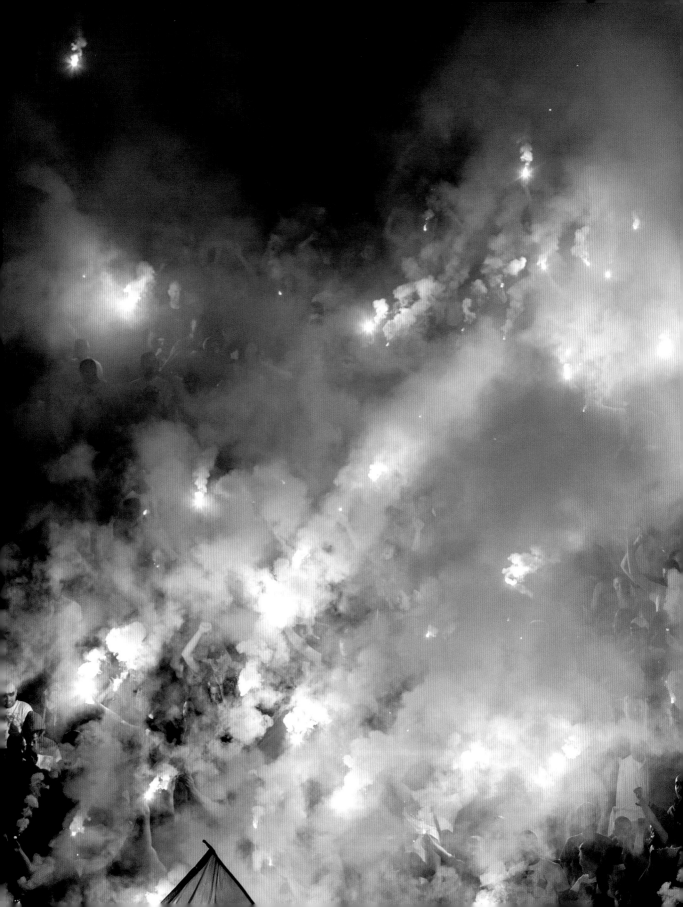

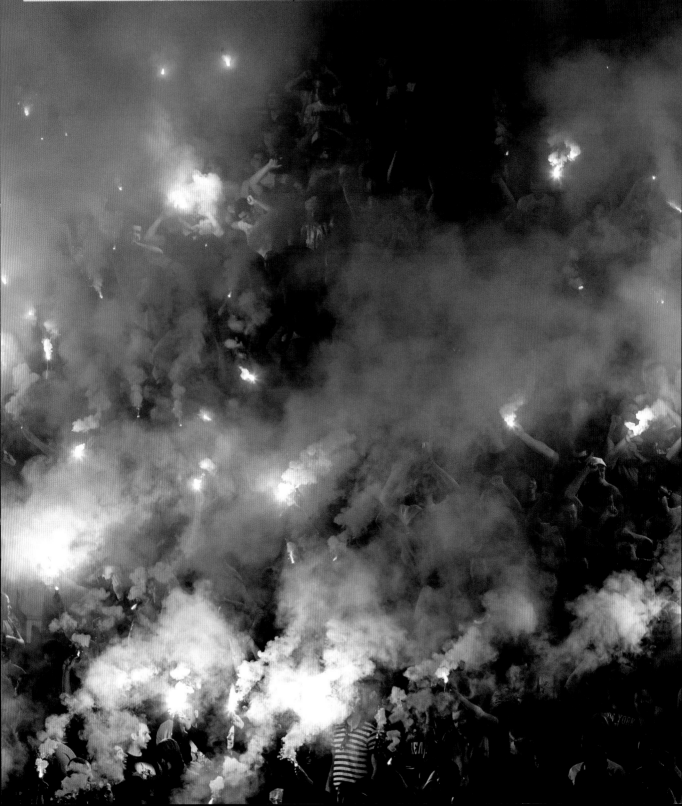

WOMEN ON THE TERRACES

FEMALE ULTRAS, YES REALLY

Sports Journalist Craig Houston had to go as far as China, as deep as China League 1 (Just below the Chinese equivalent of the Premier League) to a Greentown match to witness something unheard of in the rest of the footballing universe. Women. Honest to goodness female Ultras. Hundreds of them. Well, maybe a hundred.

> *"These women made up nearly half of the people in my line of sight. Further, the group's leader, always armed with a megaphone and repertoire of songs that would rival a Las Vegas crooner, was also a woman."*

GB Times (2018)

It's good to know that in China the gender balance in among Ultras is fifty fifty, but where are the ultra hard women hooligan's we were promised by the Sun newspaper prior to Russia 2018? The army of female Russians failed to materialise. But there certainly are young women associated to Ultras groups supporting CSKA, Spartak and Dinamo Moscow. And MMA is just as popular for young women as men in the nation that invented Kettlebells and ice baths.

Those conservative Catholics in Lazio's right wing Ultra groups don't like to see women at the football at all. Some members of the Irriducibili distributed a flyer claiming the Curva Nord as a sacred space that should not be contaminated by wives and girlfriends. Among the women who spoke out against this action was Caroline Morace, coach of the AC Milan women's team who called for these men to be banned.

> *"Sexism is also violence."*

Caroline Morace

So yes, there are women Ultras supporting men's football, and flipping the coin again - there are male Ultras supporting women's football and none more so than the Ultras of Paris Saint Germain. PSG fans were kicked out of a PSG v Chelsea fixture for being a little bit too Ultra, something unseen so far in women's football in the UK. Clubs like Lewes in the UK are trying to create more equality between their mens and womens first teams - why not support both?

ULTRA FANS, HOLY LANDS

ULTRAS IN ISRAEL

Football is big in Israel and it has been for a hundred years. Two big sporting organisations founded many of the nation's football clubs, Maccabi and Hapoel. There are five Hapoel teams and four Maccabi in the Israeli premier league.

The Maccabi World Union, (named after the medieval Jewish rebels who took control of Judea from the Seleucid Empire), is a massive, worldwide organisation promoting sports and pride in Jewish heritage. The Hapoel (workers) Sports Association represents the Israeli left wing and is linked with Histadrut, the party of the trade unions in Israel. Beitar Jerusalem was founded by Israeli right wingers in the 1930's and is now closely associated with the anti-arab Likud party.

Israeli teams play in UEFA tournaments because they were pressured out of the the Asian Football Confederation in 1974 as a result of the Arab-Israeli conflict. The IFA joined UEFA in 1994.

Most Israeli teams have at least one Ultras group in their support. And in a country where politics is inescapable, football is as tangled up in politics as everything else. Israeli Ultras can represent a wide array of positions, left and right, multicultural and anti-arab, or even define themselves as *100% against politics* like the Ultras of Maccabi Haifa.

(Provoking the response *'100% Against Maccabi'* seen on a Hapoel banner).

The nature of sporting organisations in Israel means that fans often follow their clubs across football and basketball leagues. There are videos to be found of impressive displays of Ultra style support at both men's and women's basketball games as well as football.

At the opposite end of the political spectrum, Hapoel (meaning 'worker') hold up anti-racist banners at their matches bearing slogans such as 'Who here isn't a refugee?'. They are part of the ANTIFA movement, with links to various left wing associated football clubs across the world. The Ultras Hapoel group supports co-existence with muslims and is involved in diverse charitable work, like assisting refugees coming into Israel.

> *"All other supporter groups of other teams call us "Hizballah", "Israel haters" and "Arabs" and this can explain to you how they all see us, and what we stand for and what is our point of view."*
>
> -Ultras Hapoel, rebelultras.com

ULTRAS ASIA

ULTRAS IN JAPAN AND THE FAR EAST

JAPANESE FANS BLEW MINDS AT THE 2018 WORLD CUP BY TIDYING UP THE STADIUMS ON THEIR WAY OUT AFTER THE MATCH. THIS INCONCEIVABLE DEMONSTRATION OF CIVIC RESPONSIBILITY WAS PROBABLY MORE SHOCKING TO THE EUROPEAN FAN THAN THE ANGLO-RUSSIAN VIOLENCE AT EURO '16. HOWEVER, THE JAPANESE GAME HAS BEEN ON THE RISE IN RECENT YEARS AND THE ESTABLISHED J LEAGUE IS BEGINNING TO SEE THE DEVELOPMENT OF A JAPANESE ULTRAS CULTURE.

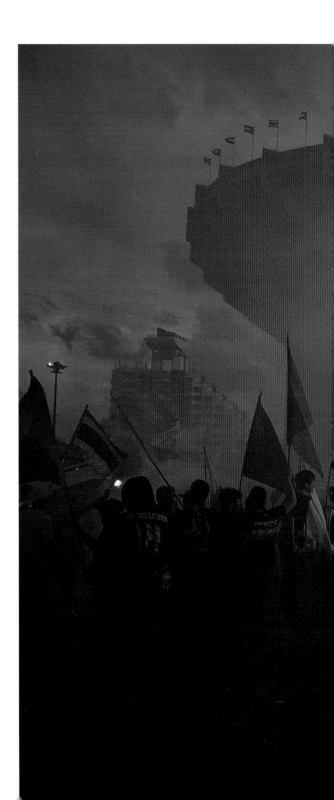

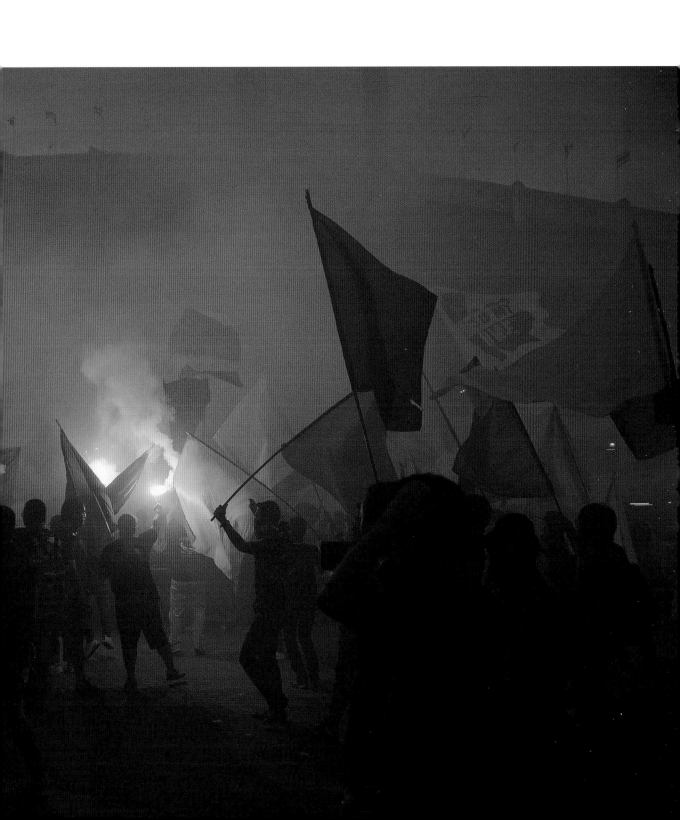

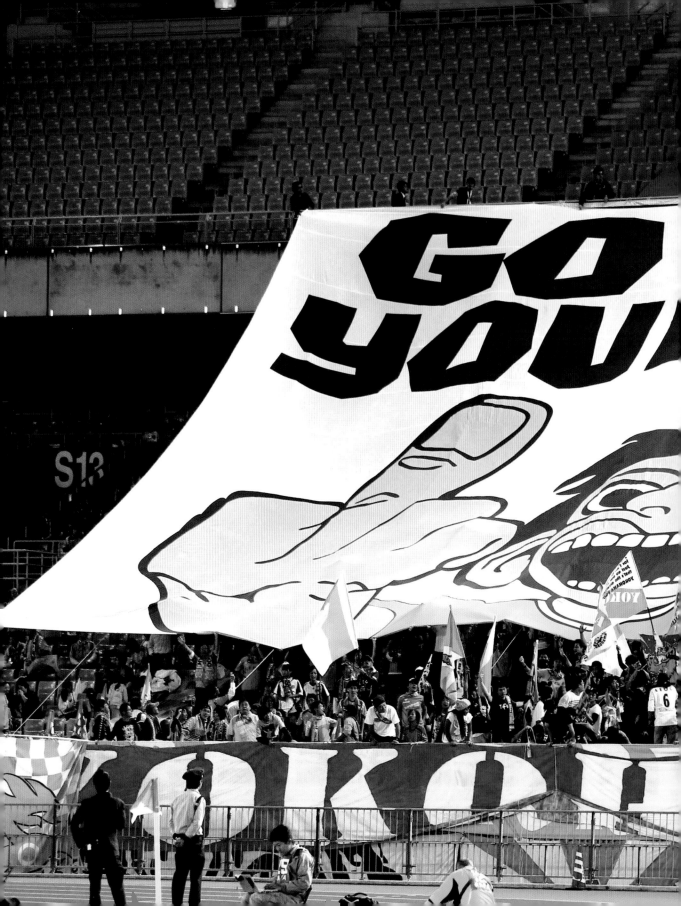

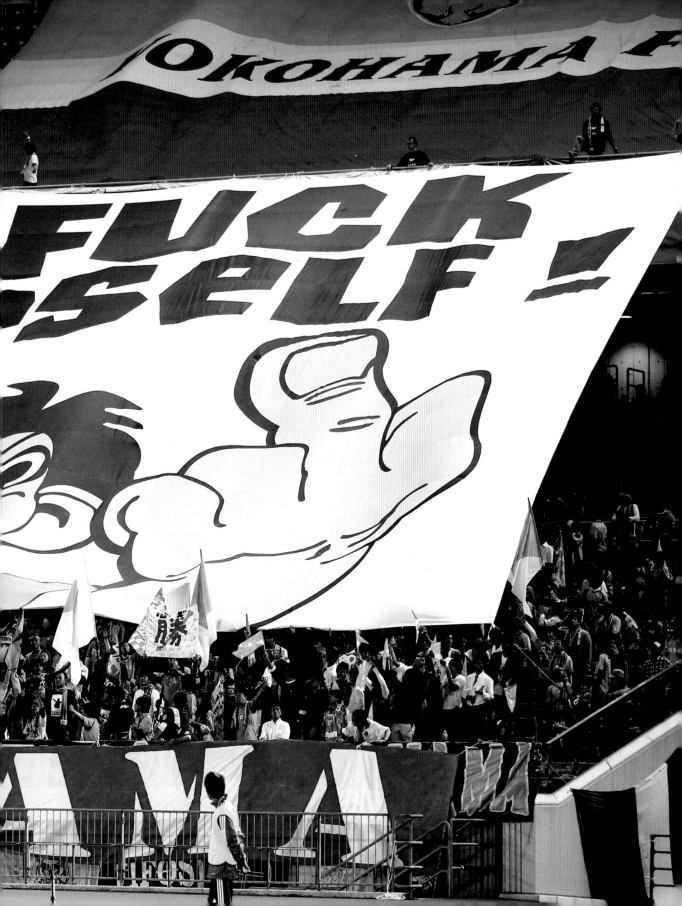

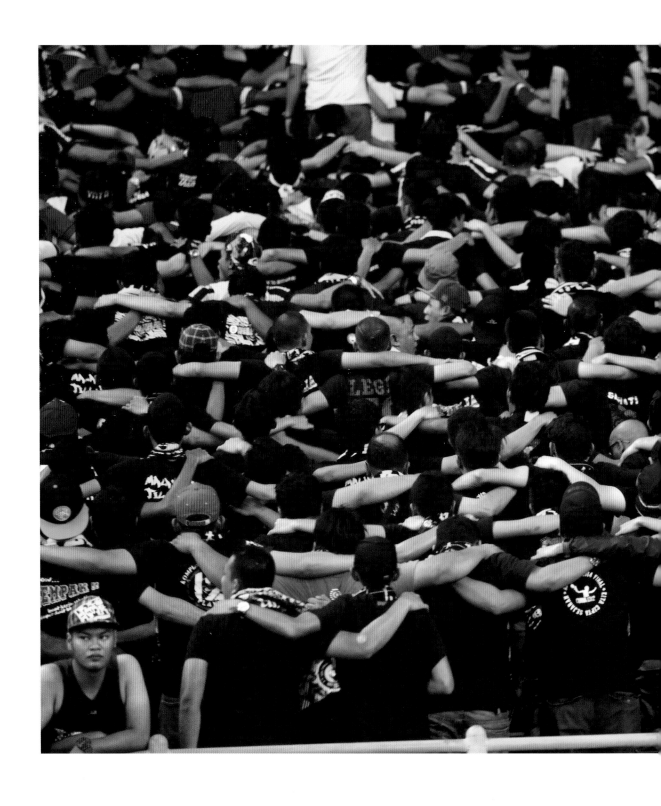

Teams like the Urawa Red Diamonds command fanatical support in Japan and have done since the millennium. In 2007, 1500 Urawa fans went out of their way to attend an inconveniently scheduled match in China against Shanghai Shenhua. The Chinese team had a group of Ultras called the Blue Devils, but they were so impressed by the passion of Urawa's support that they formed a lasting friendship with the Urawa Reds. The Blues took lessons in stadium support and the reds took lesson in raucous post match behaviour. It was a unique cultural exchange in a China where anti-Japanese sentiment is mainstream.

The Urawa Reds are not the only Ultras in Japan.

> *"Every Ultras organization in Japan has its own specialty. Like Gamba Osaka, Nagoya Grampus Eight learn chants from Italy while Yokohama F.Marinos, Avispa Fukuoka pick up their style from South America."*

http://www.ultras-tifo.net

Indeed, you'll find Ultras across Asia and Australasia following teams in China, Indonesia, Kuala Lumpur, Australia and New Zealand. And, surprisingly, both Indonesia and Malaysia have massive local Skinhead subcultures linked to their footbal. South Korea is sometimes called the Italy of Asia, and while Baseball is the de facto national sport, Korean Ultras bring the noise...

> *"...the K League Ultras have more concentrated energy in their small group. They understand that they are in a small number, so this leaves little room for passive spectators. These fans are screaming louder and jumping around much more than anything you'll catch at a baseball game."*

Brannon Valade, Football in Seoul, South Korea, Medium (2018)

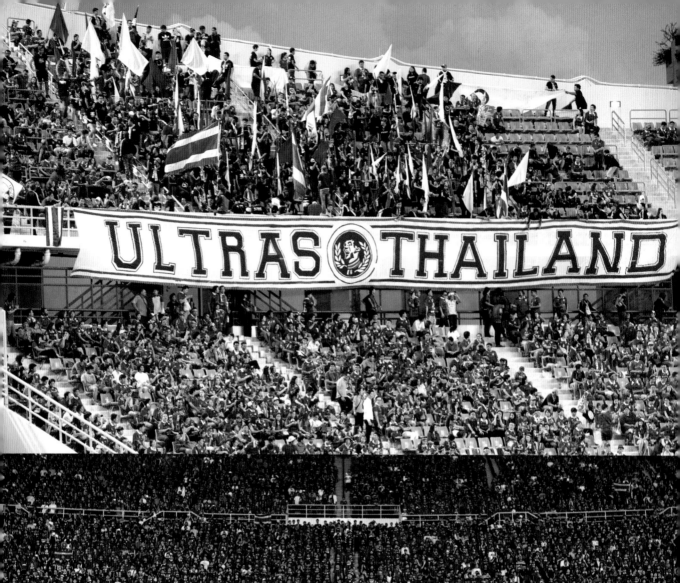

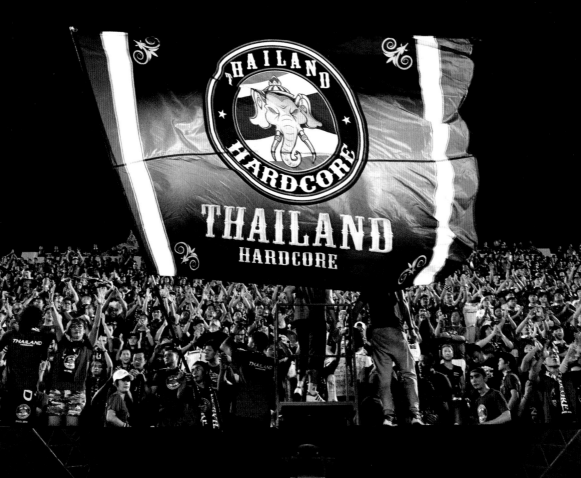

29th SEA GAMES KUALA LUMPUR 2017
MEN'S FOOTBALL

SINGAPURA		MALAYSIA
0	First-Half 00:00	0

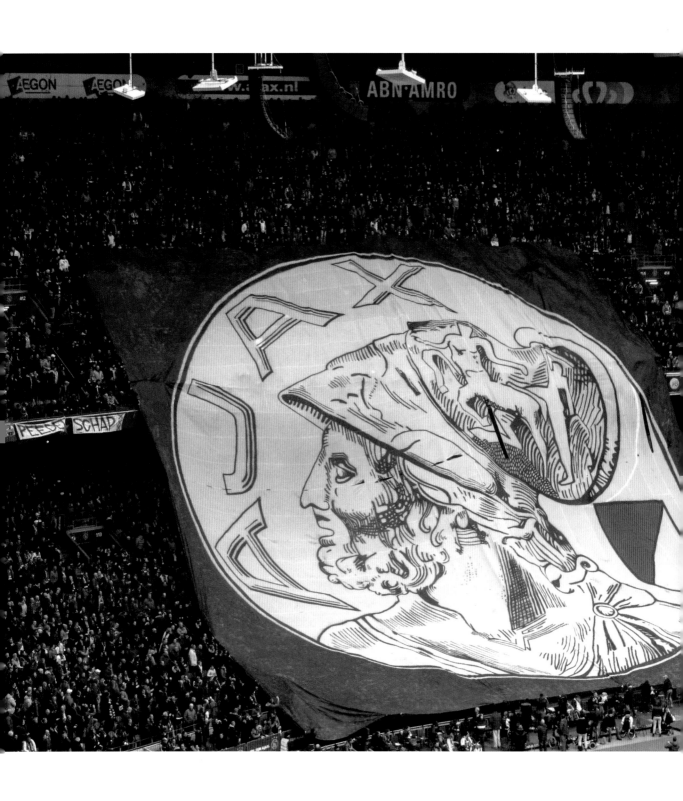

HUP HOLLAND HUP

DUTCH AGGRO

According to legend, the hooligans of Tottenham exported their naughty behaviour to the Netherlands by ripping up seats at Feyenoord stadium during a 1974 UEFA cup final. It didn't take the Dutch long to catch up. At the top end of Holland's Ultra scene Ajax and Feyenoord sport a deep and storied rivalry which peaked in the late 1990's with the "Battle of Beverwijk", in which one fan was killed. Things are less dangerous now than they were but Feyenoord fans attacked Italian police in Rome as recently as 2015.

FC Den Bosch, FC Dordrecht, PSV Eindhoven, Go Ahead Eagles, FC Utrecht and PEC Zwolle to name but a few, all have very active groups of Ultras fielding TIFO displays equal to what you can see in Serie A.

Dutch firms call themselves 'sides'. While in the 1970's sides grew increasingly well armed, especially a few hardocre groups following FC Utrecht, Ajax, Feyenoord and Midden Noord, in the 1980's, due to increased separation from opposition fans in the stadium, they switched tactics to harassing opposition goalkeepers with missiles. Some dutch hoolies have a history of antipathy toward German teams, rooted in history.

MAJOR LEAGUE ULTRAS

ULTRAS IN THE USA AND CANADA

IT MAY COME AS A SURPRISE THAT FIRST DIVISION FOOTBALL IN AMERICA NOW BOASTS BETTER ATTENDANCE THAN FRANCE'S LIGUE 1. FOOTBALL (OR SOCCER) CAME INTO NORTH AMERICAN CULTURE THROUGH THE IVY LEAGUE SCHOOL SYSTEM, AND HAS LONG BEEN CONSIDERED A MIDDLE CLASS SPORT. BEING THE US, THE MAJOR LEAGUE, STARTED IN 1996 IS ABOUT AS CORPORATE AS A SPORTS LEAGUE CAN BE, WITH TEAMS EVEN FEATURING BRANDS IN THEIR NAMES. THE NEW YORK RED BULLS BEING ONE SUCH EXAMPLE.

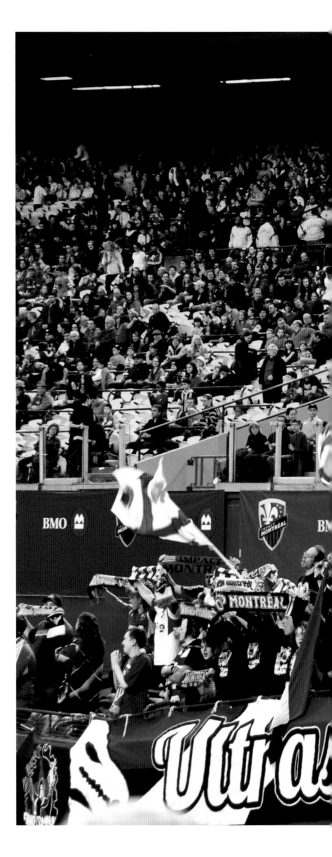

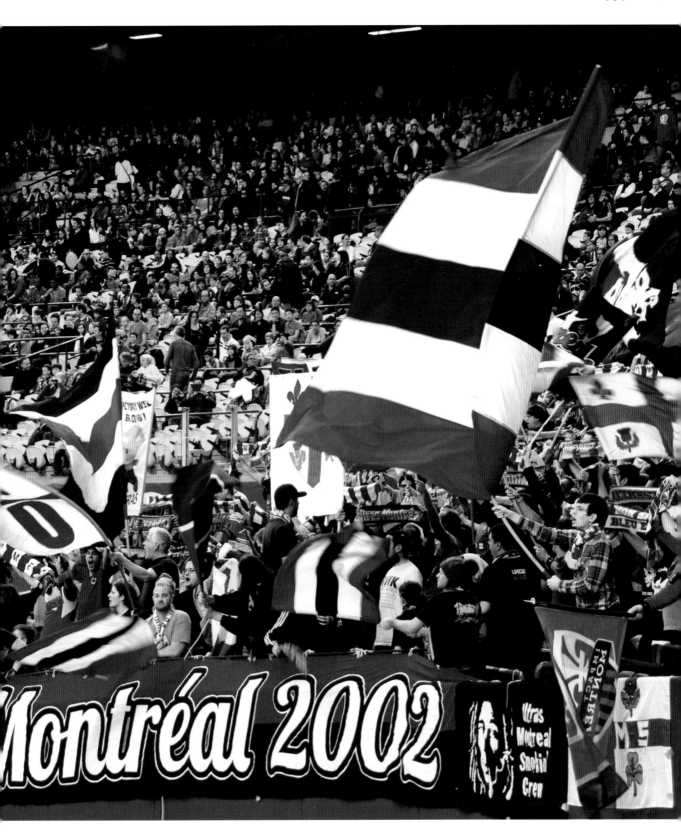

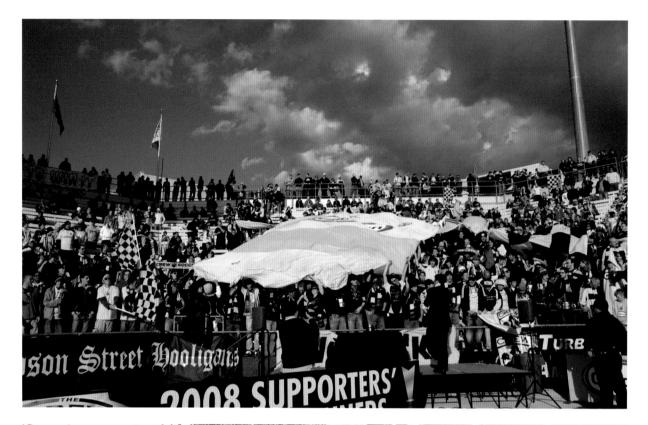

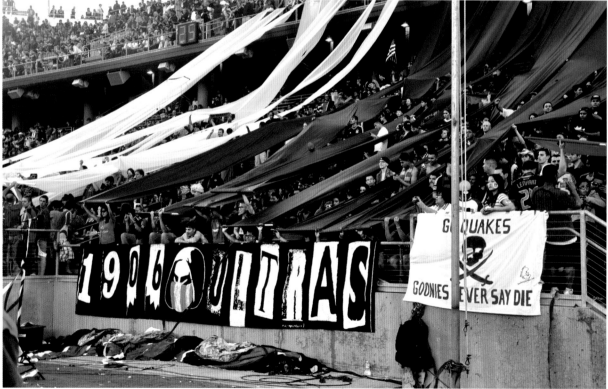

The MLS clubs have close relationships with their fan groups, and across the USA they use a range of tactics to keep the game from developing in the rowdy direction of European football. The Red Bulls offered to pay fan groups not to swear in the stadiums, one group 'The Garden State Ultras' refused. Recently the club revoked their status as an official fan group. The spectre of Euro style Ultra's culture is beginning to haunt the Major League.

> *"...fans can clearly be heard aping the same chant that echoes around stadiums up and down the UK, even down to their affected mockney accents: "Who are ya?"*

VICE (2015)

More and more US fans are seeking a more exciting experience of their Saturday football fixture. They want the passionate vibes they see in world football, and in some clubs they seek their influences south of the border, aping the Latin fan styles and even chanting in Spanish. Sector Latino of Chicago Fire were kicked out of section 101 at Toyota park for setting off a smoke bomb during a match and 'repeated incidents of violence'.

In 2018 the Inebriatti of Toronto FC went crazy with the flares in Ottawa and were immediately banned. Every time a US Ultra sets off a smoke bomb, the repercussions are swift. (Except in Orlando's Special 'Pyro Zone!')The teams are keen to nip this thing in the bud, at the same time as trying to cultivate the 'right type' of fan behaviour to improve the atmosphere at their games. Unlike in the UK, you can still watch the game from 'safe standing' areas, and Portland's Ultras, The Timbers Army, have some of the best Tifo displays in the world.

Ultras are in the USA, and they aren't going anywhere.

"RITUAL IS IMPORTANT TO US AS HUMAN BEINGS. IT TIES US TO OUR TRADITIONS AND HISTORIES"

MILLER WILLIAMS, AMERICAN POET

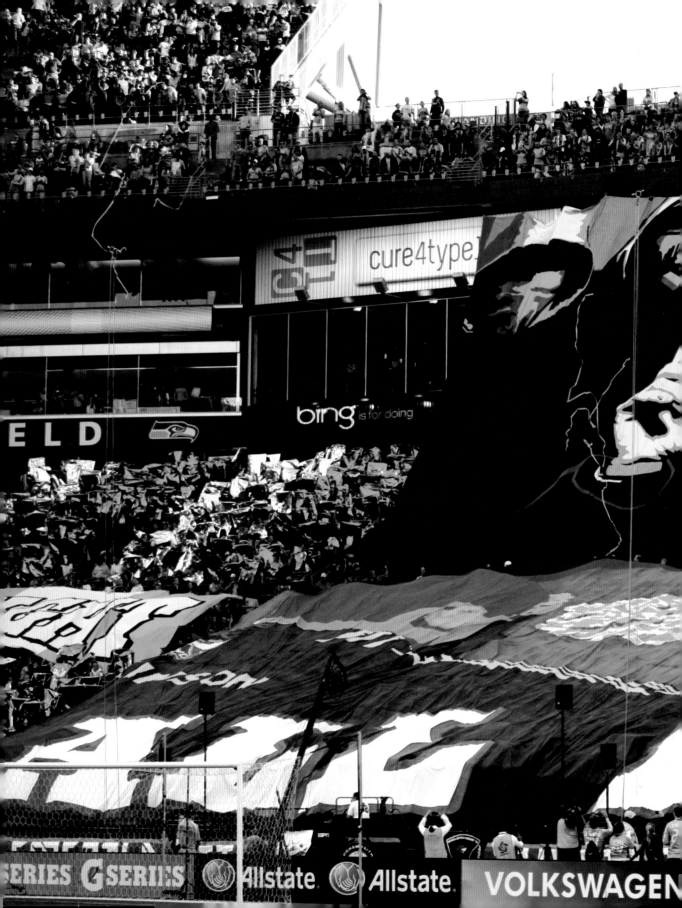

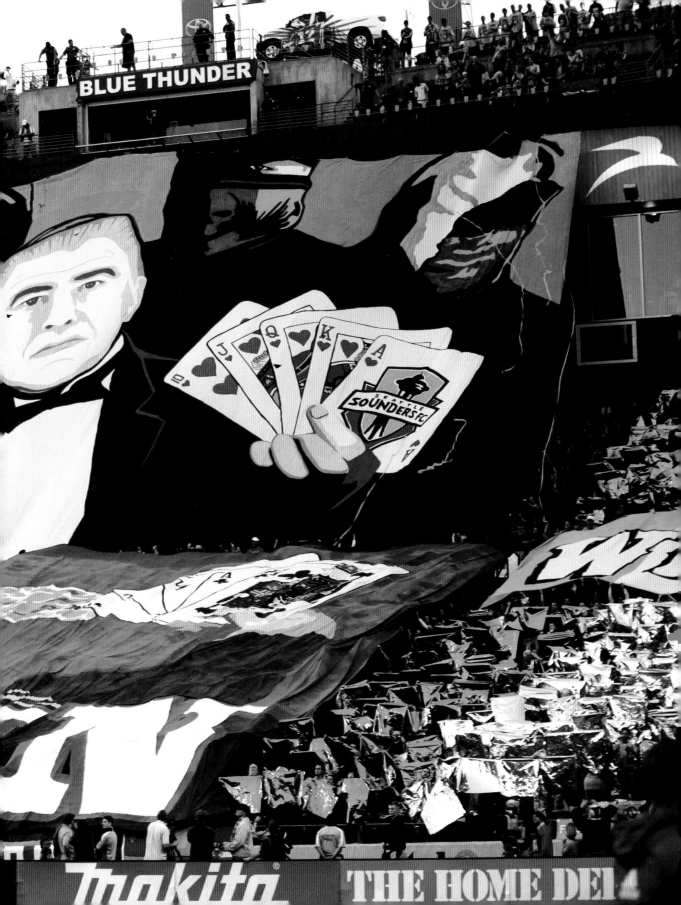

SINGING WHEN YOU'RE WINNING:

FOOTBALL

HOW DOES IT FEEL?

Why do people have such a love of the game? It is after all a pretty stressful experience, full of epic highs and crushing lows, that can just as easily leave you heartbroken as it can mad with elation.

Many fans experience real depression through following their team. Tensions, anxiety, shock and rage all form part of the emotional roller coaster. When Blackpool were relegated after a short blast in the Premier league, the entire town was depressed.

Maybe the problem is that you cannot escape the wall to wall coverage of football anymore. The analysis of defeat and failure is deep and lingering. Fans who are already unhappy, who use football as a distraction from their everyday life, are particularly vulnerable to this football induced depression. In extreme cases it can feel like mourning.

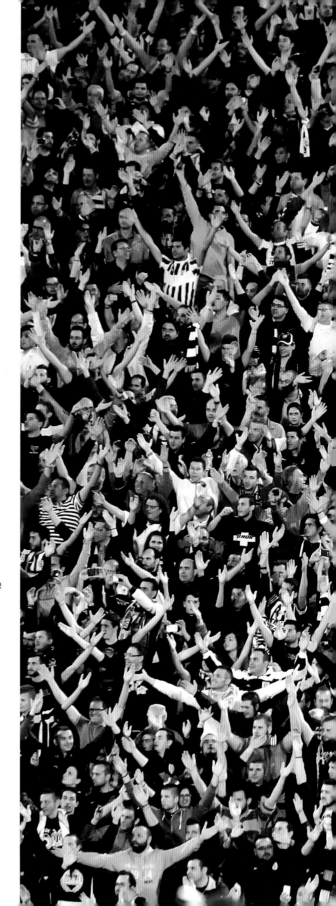

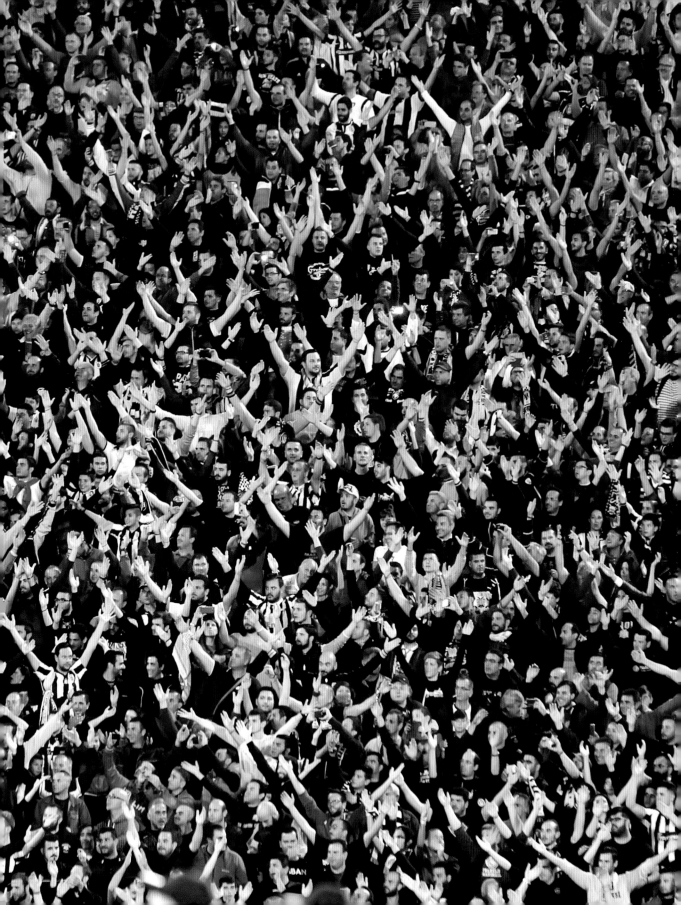

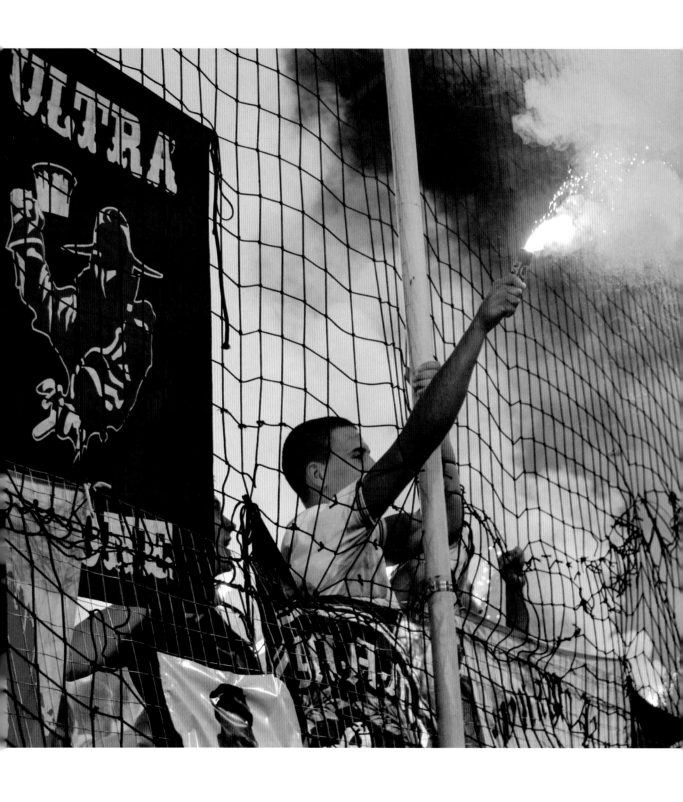

As one anonymous fan on a football message board put it recently: "I can honestly say that I have felt less emotion at funerals than I did watching QPR get relegated."

Although the Ultras are not immune to this kind of football depression, everywhere you look at Ultra fan culture, the impression is that the overall performance of the team is not necessarily the only factor in the football experience. Why is this? Perhaps it is because the joy of expressing your identity collectively is enough of a reward in itself. Recent studies have shown that there is some kind of collective joy that can emerge at a game regardless of the result.

> Obviously, fans are happier when their team wins, but there is also an emotional zeitgeist that develops among spectators that can even override the outcome of the game.

https://www.psychologytoday.com

Finding evidence for what is surely obvious to all those involved, researchers discovered the fan sitting at home has emotional highs and lows tied to the performance of his or her team - unlike the fan in the stadium whose emotional state can be influenced much more by the actions of other spectators.

Passion results when the football fan makes their support a central element of their identity. The University of Quebec identified two types of passion - one which is well balanced and another which is obsessional. These are the two types of football fan in a nutshell. And degrees of obsession would explain why some of the Ultras treat their football like a matter of life and death.

However, there is an associative issue with this type of mindset. The inability to be anything other than devastated if the team loses. This goes a long way to explaining actions such as throwing missiles at the keeper, flares on the pitch or even the pitch invasions and attacks on players and officials that can occur.

Whatever emotions you experience as a fan, they can be extreme. And in a world where we have exchanged the risk of dying of starvation for the risk of dying of boredom - perhaps that is precisely the point. We experience, in our everyday lives a time of unprecedented peace (yes really, turn off the news) and so we create simulations of war through the arena of mass spectator sport. Why? Because we want it all, the dizzying highs the crushing lows, plus the boring bit at half time...

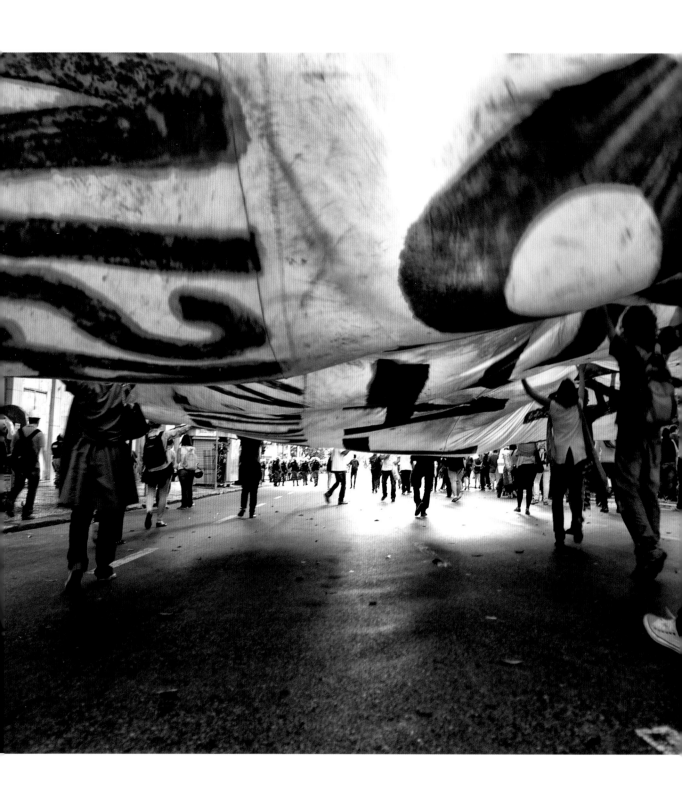

FIFA GO HOME

ENTRE OS "VÂNDALOS": BRAZIL VS THE WORLD CUP

WHEN BRAZIL WON THE RIGHT TO HOST THE FIFA WORLD CUP IN 2014 THE NATION CELEBRATED. THAT IS UNTIL THE AUTHORITIES BEGAN TO EVICT THOUSANDS OF PEOPLE FROM THEIR HOMES TO MAKE WAY FOR THE MASSIVE PROGRAM OF BUILDING THAT IT REQUIRED. AN ESTIMATED 250,000 BRAZILIANS WERE EVICTED BY FORCE PRIOR TO THE EVENT.

Large numbers of people in Brazil live in 'illegal' slums known as favelas. When the state decides to use the land that people live on, they have no legal right to contest these decisions, and the state attitude towards them is simply to apply violence.

> *The impact is being felt most strongly among the poorest citizens, including residents of Porto Alegre's largest favela, or slum, who have come to regard the soccer championship as synonymous with evictions, removals and demolition….*

https://www.washingtonpost.com

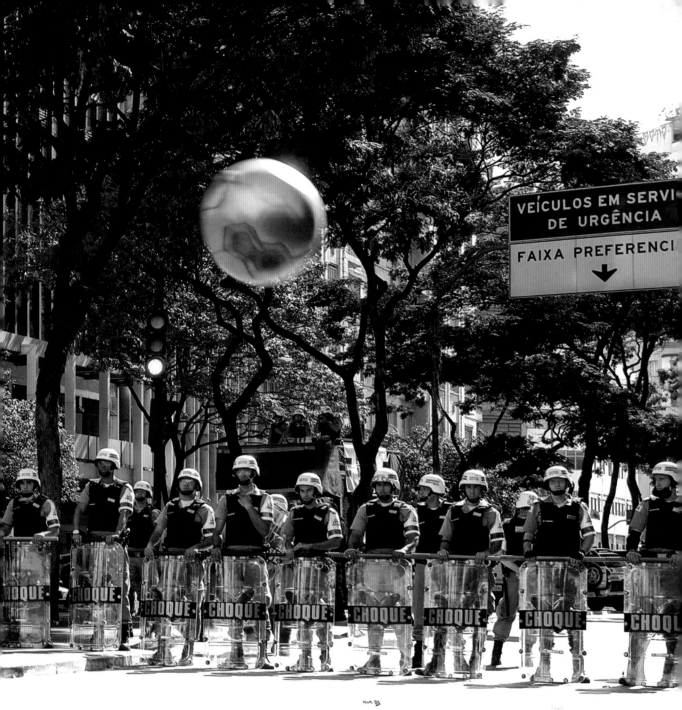

Text within image: VEÍCULOS EM SERVI DE URGÊNCIA / FAIXA PREFERENCI / CHOQUE

"A HUMAN COMMUNITY THAT
(SUCCESSFULLY) CLAIMS THE MONOPOLY
OF THE LEGITIMATE USE OF VIOLENCE
WITHIN A GIVEN TERRITORY"

MAX WEBER'S DEFINITION OF A STATE

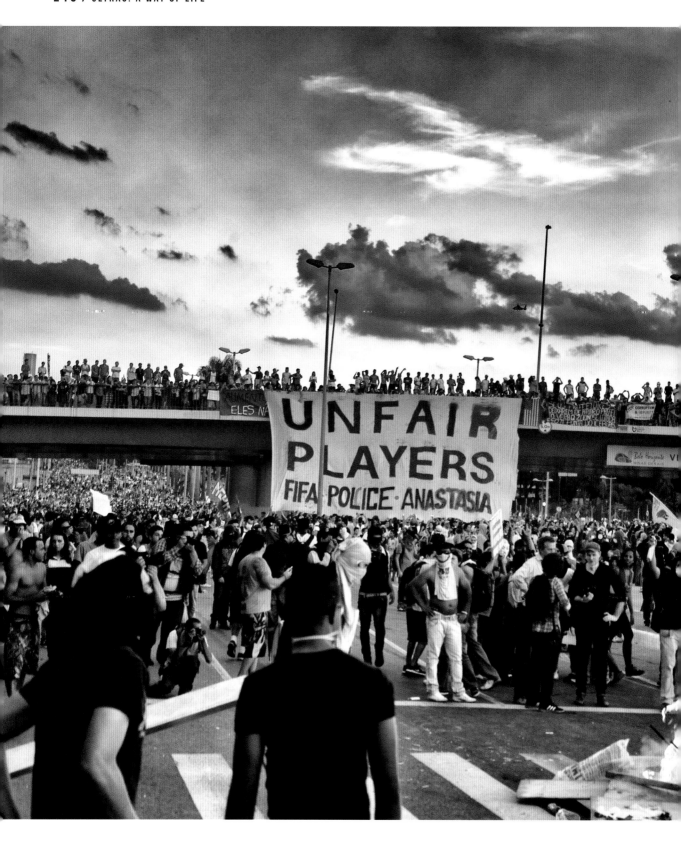

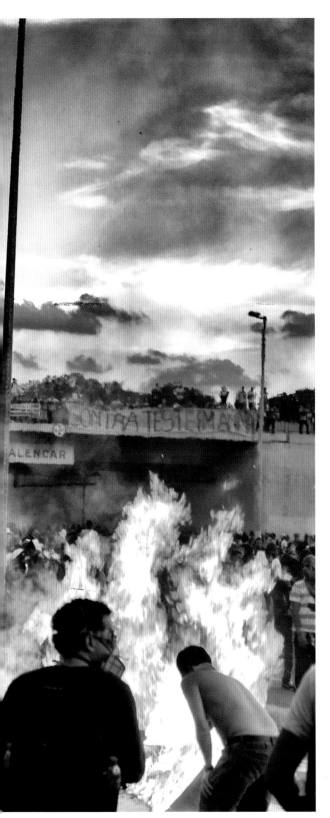

In a country where extreme inequality is the norm, the money spent on hosting the tournament was in inself a bitter pill for people to swallow. When you have been told that there is no money for improving your basic quality of life - then billions of dollars magically appear for investing in football, it's no wonder that you might protest.

OUR CUP IS IN THE STREET

- Protest Slogan

The protests started out peacefully across the country, but Brazil's notoriously heavy handed riot police reacted with force, injuring many people, including journalists - causing Amnesty International to condemn their actions and demand an inquiry. They introduced a new type of armour for the officers policing the World Cup, nicknamed the 'Robocop'. The police made liberal use of tear gas cannons and rubber bullets against a protest that remained largely peaceful and very creative.

One of the enduring images of the protests against an event which was described as 'the biggest theft in history' (Romário 2014) was a piece of street art depicting a hungry young boy crying over a dinner table, no food on the table but a football on his plate.

The following year the Brazilian government was swept out of power on a wave of rage, bringing a far-right populist to power. FIFA was also racked by a huge corruption scandal centered around three high level South American football executives.The World Cup is a festival of escapism but football cannot ignore the realities of the world in which it lives.

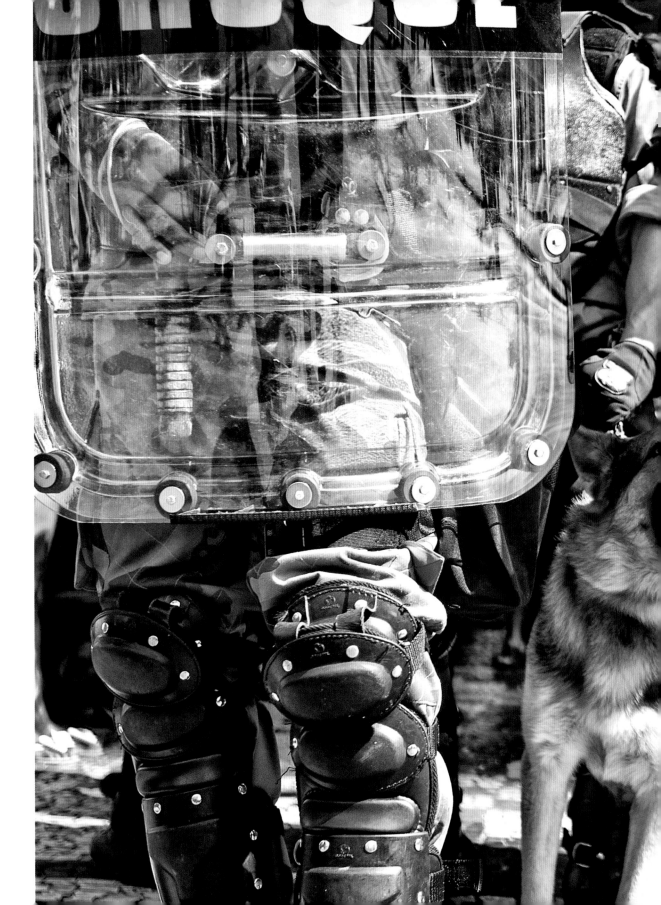

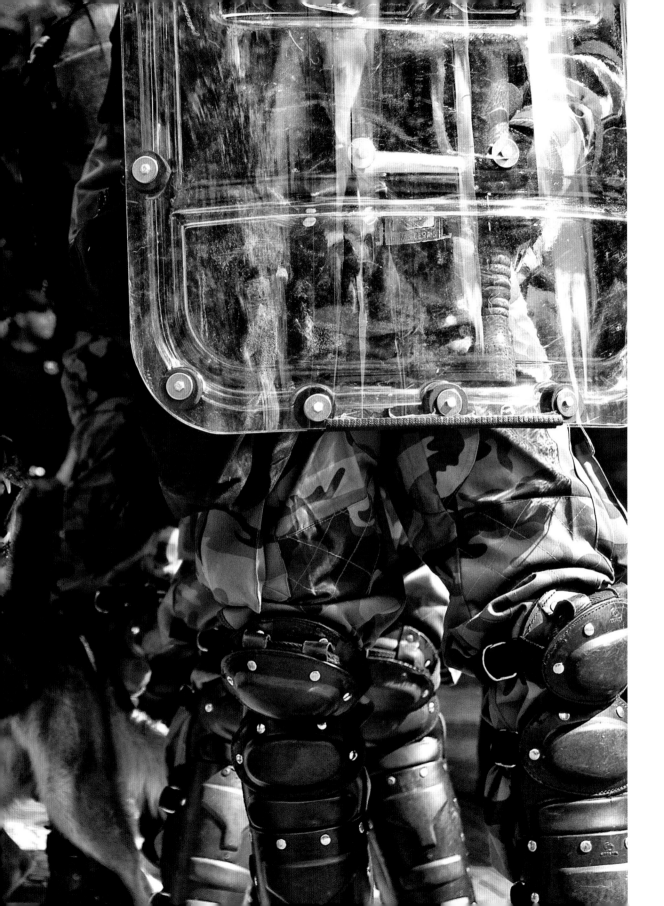

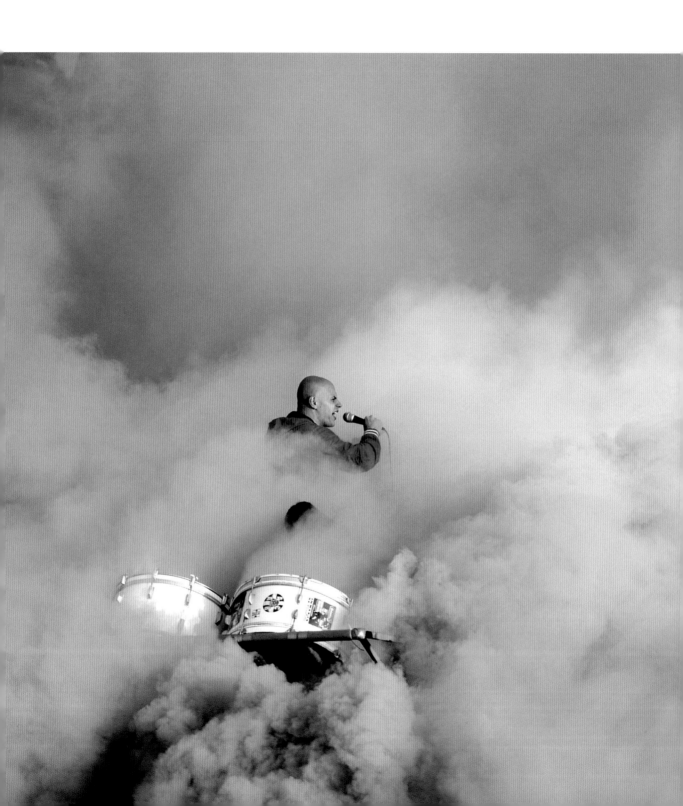

THEY THINK IT'S ALL OVER...

THE FUTURE OF FOOTBALL

All over the world, the fight for the soul of modern football is being played out, in different ways and at different stages. In some countries the power of the Ultras is so great that there is no danger of their control of the stadium's being undermined in the near future. In other countries the powers that control football are so far advanced that the game has purged the traditional fan almost entirely.

Experiments in fan owned football clubs are exciting. But wherever there are fans experimenting with non-league football - they generally follow and support the top tier of the game in addition to their grass roots activities. The top leagues are one of the most successful forms of mass-entertainment in the history of human civilisation. The level of skill displayed is otherworldly. And just when people think that corporate football is a dead duck - incredible moments emerge, like things from story books. These epic moments are difficult to match.

So what lies in the future of football? The Ultras of AS Roma feared that we will see football reduced to a television show, with stadiums either empty or filled only with an affluent and well-behaved middle class fan. They look to the future and see the total domination of a handful of superclubs, so rich that they can simply buy any player that scores against them, possibly at half time and switch their shirts before fielding them in the second half.

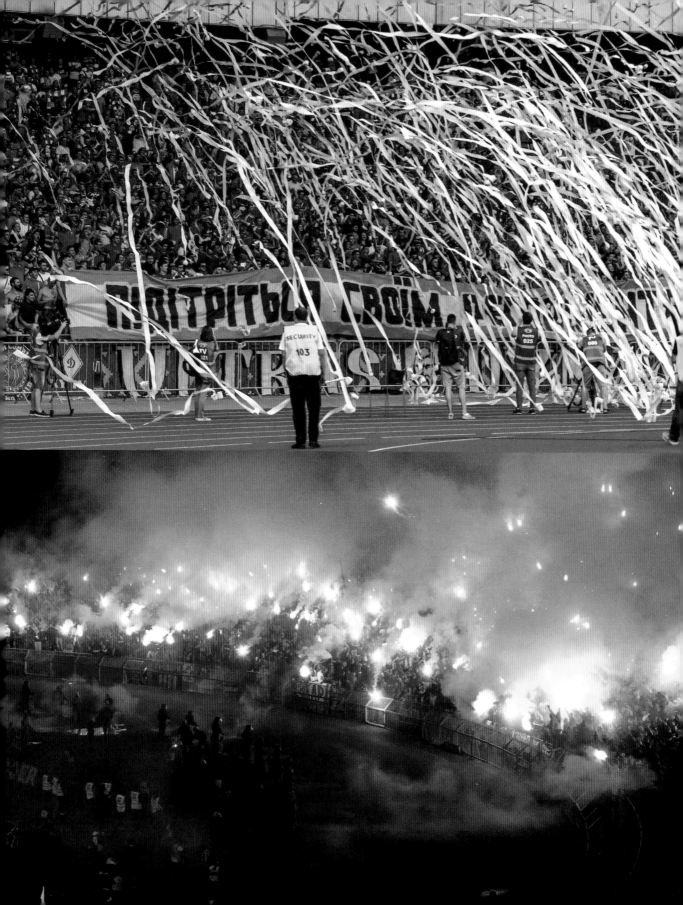

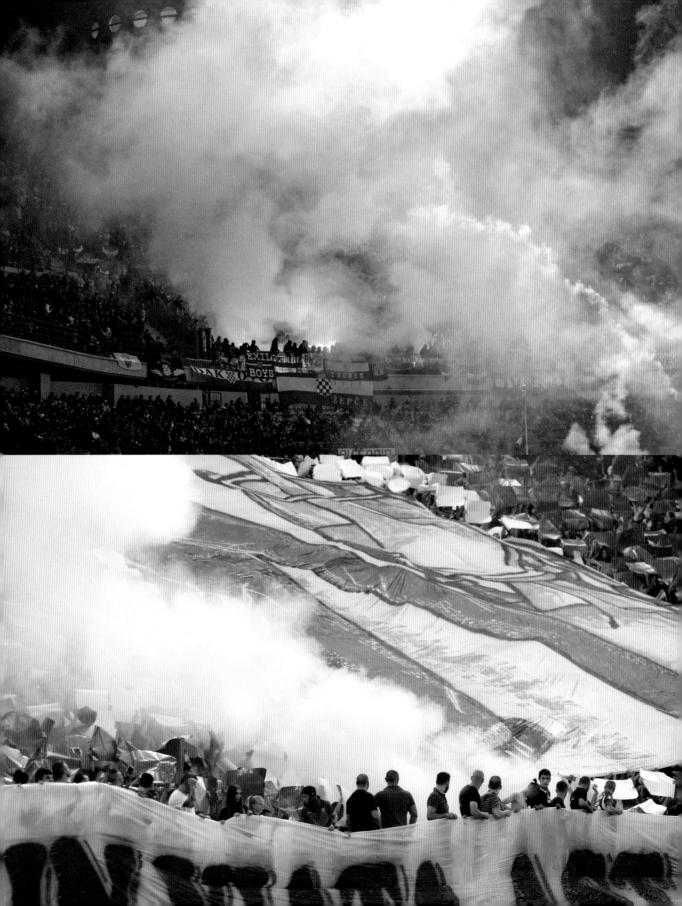

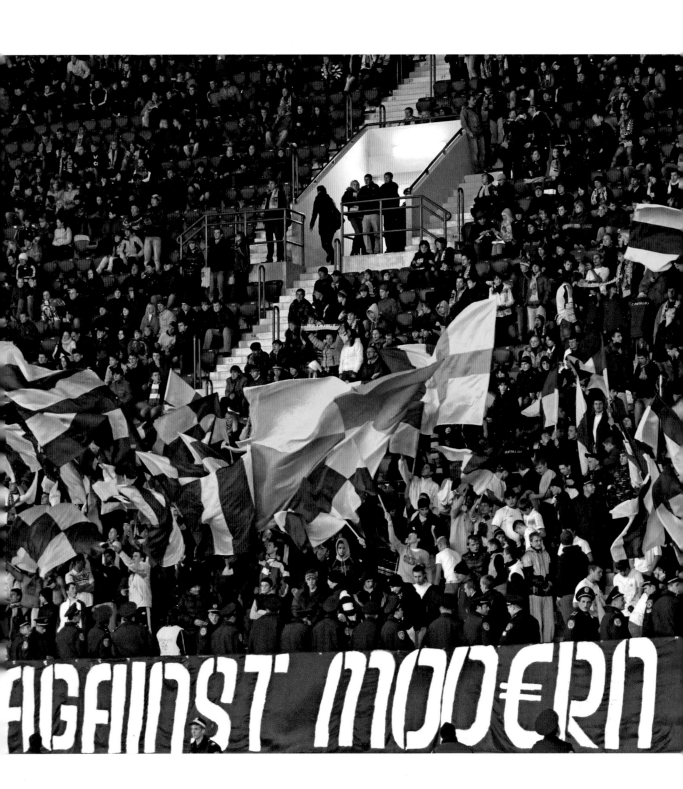

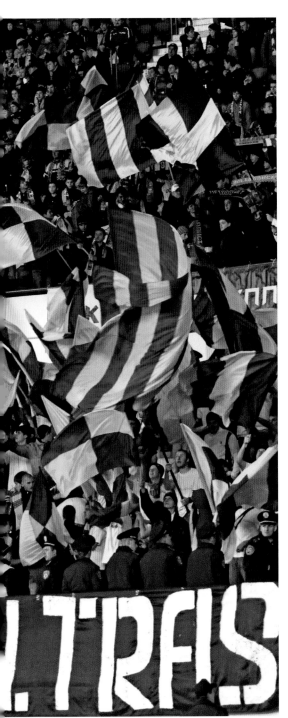

In this dystopian (although already happening) football future key fixtures will be deliberately scheduled to make it all but impossible for working class fans to attend. Away tickets are limited to tiny numbers and charged at extortionate prices, while travel companies quadruple their fares for international games.

And the footballer becomes, an arrogant rock star without the slightest concern for what colour shirt he wears, possibly not even speaking the language of his supporters, plastered in sponsorship, forbidden to express any religious, political or regional identity in his celebrations, forbidden to behave in any way other than a zealously protected brand.

Are these fears realistic? And what about the other side of the story? In the UK the stadium is a far safer place to be than it was in the 1980's. Families can follow their teams together without fear. Nobody has their view of the match obscured by pyro smoke. Not so often do you have to worry about your children listening to racist or obscene chants from the stands.

So what is the ideal future of football? Is there a balance to be struck?

If anything, this question is bigger than football. It's a question about democracy and a question about capitalism, a question about class divisions and tribal loyalties that go deeper than match day, it's a question about the future relationship between the divided factions of modern life.

It's only a game. Or is it?

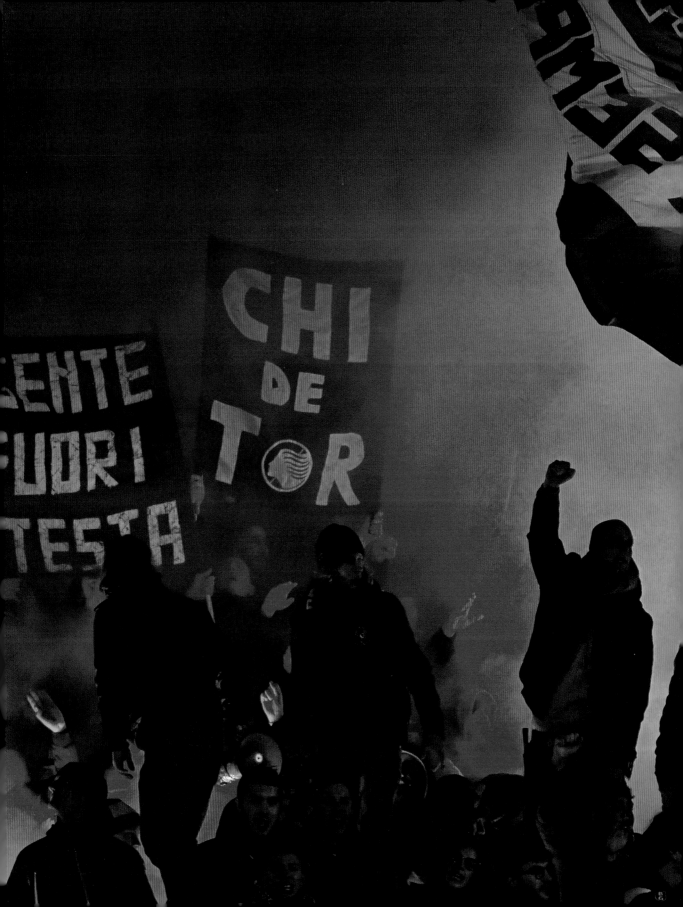

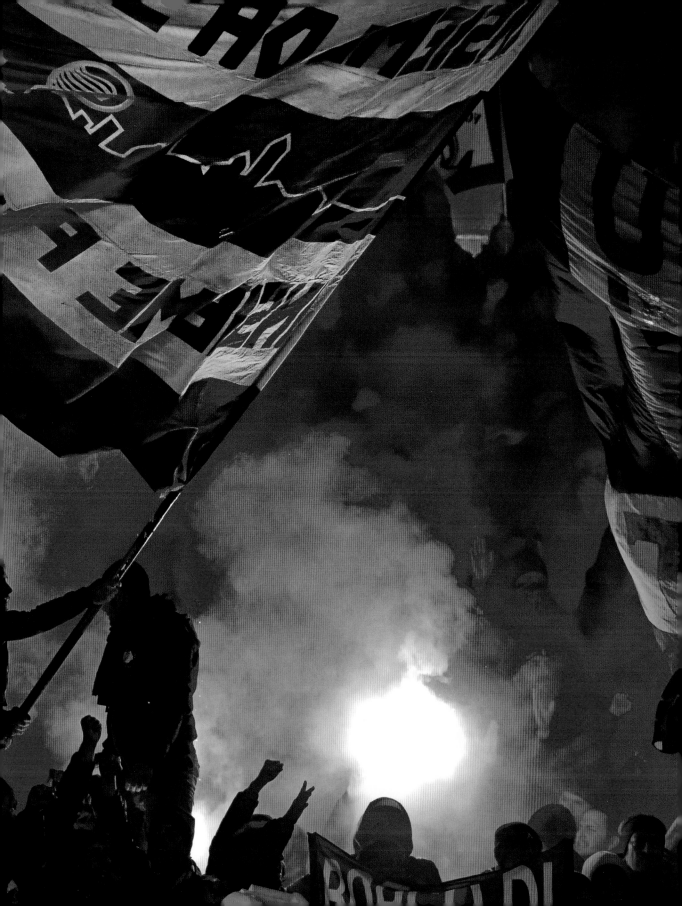

CREDITS

Other books in the Carpet Bombing Culture
Two Finger Salute series:

Mods: A Way of Life

Skins: A Way of Life

Scooterboys

Also available:

Front cover: November 1980. Mirrorpix / Back cover: Damir Sencar, Shutterstock / p1 A Skwarczynski, photographer / p2 Alastair Dunning, photographer / p3 Thessaloniki, Greece - March 02, 2016: PAOK fans clash with riot police during the semifinal Greek Cup game between PAOK and Olympiacos played at Toumba stadium. Ververidis Vasilis / p4 Warsaw, Poland - November 28: Legia Warsaw fans during UEFA Europa League football match between Legia Warsaw and Lazio Rome, on November 28, 2013 in Warsaw, Poland. Tomasz Bidermann / p6 November 5, 2017: Match Polish Lotto Ekstraklasa between KGHM Zaglebie Lubin – Cracovia. Dziurek / p8 Thessaloniki, Greece, November 7, 2017: Kleanthis Vikelidis Stadium full of fans during a friendly football match the between teams ARIS vs Boca Juniors. Ververidis Vasilis / p10 Belgrade, Serbia - FK Partizan and FK Crvena Zvezda. Fotosr52 / p12 Paul Rushton / p14 Kateryna Mashkevych / p17 Fotosr52 / p18 FC Dynamo Kyiv ultra supporter looks on during UEFA Europa League game against Besiktas. Kataonia 8 / p21 CFR Cluj - U Cluj derby, Napoca, Romania. Salajean / p22 Cluj Napoca FC CFR 1907 Cluj team supporters show their support during a soccer game in Romanian League against FC Dinamo Bucharest. Salajean / p24 Leeds vs Coventry 1983. Dave Kendall, Mirrorpix / p26 Milan, Italy. Italy vs Croatia, 2014. Paolo Bona / 1972. Liverpool supporters on their way to the match. Sunday People, Mirrorpix / p30 1985. Birmingham vs Leeds, St Andrew's Stadium. Birmingham Post and Mail Archive, Mirrorpix / p32 Exeter, England. Exeter City FC vs Plymouth Argyle. Clive Chilvers / p34 Polish Lotto Ekstraklasa match KGHM Zaglebie Lubin vs Legia Warszawa. Dziurek / 2019 Wisla Krakow vs Cracovia Krakow. Marcin Kadziolka / p38 1969 Maine Road, Manchester City vs Leeds United. Mirrorpix / p40 1985 St Andrew's, Birmingham City vs Leeds United. Birmingham Post and Mail Archive, Mirrorpix / 1983 Luton Town vs Manchester United. Mirrorpix / p44 1985 Birmingham City vs Leeds United. Birmingham Post and Mail Archive / p47 1979 Euston Station, Arsenal vs Manchester United. Mirrorpix / p48 2018 Thessaloniki, Greece, Touma Stadium, PAOK vs FC Spartak Moscow. Ververidis Vasilis / Thessaloniki, Greece - August 8, 2018: View of the full stadium behind fans during the UEFA Champions League Third qualifying round , between PAOK vs FC Spartak Moscow at Toumba Stadium / p50 1977 Wembley Stadium. Scotland vs England, Scottish fans invade the pitch and destroy the goalposts. Daily Mirror/Mirrorpix / p52 1970 Police stop skinheads and make them remove bootlaces, Ron Burton/Daily Mirror/Mirrorpix / p54 2016 Toumba Stadium, PAOK vs Olympiacos. Yiorgos GR / p56 2018 Inea Stadium, KKS Lech Poznan vs Legia Warszawa. LensTravel / p58 Lagutkin Alexey / p60 Perspolis FC vs Esteghlal FC3. SK On Tour / p60 Perspolis FC vs Esteghlal FC3. SK On Tour / p62 Celtic Park, Glasgow. The Green Brigade. Stuart Wallace/BPI/REX/Shutterstock / p64 Brazil. Ben Tavener/Creative Commons / p66 2007 Maracana Stadium, Rio de Janeiro, Brazil. Flamengo vs Botafogo. OSTILL is Franck Camhi / p68 2017 Libertadores Cup, Nilton Santos Stadium, Botafogo vs Gremio. CP DC Press / p70 Argentina. Eddie Mitford/Creative Commons / p71 Paraguay. Jimmy Baikovicius/Creative Commons / p74 Argentina. Eddie Mitford/Creative Commons / p76 2008 Buenes Aires, River Plate vs Boca Juniors. Serio Goya/AP/REX/Shutterstock / p78 2015 Bombonera Stadium, Buenos Aires, Argentina. Boca Juniors fans. Ivan

Fernandez/AP/REX/Shutterstock / p80 2015 Copa Libertadores, Boca Juniors vs River Plate. Natacha Pisarenk/AP/Shutterstock / p82 Egypt. Hossam el-Hamalawyo/Creative Commons / p84 Egypt. Hossam el-Hamalawyo/Creative Commons / p86 Egypt. Gigi Ibrahim/Creative Commons / p88 Egypt. Hossam el-Hamalawyo/Creative Commons/ p90 Egypt, White Knights. Hossam el-Hamalawyo/Creative Commons / p92 2015 San Siro, AC Milan vs FC Internazionale / p94 2019. AC Milan. Cristiano Bami / p96 2015 San Siro, AC Milan vs Crotone. Paolo Bona / p96 Stadio Olimpico Grande Torino, FC Torino vs Juventus. Fabio Diena / p98 2017 Stadio Olimpico, Rome, Roma vs Lazio. Marco Iacobucci EPP / p100 2018 AC Milan Ultras. Anton_Ivanov / p102 2018 AS Roma vs AC Milan. Bestino / p105 Genoa vs Juventus. Maudanros / p105 2018 Stadio San Paolo, Napoli. Antonio Balasco / p106 SS Lazio vs UC Sampdoria. Marco Iacobucci EPP / p106 2018 AC Milan vs FC Inter. Fabrizio Andrea Bertani / p107 2019 Bergamo, Atalanta vs FC Juventus. Paolo Bona / p107 Genoa vs Catania Genoa. Maudanros / p108 CFC Genoa vs UC Sampdoria. Paolo Bona / p108 2019 FC Inter vs Atalanta. Fabrizio Andrea Bertani / p111 VEB Arena, CSKA Moscow vs Spartak Moscow. Bukharev Oleg / p111 2017 Spartak Moscow. Paparacy / p112 Marseille France, Russia vs England. Marco Iacobucci EPP / p114 Moscow Russia, Special Purpose Police. Free Wind 2014 / p116 KGHM Zaglebie Lubin vs Lech Poznan. Dziurek / p118 Wks Slask Wroclaw vs Legia Warszaw. Trybex / p120 2019 Wisla Krakow vs Cracovia Krakow. Marcin Kadziolka / p120 Slask Wroclaw vs KGHM Zaglebie Lubin. Dziurek / p121 2018 KKS Lech Poznan vs Legia Warszawa. LensTravel / p121 2016 KGHM Zaglebie Lubin - Pogon Szczecin. Dziurk / p122 2017 Slask Wroclaw vs KGHM Zaglebie Lubin. Dziurek / p122 2017 Gornik Zabrze vs Wisla Krakow. Marcin Kadziolka / p123 Legia Warszawa vs Lech Poznan. Tomasz Bidermann / p123 2016 KGHM Zaglebie Lubin vs FK Partizan Belgrade / p124 2016 Legia Warszawa vs Lech Poznan. Tomasz Bidermann / p126 2018 Zagreb Croatia, GNK Dinamo vs HNK Hajduk. DarioZg / p129 Primosten Croatia, Hajduk Split Anniversary Mural. Pawel Kowalczyk / p130 Belgrade Serbia, FK Partizan and FK Crvena Zvezda. Fotosr52 / p132 Thessaloniki Greece, PAOK vs Olympiacos. Yiorgos GR / p134 PAOK vs Olympiacos. Ververidis Vasilis / p136 Piraeus Greece, Olympiacos vs Sporting CP. Ververidis Vasilis / p138 Thessaloniki Greece, PAOK fans protest against new sports law reform. Alexandros Michailidis / p138 2019 PAOK vs Olympiacos. Ververidis Vasilis / p139 2018 Budapest Hungary, Vidi FC v PAOK. Laszio Szirtesi / p139 AEK Athens FC vs PAOK. SKOnTour / p140 PAOK vs Olympiacos. Ververidis Vasilis / p140 PAOK vs Olympiacos. Ververidis Vasilis / p141 PAOK vs Olympiacos. Yiorgos GR / p141 PAOK vs Olympiacos. Yiorgos GR / p142 Besiktas Turkey. Firat Cetin / p144 Galatasaray Turkey. Burcu A. Creative Commons / p144 Fenerbahce Turkey. Mark Freeman Creative Commons / p146 Rome Italy. MZeta /p148 Wembley England, Spurs vs Borussia Dortmund. Cominlftode / p150 Bayern Muenchen vs FC Ingolstadt. Mitch Gunn / P150 Eintracht Frankfurt. Dirk Ingo Franke Creative Commons / p151 Vienna Austria, SK Rapid. Herbert Kratky / p151 Nicosia Cyprus, Apollon Limassol FC vs Borussia Monchengladbach. Yian Kourt / p152 FC Bayern München II vs TSV 1860 München II. SK.ontour. Photographer / p152 Gelsenkirchen Germany, Schalke vs PAOK. Ververidis Vasilis / p154 Poltava Ukraine. Oleh Dubyna / p157 Sporting Club de Portugal vs FC Porto. SK.ontour.

Photographer / p158 Spain, Getafe CF vs Real Madrid. SK.ontour. Photographer / p158 Bilbao Spain, Athletico Bilbao vs FC Barcelona. Imagestockdesign / p160 Sporting Club de Portugal vs FC Porto. SK.ontour. Photographer / p160 Sporting Club de Portugal vs FC Porto. SK.ontour. Photographer / p161 Sporting Club de Portugal vs FC Porto. SK.ontour. Photographer / p161 Sporting Club de Portugal vs FC Porto. SK.ontour. Photographer / p162 Lyon France, Olympique Lyon vs Atletico Madrid. Vlad1988 / p164 Paris St Germain. Nicolas Le Forestier / p166 2017 Lyon France, Olympique Lyon vs Ajax Amsterdam. Sebastian Nogier/EPA/REX/Shutterstock / p168 Serbia Belgrade, The Eternal Derby. Fotosr52 / p170 Belgrade Serbia, FC Partizan vs Red Star Belgrade. Nerbojsa Markovic / p170 Belgrade Serbia, Red Star Belgrade vs Cukaricki. ToskanaINC / p171 2019 Belgrade Serbia, The Eternal Derby, FC Partizan vs FC Red Star. Fotosr52 / p171 2018 Belgrade Serbia, The Eternal Derby, FC Partizan vs FC Red Star. Fotosr52 / p172 Serbia Belgrade, Red Star Belgrade vs Cukaricki. ToskanaINC / p174 Budapest Hungary, Green Monsters, Ferencvarosi TC v Maccabi Tel Aviv. Laszio Szitesi / p174 Kyiv Ukraine, Dynamo Kyiv vs Arsenal. Katatonia82 / p175 Brugge Belgium, Club Brugge vs Zulte Waregem. Kivni / p175 Kharkov Ukraine, Metalist Kharkiv vs Metallurg Donetsk. Lurii Osadchi / p176 Zabrze Poland, Gornik Zabrze vs Wisla Krakow. Marcin Kadziolka / p178 Odessa Ukraine, Shaktar vs Dynamo Kiev. Alexey Lesik / p180 2017 Bucharest Romania, football fans take part in anti-corruption protests. Creative Lab / p180 2017 Bucharest Romania, football fans take part in anti-corruption protests. Creative Lab / p181 Kyiv Ukraine, FC Dynamo Kyiv vs Shakhtar Donetsk. Katatonia82 / p181 Rio de Janeiro Brazil, Vasco da Gama vs Flamengo. A. Ricardo / p182 Belgrade Serbia, The Eternal Derby, FC Partizan vs Red Star Belgrade. Fotosr52 / p186 Bangkok Thailand. Nattapan72 / p188 Kanagawa Japan, Yokohama FC vs Yokohama FC Marinos. Aflo/Shutterstock / p190 Kuala Lumpur Malaysia, Malaysia vs Thailand. Feelphoto / p192 Bangkok Thailand. Mooinblack / p192 Bangkok Thailand. Sooksun Saksit / p193 Bangkok Thailand. Mooinblack / p193 Selangor Malaysia. Abdul Razak Latif / p194 Ajax. Sk.ontour. Photographer / p196 Montreal, Canada. Abdallahh / p198 Columbus Crew USA, Sam Fahmi Creative Commons/ p198 San Jose Earthquake USA, Aaron Sholl Creative Commons / p200 Seattle Sounders FC USA. Ted S. Warren/AP/REX/Shutterstock / p202 Thessaloniki Greece, PAOK vs Borussia Dortmund. Ververidis Vasilis / p204 Odessa Ukraine. Vlad1988 / p206 Belo Horizonte, Brazil. Protests against World Cup. Fernando Henrique C. Oliveira / p208 Belo Horizonte, Brazil. Protests against World Cup. Fernando Henrique C. Oliveira. Photographer / p210 Belo Horizonte, Brazil. Protests against World Cup. Fernando Henrique C. Oliveira. Photographer / p212 Belo Horizonte, Brazil. Protests against World Cup. Fernando Henrique C. Oliveira. Photographer / p214 Ruch Chorzow, Poland. MediaPictures.pl /p216 FK Crvena Zvezda Beograd vs FK Partizan Beograd. SK.ontour. Photographer / p216 Kyiv Ukraine, Dynamo Ultras. Photo-oxser / p217 Milan Italy, Italy vs Croatia. Paolo Bona / p217 Bucharest Romania, Dinamo Bucharest vs FCSB. Micea Moira / p218 Kharkiv Ukraine, FC Metalist Kharkiv vs FC Volyn Lutsk. Lurii Osadchi / p220 Bergamo, Italy 2019. Atalanta vs Juventus. Paolo Bona / p224 Stockholm Sweden, DIF vs AIK. Stefan Holm. All images not specifically attributed above copyright of Shutterstock.

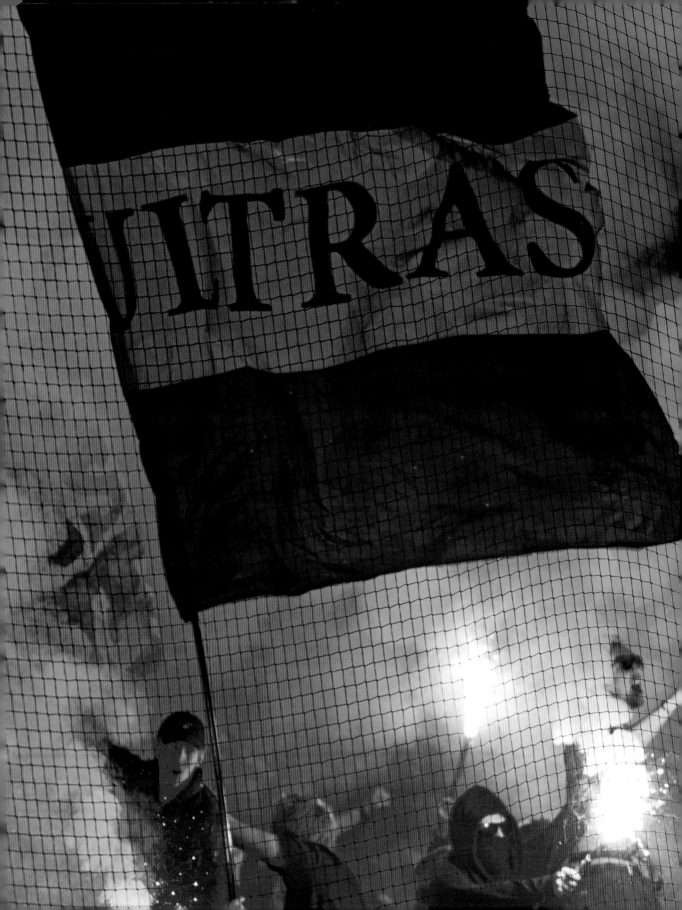